Books From California
51 W. Easy St
Simi Valley, CA 93065
UNITED STATES
amazonsales@booksfromca.com

Books From California
51 W. Easy St
Simi Valley, CA 93065
UNITED STATES

To: Richard Skurdall
174 Karnten Road #15
Montgomery Center, Vermont 05471
UNITED STATES

Marketplace:	Amazon US
Order Number:	9671326
Ship Method:	Standard
Customer Name:	Richard Skurdall
Order Date:	6/12/2021
Marketplace Order #:	112-7631438-9585857
Email:	vx0l2vgqcmyvr4t@marketplace.amazon.com

Items:

Qty	Item	Locator	Condition	Price
1	Käthe Kollwitz in Dresden Kuhlmann-Hodick, Petra,Fischer, Hannelore,Matthias, Agnes,von der Knesebeck, Alexandra SKU: mon0001899485 ISBN: 191130030X - Books	C -2-01-982-001-247	Very Good	$19.01

Subtotal:	$19.01
Shipping:	$3.99
Total Tax:	$1.38
Total:	$24.38

Notes:

Thanks for your order!

If you have any questions or concerns regarding this order, please contact us at amazonsales@booksfromca.com

Käthe
Kollwitz
in Dresden

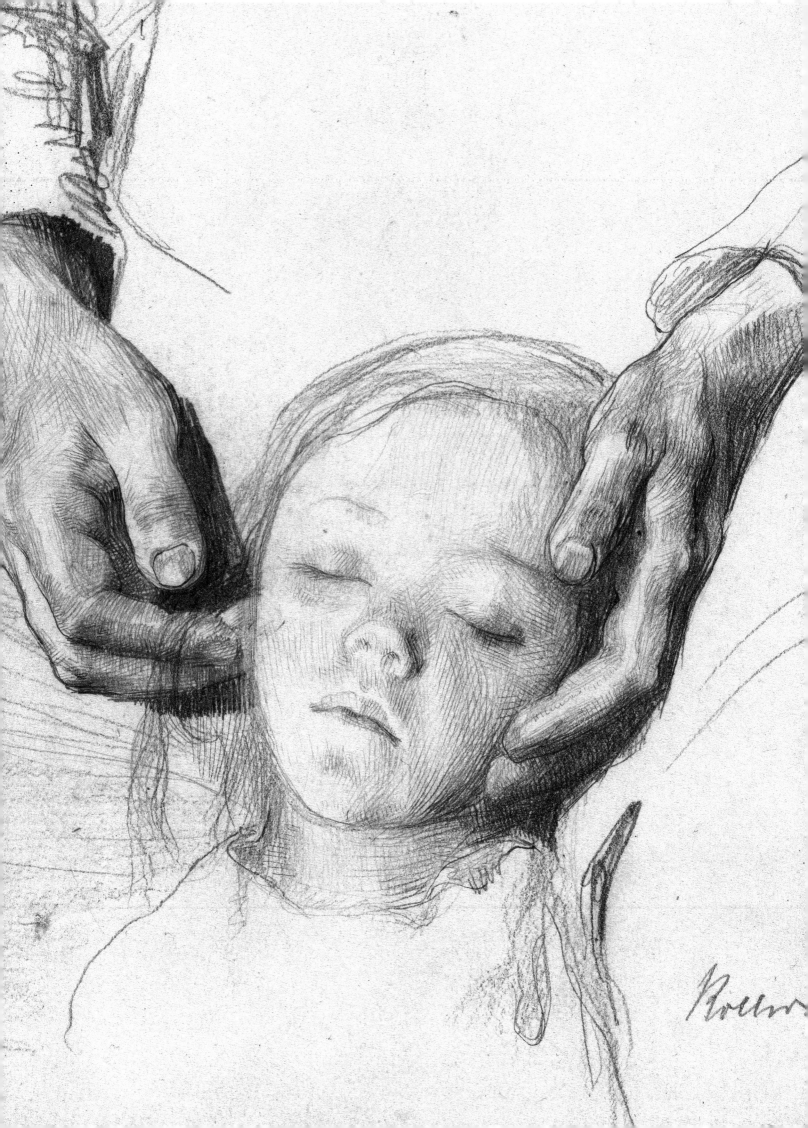

Käthe Kollwitz
in Dresden

Edited by

The Staatliche Kunstsammlungen Dresden
Petra Kuhlmann-Hodick, Agnes Matthias

With essays by

Hannelore Fischer, Alexandra von dem Knesebeck,
Petra Kuhlmann-Hodick and Agnes Matthias

STAATLICHE KUNSTSAMMLUNGEN DRESDEN

KUPFERSTICH-KABINETT

in association with

PAUL HOLBERTON PUBLISHING

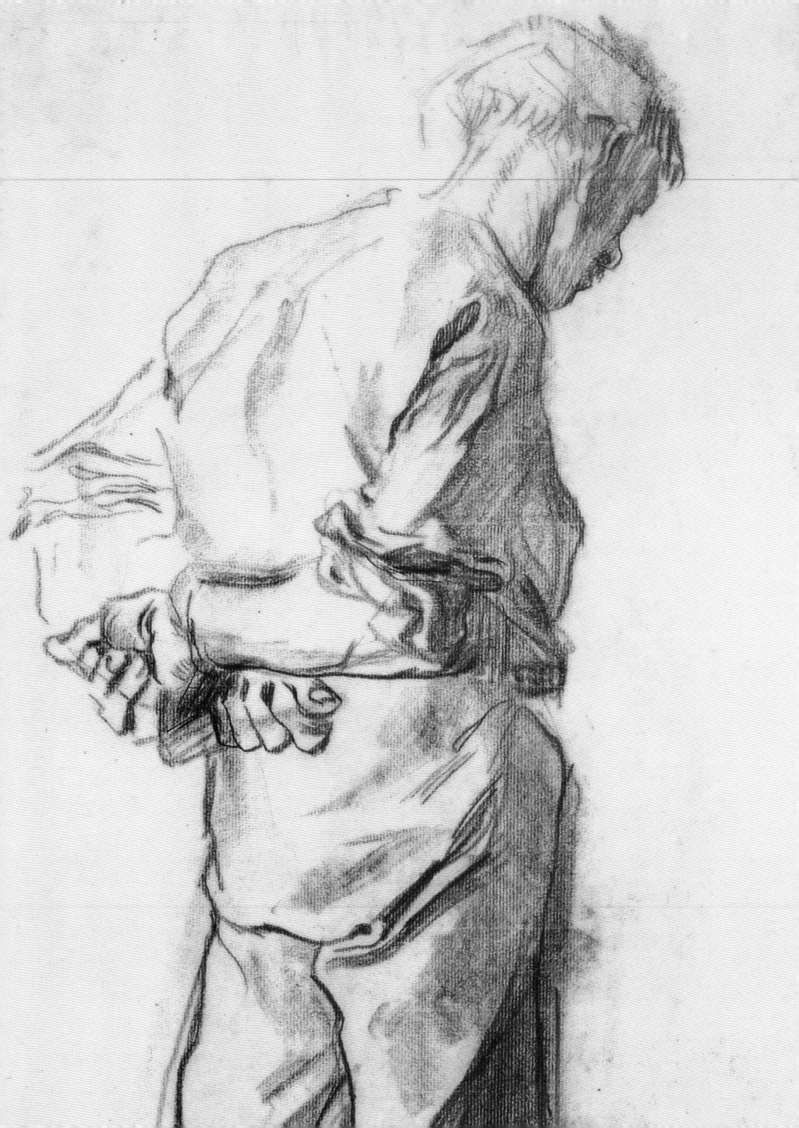

CONTENTS

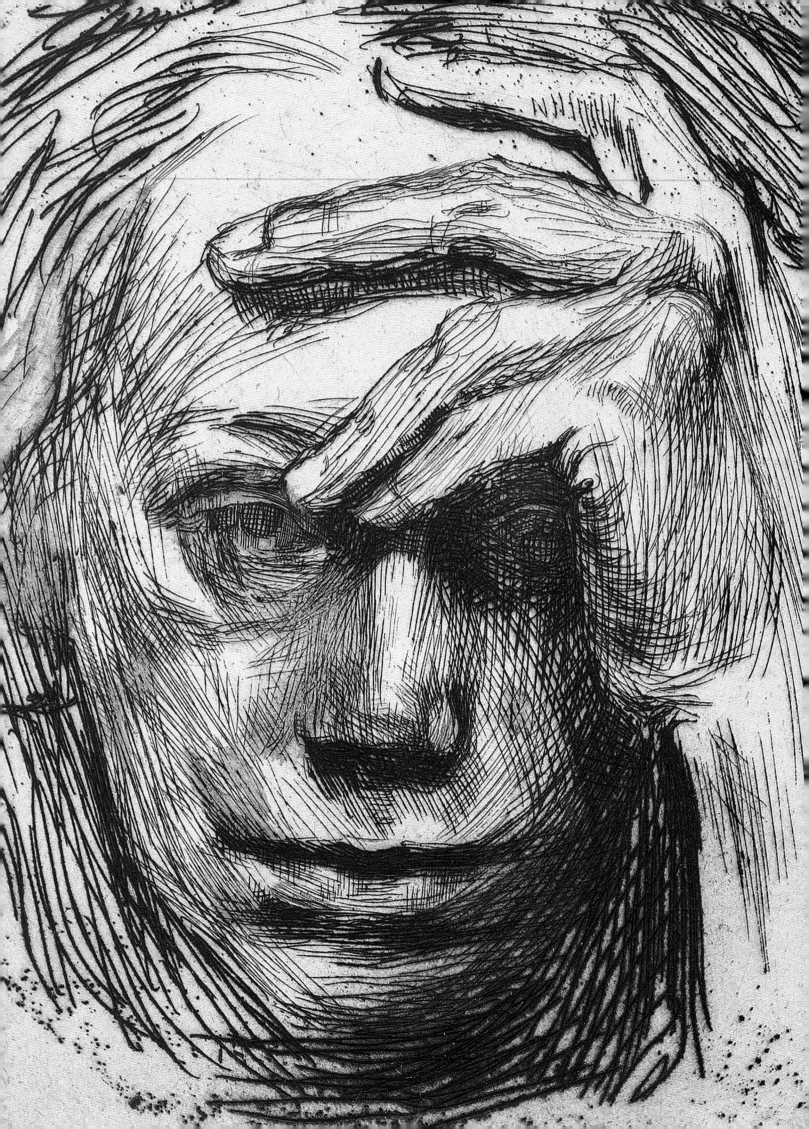

FOREWORD

Today, 150 years after her birth, Käthe Kollwitz is acknowledged as one of the pre-eminent artists of the twentieth century. Her work unmistakably expresses a deep interest in the humane and gives clear voice to her socially committed, pacifist attitude. And yet the artist's incisive multi-faceted powers of observation and her both subtle and experimental use of graphic media protect her images from being misunderstood as simplistic pleas to save the world. The profound, beseeching character of many of her works may still provoke viewers, triggering discomfort in addition to approval. The societal demands that she herself linked to her art can be heard in her 1922 assertion: "I am agreed that my art has a purpose. *I want to have an effect* in these times in which people are so helpless and needy."

As a graphic artist, Kollwitz is represented in the most significant public and private collections worldwide, but, at the start of her career, she could not expect recognition in the way that her male colleagues naturally could. For this reason, it is important to highlight the institutional achievement of the Dresden Kupferstich-Kabinett, which, in the person of its Director, Max Lehrs, became a tenacious supporter of the unknown young artist.

Enabling the creation of art by devoting to it both material and intellectual attention has always been an important task of museums, even if it requires running certain risks; the obvious tangible success of the museum's collecting in Kollwitz's case should not hide the fact that the inventories include a large number of lesser-known names alongside the few artists who achieved fuller recognition.

In 1917, for Käthe Kollwitz's fiftieth birthday, two displays were organized in the Kupferstich-Kabinett. One of them was dedicated to drawings of hers newly acquired by the museum, among them the youthful self-portrait that serves as the cover image for this catalogue. Thanks to Max Lehrs's dedication, Dresden houses the oldest museum collection of the artist's work – and still one of the most comprehensive. Lehrs began in 1898 with the acquisition of the graphic cycle *A Weavers' Revolt*. Exactly one hundred years later, in 1998, the latest works were purchased – five prints from the collection of the notable Dresden artist Hans Theo Richter and his wife

Hildegard. In the current anniversary year, 2017, the Dresden Kollwitz collection will be enriched with an especially happy (re-)addition: thanks to The National Board of Antiquities in Helsinki, three works from among the 75 missing from the collection since 1945 have been identified and will be returned to Dresden. They include *Self-portrait, hand on forehead*, dating from mid June 1910. Two proofs of this striking etching were purchased in 1952 and 1954 (see detail opposite) in two different states. From now on the sheet acquired in 1917 will be reunited with the group.

Käthe Kollwitz in Dresden focuses on the exceptional collection of the Kupferstich-Kabinett, supplemented by pieces on loan from the Käthe Kollwitz Museum in Cologne, the Kupferstichkabinett of the Staatliche Museen zu Berlin, the Akademie der Künste Berlin, the Sächsische Landesbibliothek – Staats- und Universitätsbibliothek Dresden as well as the Kunstbibliothek of the Staatliche Kunstsammlungen Dresden. We are deeply grateful to all the lenders, as well as to Alexandra von dem Knesebeck for her thorough and illuminating account of the as yet unpublished correspondence between Kollwitz and Lehrs and to Hannelore Fischer for her knowledgeable analysis of Käthe Kollwitz's self-portraits in the exhibition catalogue. We would especially like to thank Petra Kuhlmann-Hodick and Agnes Matthias, who, through friendly, collegial cooperation as editors and co-curators, have generated due attention for the Dresden collection in this, Käthe Kollwitz's anniversary year, and have substantially enriched the scholarship on the artist with this catalogue. This beautifully produced publication by Paul Holberton and Laura Parker is intended to bring the collection to the attention of an international audience as well.

Finally, our personal thanks go to Andrea Woodner as artist, friend and patron. Without her generous support, this publication could not have been realised.

STEPHANIE BUCK
Director
Kupferstich-Kabinett

MARION ACKERMANN
General Director
Staatliche Kunstsammlungen
Dresden

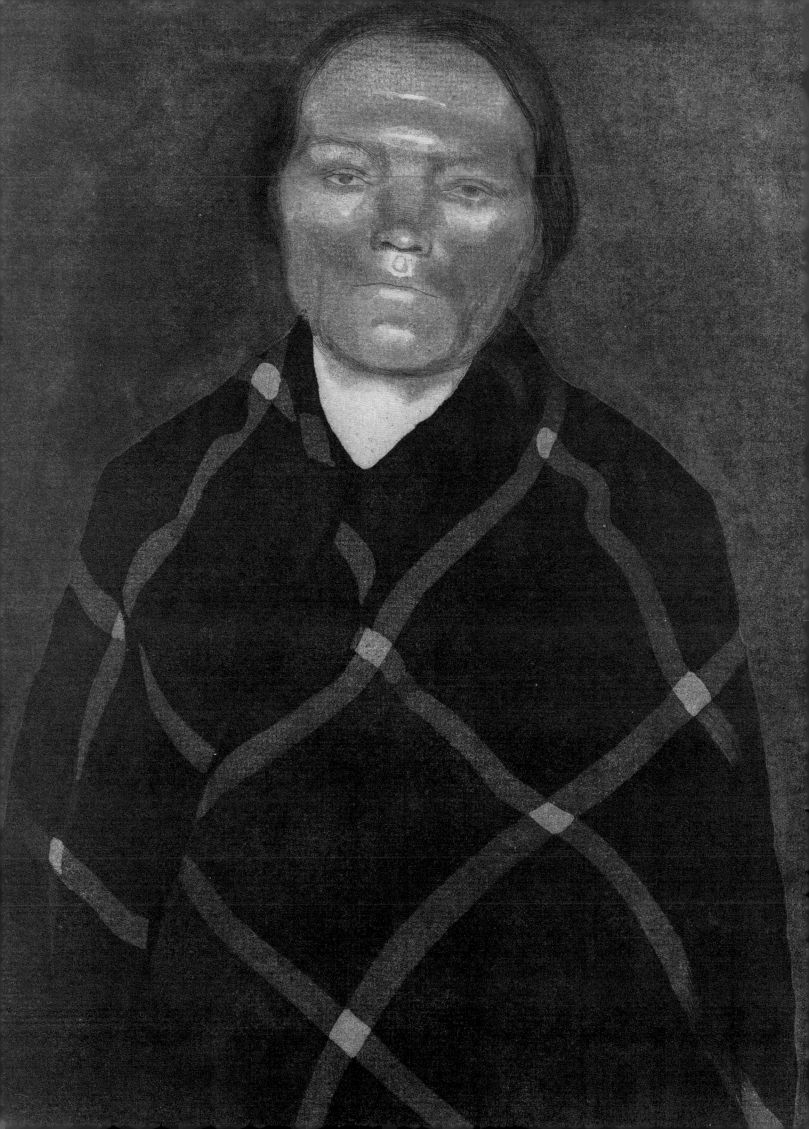

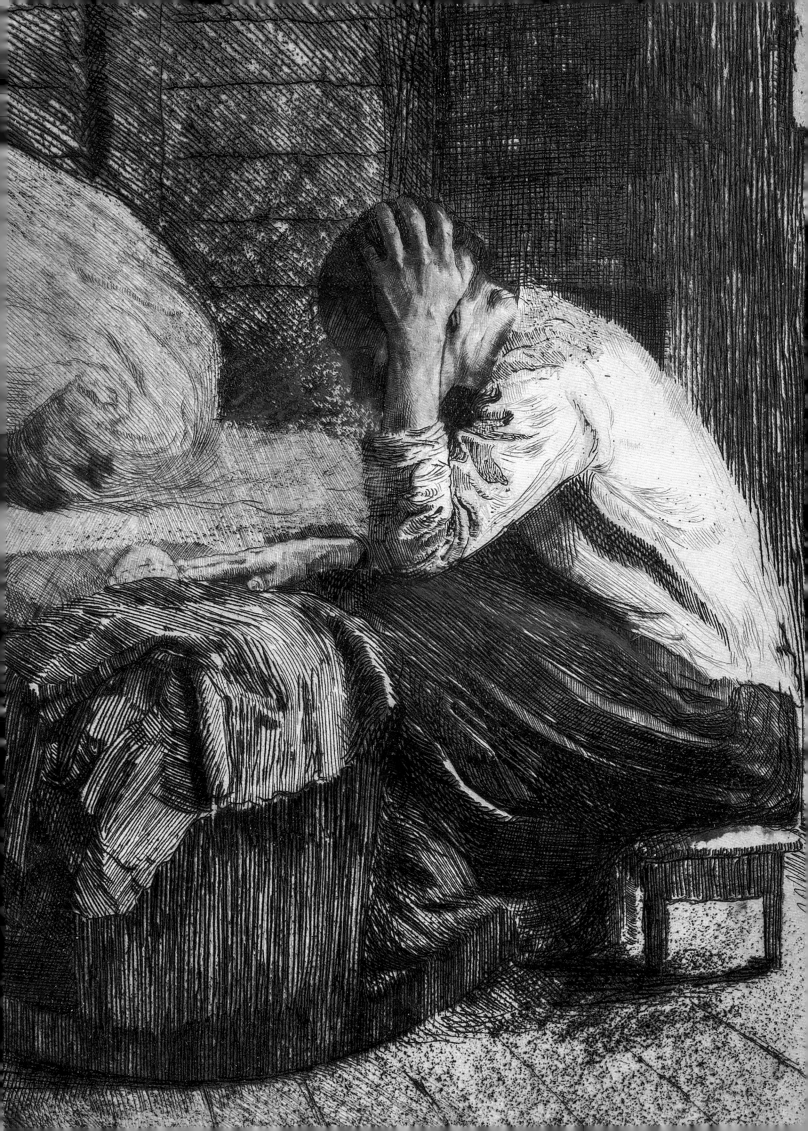

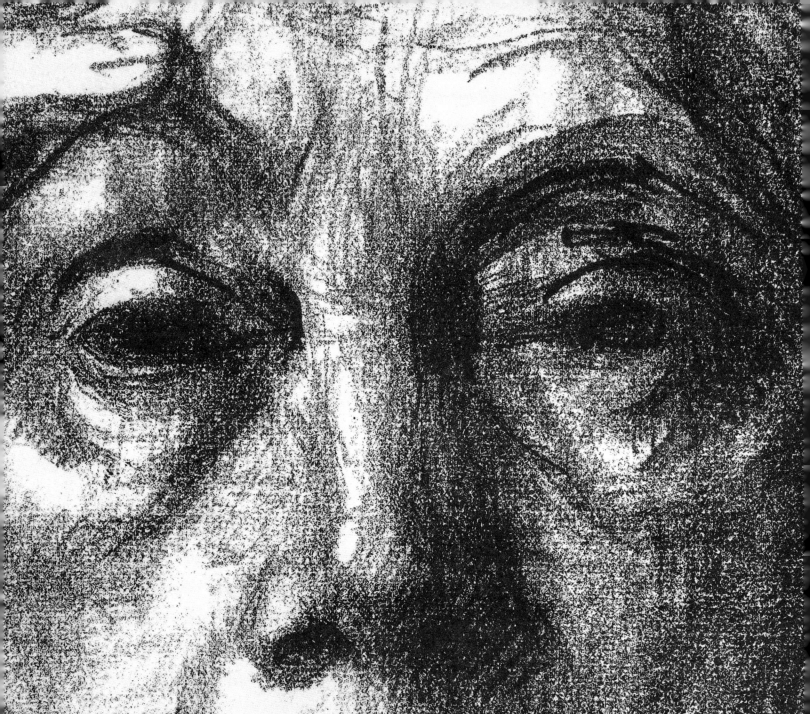

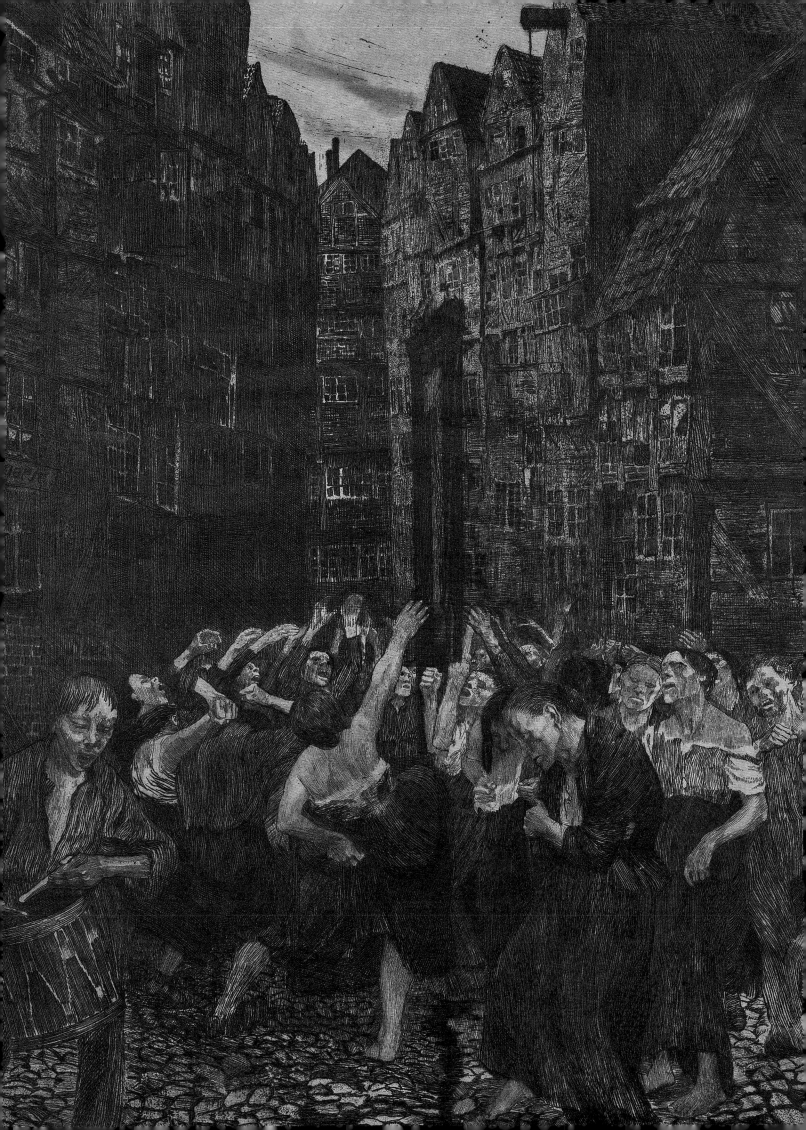

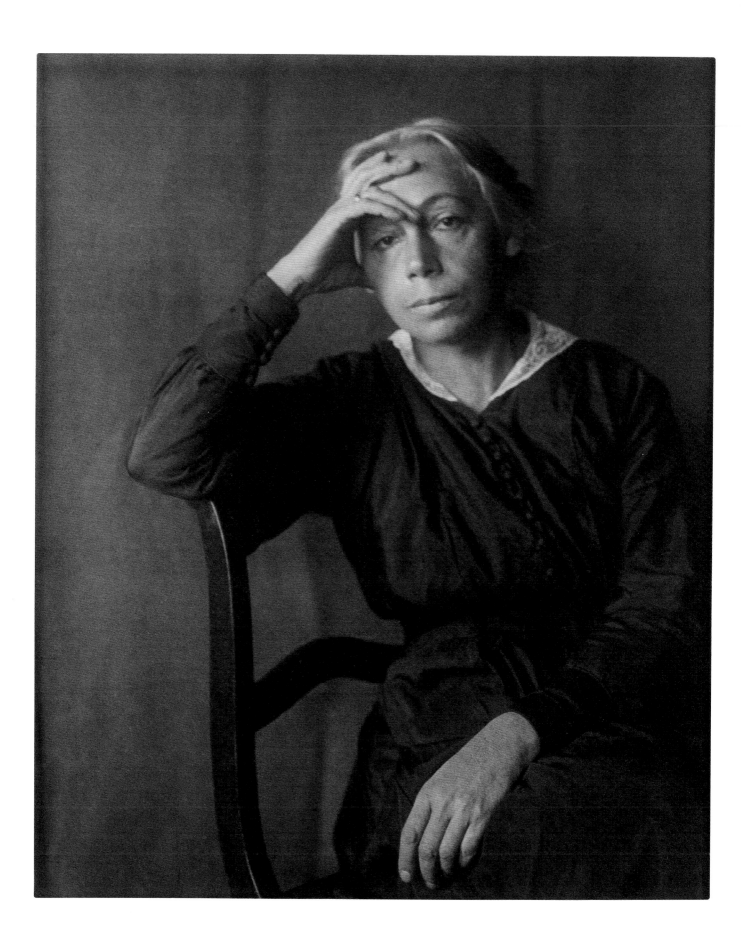

Collecting the modern for the museum:
Käthe Kollwitz and the Dresden Kupferstich-Kabinett

PETRA KUHLMANN-HODICK

In 1938, in an obituary for Max Lehrs, the long-standing Director of the Dresden Kupferstich-Kabinett who had died in November of that year, the Austrian art historian Arpad Weixlgärtner outlined his life and achievements. "[Lehrs] earned his stripes in the book and art trade from 1873 to 1878, in 1880 he became librarian at the Schlesische Museum in Breslau, in 1883 assistant at the Dresden Kupferstich-Kabinett. He was its director from 1896 to 1904 and again from 1908 to 1924. From 1904 to 1908 he was Friedrich Lippmann's successor as director of the Königliche Kupferstichkabinett in his home city, Berlin."[1] If Weixlgärtner characterized Lehrs on one hand as an "archetypal specialist" of the art of the past, whose chosen field was early printmaking, he also attested to his "lively, even burning interest in modern art".[2]

Besides overseeing the historical holdings, the programmatic obligation to collect and exhibit contemporary art was the major force driving Lehrs in his activities at the Dresden Museum. From this impetus arose the first museum collection, in 1898, of works by the artist Käthe Kollwitz. In 1901, after his first acquisitions, Lehrs published an article in the magazine *Die Zukunft* (The Future) on Kollwitz,[3] sustained by an optimistic view of the contemporary development of the "graphic arts". By the end of his directorship in December 1923, he had collected 179 of her prints and twenty-one of her drawings.[4]

Werner Schmidt, Director of the Kupferstich-Kabinett from 1959 to 1989, summarized Dresden's

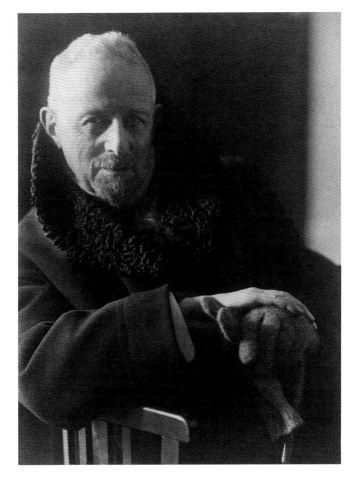

FIG. 2
Ursula Richter (1886–1946), *Max Lehrs*, 1924, gelatin silver print, 151 × 113 mm, Kupferstich-Kabinett, SKD, inv. no. D 1924-146

FIG. 1
Hugo Erfurth (1874–1948), *Käthe Kollwitz*, 1917, brown pigment print, 294 × 243 mm (matt section), Kupferstich-Kabinett, SKD, inv. no. D 1919-13

Abb. 11 Drei Schränke von vorn

FIG. 3
Schematic sketch of three collection and presentation cabinets with changeable frames, from Hans Wolfgang Singer's *Handbuch für Kupferstichsammlungen* (Handbook for Print Room Collections) of 1916, p. 35

Kollwitz collection and its origins at the 1960 exhibition for the fifteenth anniversary of the artist's death and again more fully in 1989 in the catalogue for the reopening in its new site of the Käthe Kollwitz Museum in Cologne, indicating the significance as a resource of this correspondence between the art historian and the artist.[5] These letters do not merely supplement the comprehensive portfolio of the artist's written communications, but present their own distinct cluster of interests. They cover the entire course of the business and private relationship between Lehrs and Kollwitz and at the same time illuminate an important area of the Dresden Kupferstich-Kabinett's acquisition activities at the turn of the nineteenth century.[6]

Collecting and exhibiting original prints
In a 1912 article entitled 'Zur Geschichte des Dresdner Kupferstichkabinetts' (On the History of the Dresden Kupferstich-Kabinett), Lehrs himself addressed the larger context in which the origins of Dresden's "contemporary art" collection were to be positioned.[7] He praised the innovations achieved by Friedrich Lippmann at the Berlin Kupferstichkabinett, which in part were modelled on the Print Room in the British Museum in London, especially in respect of improvements in conservation and a scholarly approach to the care of holdings as well as a quality-focused

policy regarding new acquisitions.[8] Lippmann "generated enthusiasm with varying exhibitions and increased or improved the collections entrusted to him according to a programme and with a confident eye for what was important and outstanding as no other director of a print room before or after him has been able to do".[9] "Unfortunately," continued Lehrs, for decades the Dresden Museum had subjected a permanent exhibition of its treasures, put together "by an expert director [Ludwig Gruner]",[10] to the wear and tear of light and dust, while at the same time keeping holdings in store that were not easily accessible owing to inconvenient opening hours and unmotivated staff. "In Dresden, this changed very quickly under the direction of Karl Woermann."[11] Lehrs's superior, who transferred the directorship of the Kupferstich-Kabinett to him in 1896, "ensured that a new spirit moved into the rooms previously timidly avoided by the public".[12] He introduced a programme of larger monographic or thematic exhibitions every quarter.[13] New storage cabinets were purchased which from 1898 furnished the Oberlichtsaal (Skylight Hall) – where the drawings were kept – "and behind whose glass doors new acquisitions were presented to the public on a monthly basis".[14] A member of Lehrs's staff, Hans Wolfgang Singer, described this combination of collection cabinets and a space designated for

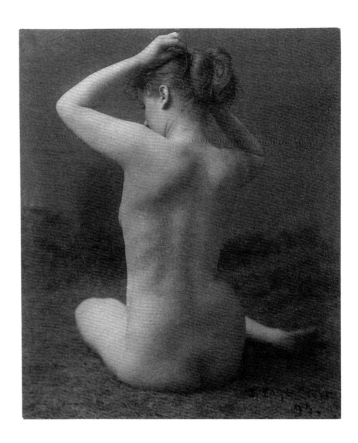

changing exhibitions in a programmatic manual,
Handbuch für Kupferstichsammlungen (Handbook for
Print Room Collections) that appeared in 1916 (fig. 3).
Works or groups of works by Kollwitz were repeatedly
displayed in these 'New Acquisitions' exhibitions.
Indeed, it is in just such a physical context that we can
imagine the display, in 1917 – in the middle of the First
World War – in which, for her fiftieth birthday, the
Kupferstich-Kabinett focused for the first time on the
artist's drawings (immediately preceding the quarterly
exhibition of that year, dedicated to Kollwitz's work
as a whole).[15] Together with ten other drawings, three
self-portrait drawings were acquired by the Dresden
Museum on this occasion in 1917.[16]

According to Lehrs, "under Woermann's direction,
the management had already decided to give modern
graphic art the recognition it deserved" – not least
because no funds were available to acquire older work
in significant quantity. "In Germany, after the merely
reproductive line engraving of the 1850s and 1860s had
had its day, etchings had emerged everywhere, striving
for colourful, painterly effects. The main practitioners
were William Unger in Vienna and later Karl Koepping
in Dresden and Peter Halm in Munich. Arising from
and alongside this trend there was a rush to take up
the cause of original etching and lithography, and men
like Max Klinger, Karl Stauffer-Bern, Wilhelm Leibl,
Hans Thoma, Otto Greiner, Leopold, Count Kalckreuth,
Ernst Moritz Geyger, Max Liebermann and Emil Orlik
elevated their creations conceived for the copperplate,
stone or woodblock to a status equivalent to painting
and sculpture. In the 1880s, however, there was no
print room in Germany that had targeted these works
as the material for a serious, programmatic collection.
The idea, apparently, was for Dresden to be the first."[17]
Since in this field there was obviously as yet no major
competition from wealthy private collectors, only

"relatively modest investments" were necessary to set
about working toward this goal.[18] "With no drawdown
on the budget"[19] the museum also began to assemble a
collection of pictorial photography from 1898, which
in the context of a drawings and prints collection also
constituted a pioneering endeavour (fig. 4).[20]

Lehrs, who managed to establish a comprehensive
inventory of work by all the representatives of
contemporary original printmaking, and in his
constant, intense exchanges with artists continually
strove to negotiate the lowest price possible or to
arrange donations, rejected the "prevailing precept,
for example, in the British Museum ... that the work of
living artists only be accepted as gifts", as this tenet was
inconsistent with the goal of "purchasing only the best of
contemporary production to preserve it for posterity".[21]

In this context, he deplored all the more strongly
the demand, declaimed in the "eternal siren song
of the local residents", that whenever funds for the
acquisition of new art were available one should, from
a social point of view, preferably bestow them on local
artists. Lehrs saw here the "misconceived patriotism of
the daily press", because, as he pointed out, "with very

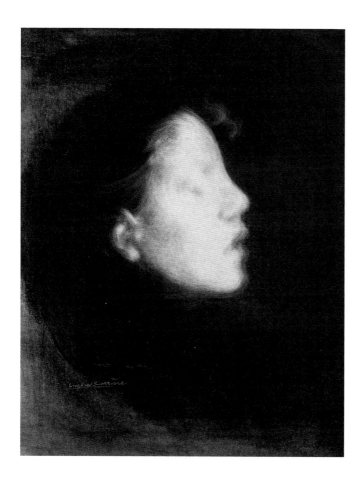

FIG. 5
Eugène Carrière (1849–1906), *Nelly Carrière
(Les yeux clos)* (Nelly Carrière (eyes closed)), 1895,
brush lithograph with scraper, on simulated Japan
paper, 467 × 361 mm (image), 623 × 463 mm (sheet),
Kupferstich-Kabinett, SKD, inv. no. A 1914-29

for whose representation in the Dresden Museum Lehrs was assiduously working.[24] He regretted, however, that "in order to avoid dissipating funds" buying work "by foreign artists … [he would have to] forego purchasing drawings from the outset".[25]

The British art historian and curator Campbell Dodgson described Lehrs's noteworthy position in his commemoration of his Dresden friend and colleague, attesting to his "… combination of fine taste, unerring sense of quality, and good knowledge of the trade and the condition of the market for prints".[26] "Though he [Lehrs] collected very completely modern German and especially Saxon prints, by such artists as Menzel and Richter, Klinger and Greiner, Stauffer-Bern, Liebermann and Kollwitz, he realised also the importance of French 19th century graphic art, and enriched the Dresden Cabinet by magnificent collections of Daumier, Toulouse-Lautrec, Manet, Carrière, Forain … and others, before a great rise in their prices had taken place. Nor did he neglect the modern British school, with Whistler, Shannon, Strang and Bone"[27] (fig. 5). To complete Dodgson's summary, other French artists such as Théophile-Alexandre Steinlen, Edgar Degas, Auguste Renoir and Auguste Rodin were added by Lehrs, as well as Odilon Redon, Pierre Bonnard, Edouard Vuillard and Maurice Denis, and the Belgian James Ensor, the Swede Anders Zorn and the Norwegian Edvard Munch.

In his efforts to awaken "artistic sensibility" or "artistic receptivity" – in his view "innate in many people who have not received any artistic exposure whatsoever" – Lehrs came to realise that "in this, women are superior to the ostensibly stronger sex", as he thought he could "easily corroborate with a statistical survey of the Kupferstich-Kabinett's viewing requests".[28]

few exceptions, our picture galleries provide a dismal example of the laxity of their directors when faced with the faddish tastes of their time".[22] He was not only referring to these museums' acquisition policies, which in his view were outdated and biased by the interests of their governing committees, but also indirectly to the protest of German artists initiated by Carl Vinnen in 1911 against the purchase of foreign art. This was triggered by a lengthy conflict with Gustav Pauli, Lehrs's former colleague in the Dresden Museum, who had directed the Bremen Kunsthalle since 1904 and who followed Alfred Lichtwark as Director of the Hamburg Kunsthalle in 1914.[23] Kollwitz was among the 123 signatories to Vinnen's appeal; she told her son Hans, however, that she had immediately regretted having supported it, as she realised when visiting the French section of the Berlin Nationalgalerie how important her encounters with the works of these French artists (during her visits to Paris in 1901 and 1904) had been – the very ones whose acquisition had been contested and

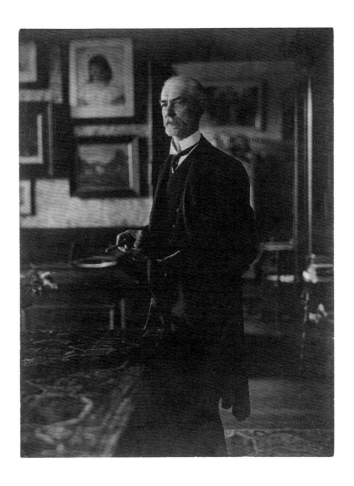

Connoisseurship and modernity

Lehrs's acquisition activities in the field of modern
works on paper found their basic impetus and sustained
support in his collaboration with Woldemar von
Seidlitz (fig. 6). Von Seidlitz, who was born in
St Petersburg in 1850 and died in Dresden in 1922, had,
like Lehrs, studied art history with Anton Springer in
Leipzig, in addition to earning a doctorate in economics.
From 1878 he was assistant to Friedrich Lippmann at
the Berlin Kupferstichkabinett, until he was invited
to Dresden in 1885. One of Seidlitz's specialisms in the
art of earlier periods was Rembrandt's prints. As the
chief councillor at the Directorate General of Dresden's
Royal Collections of Art and Science he represented
the museums' interests to the Ministry until his
retirement in 1919.[29] In this position he wrote an highly
commendatory appraisal of Lehrs's performance
when Lehrs took over the directorship in Berlin.[30] On
many occasions Seidlitz served on the advisory board
for the 'Große Dresdner Kunstausstellung', the most
important annual art exhibition in Dresden, and,
together with Hugo von Tschudi, Alfred Lichtwark
and Julius Meier-Graefe, was among the organizers
of the 'Jahrhundertausstellung deutscher Kunst'
(Centennial Exhibition of of German Art), hosted at
the Berlin Nationalgalerie in 1906. Seidlitz's efforts to
acquire modern art led to vehement, often unsuccessful,
confrontations with the gallery committee. Through
prefinancing and resale and even more through cost
absorption or donation, he promoted, in addition,
the art and natural science museums and institutions
under his aegis.[31] The Dresden Kupferstich-Kabinett,
in particular, profited from his passion for art. To
his credit was the introduction of a new avenue of
collection within the development of contemporary
printmaking, a "choice selection of Japanese coloured
woodcuts (ten portfolios with 255 sheets)".[32] Over 1,400

acquisitions of the Dresden Museum, as far as can be
traced through the inventories,[33] are to be connected
directly to his activity. In the Museum, large holdings of
the most important representatives of French modern
art, especially Henri de Toulouse-Lautrec, are traceable
to him, as well as prints and drawings by artists highly
esteemed by both Kollwitz and Lehrs – Menzel, Klinger
and Liebermann as well as Orlik and Greiner. Works by
Kollwitz's teacher, Karl Stauffer-Bern, were donated by
Seidlitz. It was he who initially drew Lehrs's attention
to Kollwitz in 1898 and campaigned for her expressly.[34]
In 1899 he purchased ten prints from her and in 1902
three drawings as gifts for the collection.

This synopsis of acquisition strategies serves to
characterize the horizon of international contemporary
art in relation to which Kollwitz's work as a printmaker
was regarded at the time. The interest Seidlitz and
Lehrs took in her work answered the criteria of their
distinct specialisms – the relevant publications of both
men on contemporary graphic art and especially those
by Lehrs on Käthe Kollwitz make this clear. The basis of

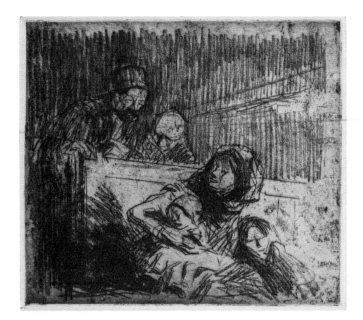

FIG. 7
Jean Louis Forain (1852–1931), *Témoins à l'audience*
(Witnesses at a Hearing), third version, etching
and soft ground etching on hand-made paper,
257 × 295 mm (plate), 476 × 633 mm (sheet),
Kupferstich-Kabinett, SKD, inv. no. A 1909-163

their writings and their didactic goal was a sensitizing of perception. The path leading to this was an exact analysis of the facture of the works and their underlying techniques, regarding which the artist was also in communication with Lehrs.[35]

While Lehrs was of the opinion that one could only introduce the public to older, historic art forms by starting from the visual language in which they were conceived,[36] he himself developed an expertise and approach deriving from his studies of early prints with which he came to appreciate contemporary art. In general, he was admired for his practice of "careful stylistic analysis" – "as he, with the help of the most minute comparisons, determined individual states and differentiated copies from originals"[37] – but also for his expert knowledge of the art trade, which benefited him in research as well as in assembling the collection.[39]

The question naturally arises as to the relationship of the Dresden 'museum civil servant' to the social critique essential to Kollwitz's art. After finishing work on her *War* series (cat. 72–78), Kollwitz wrote an entry in her diary outlining her artistic "programme" and consciously distinguishing herself from the more recent Expressionist currents: "Admittedly *pure* art in the sense of, for example, Schmidt-Rottluff is not mine. But art it is. Every person works as he can. I am agreed that my art has a purpose. *I want to have an effect* in these

times in which people are so helpless and needy."[39] In an autobiographical reminiscence of 1941, she spoke with pride of her first successes with her *Weavers* cycle, of Menzel's praise, which was reported to her, and also of the significant support she received from Lehrs. Consciously amplifying her tone, she defended herself against being "branded a 'social artist'". "Certainly, even then, my work, through my father's attitude, my brother's, through all the literature of that time, dealt with socialism. The actual reason, however, why I almost always chose to represent the life of working people was that the subjects taken from this sphere simply gave me unconditionally what I felt to be beautiful."[40] The viewpoint expressed here, argued from an artistic perspective, was undoubtedly representative of Lehrs's position as well. In his article for *Die Zukunft* of 1901, he wrote: "As I have occasionally said elsewhere, art should and must not serve the fluctuating goals of political parties. High above men's heads is her path through the sky; and she should shine on everyone."[41]

Considerations on the relationship between content and form, directly comparable to Lehrs's position, form the basis of a 1911 article by Seidlitz on Forain (fig. 7): "What primarily distinguishes Forain's illustrations is his exclusive emphasis on the artistic and his complete mastery of the means of representation, which he never uses schematically, but rather consistently adapts to his particular purposes Contemporary life, the people he can observe daily, offer him inexhaustible material for his images." The artist "in this way elevates the random event in its temporally limited form to the heights of the eternally human. In this combination of eternal content and a transient, but therefore living, form lies the power of his work."[42]

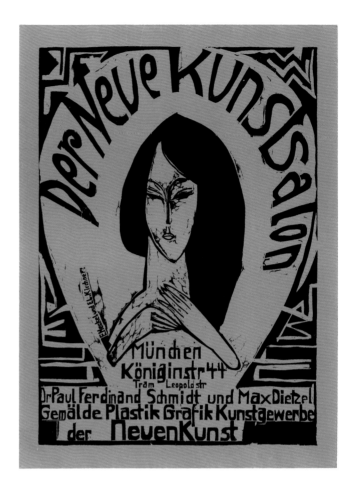

The relative notion of 'contemporary'

On 18 February 1924 Lehrs's successor Kurt Zoege von Manteuffel – also a specialist in early prints – thanked Kollwitz for her gift of three sheets she had given to him for the collection through Lehrs, who had recently retired.[43] Kollwitz mentioned the consignment and intended gift in a card to Lehrs on 13 January 1924.[44] She had also sent a print, *Self-portrait towards the left* of that year, to Lehrs as a gift.[45] He in turn recommended it to Zoege von Manteuffel, who purchased a proof for the collection.[46]

On a smaller scale, Zoege von Manteuffel continued the Kollwitz collection – just as he continued to acquire works by Liebermann, Lovis Corinth and Ernst Barlach, and individual pieces from Max Slevogt and Georg Kolbe as well. Meanwhile since 1919, the year Seidlitz retired, younger artists had started to appear on the scene,[47] in particular, members of the Die Brücke group. The Kupferstich-Kabinett had not immediately acquired works by these artists when they became the talk of Dresden in 1905 following exhibitions at the Sächsische Kunstverein (Saxon Art Association) and the Arnold and Richter galleries.[48] But the 1919 Munich exhibition poster *Der Neue Kunstsalon* (The New Art Salon; fig. 8), designed by Ernst Ludwig Kirchner and Erich Heckel, gained both artists entry into the Museum.[49]

Also in 1919, works by Karl Schmidt-Rottluff and Max Pechstein, both of whom had previously belonged to Die Brücke, were added to the Museum's holdings for the first time. From the wider circle of younger artists, works by Conrad Felixmüller, Oskar Kokoschka and Max Beckmann were also purchased that year, and in 1925 work followed by George Grosz and in 1928 by Otto Dix. A few years later, in 1936, many of these works were labelled 'degenerate art', and were confiscated and removed from the collection. Among them was the first of Wassily Kandinsky's works to be acquired by the Museum, purchased in 1931, the woodcut series *Small Worlds*.[50]

Kollwitz, though she followed her own path, seems from this perspective a representative of the older generation, more highly appreciated by Lehrs and Seidlitz. The expressive will that Lehrs perceived as creative power in Kollwitz correlates with the refinement of facture that he must have missed in the Die Brücke artists and in the younger German and foreign artists, who tended more to abstraction. Initially she herself did not have much regard for Expressionism. Gradually, though, Kollwitz, whose artistic roots were dominated by Naturalism, developed an understanding for the new artists' expressive means as she came directly into contact with the latest avant-garde scene in Berlin through the Secession and her connection with the progressively orientated art dealer and publisher Paul Cassirer.[51] On 31 March 1920 she remarked in her diary: "First jury day. Kolbe, Mosson, Scheibe, Schmidt-Rottluff, Pechstein, Heckel. Very good batch. Many interesting and good things. Mainly ultra-

modern. But my eyes are quite accustomed, I can go along with a lot that I used not to understand at all."[52]

It seems it was even more difficult for the Museum staff, even though their acquisition policies were by their own estimation progressive, to come to grips with this new direction than it was for the artist. Lehrs placed Old Masters and contemporary artists in a continuum of development, without pitting various periods of art against each other. What counted for him was the expressive power of the work of art and what he perceived as artistic quality.

Through Max Lehrs's efforts, the work of Käthe Kollwitz was recognized at the Dresden Museum as significant contemporary art that reflected the questions and concerns of its time. In the end, it was by virtue of the artistic qualities that Lehrs admired in her work that that work has withstood the test of time, both during phases of rejection in the Empire and the 'Third Reich' and through a period of political appropriation in the German Democratic Republic (GDR), to be held in undiminished regard today.

NOTES

1 Weixlgärtner 1938, p. 157. Hans Wolfgang Singer took over Lehrs's position in Dresden for three months, then Ludwig Sponsel, who became Director of the Grünes Gewölbe (Green Vault) and the Münzkabinett (Numismatic Collection) upon Lehrs's return to the Kupferstich-Kabinett in 1908.
2 Weixlgärtner 1938, p. 157.
3 See Lehrs 1901.
4 Today there are 257 prints (eleven of them in four portfolios) and 21 drawings by the artist in the Dresden Museum; another 65 prints and ten drawings have been missing since 1945.
5 W. Schmidt 1960, p. 19, and W. Schmidt 1988, p. 10 and passim. Including the letters from Kollwitz to Lehrs from part of his estate in

the Bayerische Staatsbibliothek (Bavarian State Library; BSB), the correspondence preserved in the archives of the Staatliche Kunstsammlungen Dresden has been studied for the first time in the present volume by Alexandra von dem Knesebeck; see pp. 22–43.
6 While the fourteen letters Kollwitz sent to the Bielefeld curator and museum director Heinrich Becker between 1929 and 1944, published in 1967, offer insight into the National Socialist period, which was extremely problematic for Kollwitz as a politically engaged artist and also for Becker, who was dismissed from the directorship of the Bielefeld Kunsthalle in 1933, her correspondence with Lehrs relates primarily

to the artist's early work (see Weisner 1967).
7 Lehrs 1912.
8 On conservation measures see Lehrs 1912, p. 84. This, as well as the systematic compilation, processing and commentary on the holdings on index cards was overseen by his directorial assistant, Singer, and was further developed into guidelines published by him in 1916 in his *Handbuch für Kupferstichsammlungen* (Handbook for Print Room Collections); see Singer 1916. Lehrs's contact with the British Museum dates to his visit to London in 1893, when he met the long-time Keeper of the Print Room there, Campbell Dodgson; they often met to discuss business in Dresden, at auctions in Berlin and Leipzig and also on holiday

in the Bavarian mountains. Dodgson honoured Lehrs in an obituary in *Maso Finiguerra*; see Dodgson 1938.

9 Lehrs 1912, p. 1.

10 Ibid. p. 3.

11 Ibid.

12 Ibid.

13 See p. 137 in the present volume.

14 Lehrs 1912, p. 5.

15 Previously there had been a 'quarterly exhibition' honouring Max Liebermann's seventieth birthday in 1917. Although the exact hanging of the works cannot be reconstructed, the impression such a dense presentation would have given can be recaptured in the mounting of the current exhibition, conceived by Agnes Matthias; see the catalogue portion of the present volume, section IV: Contemporary. Collecting and exhibiting 100 years ago, p. 137, cat. 53–66.

16 See W. Schmidt 1960, pp. 15–18. The fundamental meaning of the self-portrait within the artist's oeuvre is the topic of Hannelore Fischer's essay in the present volume, pp. 56–61. There are a total of 41 sheets of self-portraits in Dresden, which is more than one sixth of all Dresden's Käthe Kollwitz holdings. Not included in this calculation are the numerous undeclared self-portraits.

17 Lehrs 1912, p. 5. Lehrs describes how he was introduced to prints by his parents, who brought their child into close contact with the founders of what would later be the Berlin auction house Amsler & Ruthardt. "According to the tastes of the time, my father preferred … unfortunately the then highly respected modern line engravings … prints of that sort were considered the most elegant decoration at the time in Berlin apartments and every wealthy, educated person tried to display his relationship to art and especially to the celebrated Urbinate [Raphael] by collecting Volpato's prints after him in their entirety in his dining room or salon": Lehrs 1925, p. 2.

18 Lehrs 1912, p. 5.

19 Ibid., p. 10.

20 On the historic photography collection see Matthias 2010.

21 Lehrs 1912, p. 7. Campbell Dodgson assembled a comprehensive collection for himself of contemporary prints, with outstanding works by German Expressionist artists; he donated this collection to the British Museum in 1968; see London 1984, preface.

22 Lehrs 1912, p. 7.

23 See Kollwitz 2012, pp. 778–79. The trigger for the letter was the Bremen Kunsthalle's purchase of the 1889 painting *Poppy Field* by Vincent van Gogh for 30,000 marks, which had been preceded by lengthy dispute. The Dresden Museum owns a work by Van Gogh – an etching, *Portrait of Doctor Gachet* – which was acquired shortly after the Vinnen controversy (inv. no. A 1912-621).

24 Kollwitz 2012, pp. 778–79. On Kollwitz and Paris see Cologne 2010; see also Washington 1992, pp. 77–78.

25 Lehrs 1912, p. 9. The donation of three drawings by Henri de Toulouse-Lautrec, with which his mother thanked Lehrs for his unflagging support for her dead son's work, represented a large and symbolic enrichment for the collection; see Kuhlmann-Hodick 2004.

26 Dodgson 1938, p. 352.

27 Ibid.

28 Lehrs 1912, p. 12.

29 On Woldemar von Seidlitz, the person and his career, see the summary of Holler 1997.

30 Seidlitz 1905.

31 See Lehrs 1919.

32 Lehrs 1912, p. 10.

33 Holler 1997 and Lehrs 1919 point out that Seidlitz always endeavoured to remain anonymous in his endowments.

34 See Knesebeck in the present volume, p. 23, as well as Kollwitz 2012, p. 345.

35 See Agnes Matthias's essay in the present volume, pp. 44–55.

36 Lehrs 1912, p. 11.

37 Weixlgärtner 1938, p. 157.

38 Weixlgärtner mentions Lehrs as a "feared" bidder at the Gutbier auctions in Dresden, the Gutekunst auctions in Stuttgart and the Boerner auctions in Leipzig.

39 Kollwitz 2012, p. 542.

40 Ibid., p. 741.

41 Lehrs 1901, p. 355.

42 Seidlitz 1911, p. 97.

43 SKD archive, 01/KK 04 vol. 26, nos. 39–40. This refers to an illustration and two posters, inv. nos. A 1924-127 to A 1924-129; all three sheets are presently missing. The complete series of Kollwitz's *War* (inv. no. B 522/h), sent by the artist in 1923 and pre-financed in 1922, was not inventoried until 1924. See Agnes Matthias's essay in this volume, p. 54.

44 Bayerische Staatsbibliothek München (BSB), Ana 538 Kollwitz, Käthe. Possibly incorrectly it bears the same date as the letter to Lehrs in which one of the sheets had already been mentioned.

45 Letter from Kollwitz to Lehrs, 2 November 1924, BSB, Ana 538 Kollwitz, Käthe (Kn 209).

46 Inv. no. A 1924-347, presently missing.

47 Franz Marc and Emil Nolde had been represented in the Museum since 1915.

48 See the catalogue of exhibitions and publications of the Die Brücke group 1905–11 in Dresden 2001, pp. 389–406.

49 Inv. no. A 1919-499. Kirchner's seven works acquired in 1919 and 1921 were joined by thirteen more before the Second World War. Eleven works by Heckel were listed in 1919 and between 1924 and 1930 twenty-one prints and seven drawings.

50 Inv. no. B 1930-1. In total 360 items from the holdings are registered as having been confiscated. Immediately after the War, acquisitions began again of the work of these formerly ostracized artists within the very limited means of the time. Likewise, acquisitions of work by Kollwitz, who had died in 1945, were reinitiated. Despite the rejection that she experienced during the National Socialist period, her work in Dresden was not affected by the confiscations. Seventy-five of her works have been missing since the War, however. Between 1946 and 1998 118 prints and six drawings were added to the collection of the Dresden museum.

51 Telling is the anecdote in which she relates how Cassirer described the replacement of the "im" (Impressionists) by the "ex" (Expressionists); see entry of 23 November 1917, Kollwitz 2012, p. 342.

52 Kollwitz 2012, p. 464.

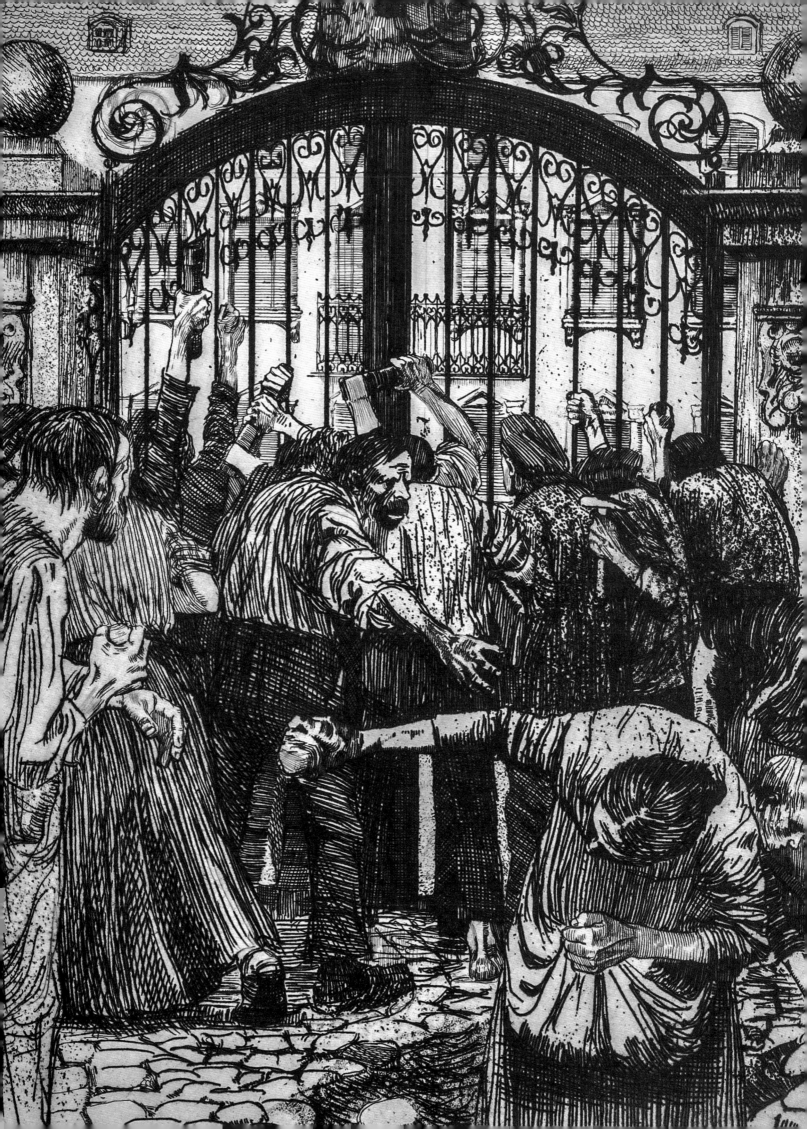

"For my part, I must tell you once again how your appreciation for and commitment to my work has supported and encouraged me":[1] On the correspondence between Käthe Kollwitz and Max Lehrs

ALEXANDRA VON DEM KNESEBECK

Max Lehrs, Director of the Dresden Kupferstich-Kabinett, and the graphic artist and sculptor Käthe Kollwitz corresponded with each other over forty years. Kollwitz had no connection to any other museum curator for such a long period. Their correspondence began in 1898, at the start of her career. It continued even as the artist reached the apex of her fame during the Weimar Republic, through the National Socialists' extensive prohibition on exhibitions of her work, and ended only with the death of Max Lehrs in 1938.

In 1897, Kollwitz completed her first cycle, *A Weavers' Revolt* (cat. 15, 17, 19–22). For four years the artist quietly worked on the series, after first debuting in Berlin with a few single prints and drawings in 1893 and 1894.[2] With these works she had already attracted attention: the leading art critic Julius Elias, a champion of Naturalists and Impressionists, prophesied that "she [could] be certain of a successful future".[3] When she presented the *Weavers* cycle to a broader audience, at the 'Große Berliner Kunstausstellung' in 1898, she achieved an immediate breakthrough.[4] Max Liebermann, a member of the jury, prevailed on the other members to recommend the cycle to the Emperor for a medal.[5] In addition, it caught the eye of Woldemar von Seidlitz, chief councillor at the Directorate General of Dresden's Royal Collections of Art and Science, who had visited the exhibition and subsequently remarked on Kollwitz's *Weavers* to the Director of the Kupferstich-Kabinett, Max Lehrs.[6] If Seidlitz discovered the *Weavers* cycle at the 'Große Berliner Kunstausstellung' among the 1900 works presented there, it must have been due to his special interest in prints and drawings;[7] besides an overwhelming number of paintings, only 90 prints, by largely unknown artists, were on display. But in addition, according to Seidlitz, a committed patron of contemporary art, the *Weavers* cycle fulfilled the requirement to be demanded in a modern work of art: from such work one expected "honesty of sentiment", the basis of a "lively, warmly felt subject-matter" and that it represent "true beauty".[8]

Even if Seidlitz found the *Weavers* cycle artistically convincing, it was, considering the topic, not without risk to recommend that Lehrs buy it. Kollwitz, who might be regarded as a Naturalist in her early work,[9] owed the inspiration for the series to Hauptmann's drama *The Weavers*. In contrast to the writer, however, she did not depict the historic weavers' revolt of 1844, but rather a fictitious present-day weaver uprising. At the beginning of the 1890s, there had been once again a terrible famine among the Silesian weavers. Imagery reflecting the situation and calls for aid donations were prevented by the authorities for fear of increasing agitation by the Social Democratic Party of Germany. The authorities perceived Hauptmann's play as likely to do that, as an incitement to class hatred, and banned its performance. Hauptmann, who unlike Kollwitz was not a Social Democrat, had to sue in court to see his play performed, emphasizing that his drama was to be viewed not as political propaganda for the Social Democrats but as a poetic appeal to the

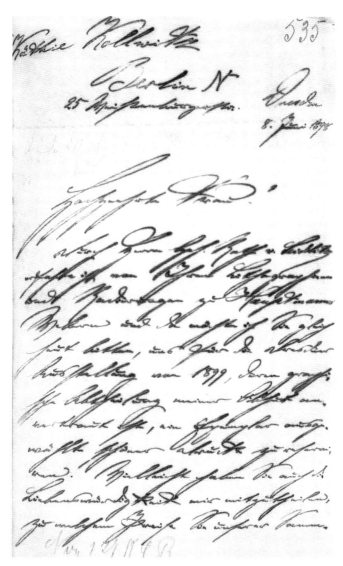

FIG. 9
The first letter from Max Lehrs to Käthe
Kollwitz, 8 June 1898, SKD archive, 01/KK 04
vol. 4, nos. 535–37

side, only the copies of 60 official letters reproduced on carbon paper during his time as Director in Dresden until the end of 1923 are extant (figs. 9 and 10). All his original letters are believed to be lost. If not before, they must have been destroyed in 1943 when the house Kollwitz had lived in for fifty years in Berlin fell victim to an air raid. The copies of Lehrs's official letters are held today in the archive of the Staatliche Kunstsammlungen Dresden, together with 49 letters and postcards from Kollwitz dating up until late 1923 that Lehrs considered business-related. From the same period, 57 other letters from Kollwitz, which Lehrs regarded as private communications, as well as 37 from the artist to Lehrs between 1924 and 1938 – in addition to Lehrs's private correspondence with other artists – were carefully bound in a volume and preserved as part of Lehrs's estate at the Bayerische Staatsbibliothek München (Bavarian State Library, Munich) and can be viewed online.[12] Lehrs's separation of business and private correspondence could not be strictly respected simply because the letters, naturally, often mixed matters that affected the Museum with other topics. The business correspondence, especially, provides valuable and as yet little-noted insight into Kollwitz's rise to become the most famous woman artist of her time. This is the subject of the present essay.

In his first letter to Käthe Kollwitz, of 8 June 1898, Lehrs not only encouraged her to send him the *Weavers* cycle but also offered her his support without, at that point in time, having seen even one of her other works. Lehrs begins his letter with an invitation to the next 'Große Dresdner Kunstausstellung': "I have heard of your lithographs and etchings on Hauptmann's weavers from Privy Councillor von Seidlitz, and I would like to ask you now to reserve a choice example of beautiful engraving for us for the Dresden exhibition in 1899, in which I am responsible for the graphic section".[13]

compassion of the 'haves'. Kollwitz, too, immediately felt the negative reaction of the authorities towards her *Weavers* cycle: Emperor Wilhelm II denied her the medal recommended by the jury at the 'Große Berliner Kunstausstellung'. The Prussian Minister of Culture, Robert Bosse, had thus advised him because of the work's subject-matter and because the series "completely lacks any mitigating or conciliatory element".[10] Presumably this explains why the Berlin Kupferstichkabinett only first dared to acquire a few of Kollwitz's graphic works, among them the *Weavers* cycle, in 1902, four years after Dresden.[11] In the German Empire, the kingdom of Saxony was independent of Berlin in artistic affairs.

Of the correspondence between Lehrs and Kollwitz, begun in June 1898, only the artist's contribution – 143 letters and cards – has survived intact. From Lehrs's

FIG. 10
The first letter from Käthe Kollwitz to Max Lehrs, 13 June 1898, SKD archive, 01/KK 04 vol. 4, nos. 538–39

I will have many opportunities to show your work and win new friends for you".[15] Indeed, he alerted museum colleagues and artists to Kollwitz's work as often as he could over the following years and showed her work to collectors he knew personally.[16] These last relied on the museum director's expertise and returned the favour by serving as sponsors when Lehrs wanted to acquire works that exceeded his meagre budget.[17] He made no secret of the Museum's difficult financial situation, even in his first letter to Käthe Kollwitz: "Since our means are quite limited, it is of course not possible to pay the prices that are standard for works for exhibitions for the general public, a circumstance that the artists – I'll name here just Mssrs. Klinger, Thoma, Liebermann, Israels, etc. – have always kindly made allowance for".[18] For this reason, too, it was opportune to purchase from young artists, not yet at the height of their fame, who, in return for Lehrs's support, would sell their work to the Museum at a low price or would donate it.[19]

After receiving the *Weavers* cycle from Kollwitz, Lehrs answered by return of post: "Although I normally withhold all critical appraisal of the works sent to me for our museum, I cannot resist telling you that I find your solution to such a difficult task outstanding I can only congratulate you heartily on this feat." Lehrs concluded the letter with the request: "Did you make any attempts in the graphic realm before this work [*A Weavers' Revolt*]? If so, please send them to me for inspection You would be doing me a real favour if you were amenable to giving any of the incomplete trial proofs that surely fall under the table in every artist's workshop to our museum."[20]

Käthe Kollwitz responded promptly to Lehrs's request and sent him more of her work. She presented proofs of two states of the fifth and sixth sheets of the *Weavers* series to the Museum as gifts.[21] They were of no use to her as objects for sale. Proofs of prior

In 1897 Dresden had begun – long after Berlin and Munich – to host large art exhibitions at regular intervals. From the outset, though, the city had the important advantage that the exhibitions in Dresden, unlike those in Berlin and Munich, only accepted works from artists personally invited by the jury to submit them. This condition gave the Dresden events an elite status, especially as regards graphic art and sculpture, which in contrast to Munich and Berlin were selected by the Museum, not by the artists.[14] From 1899 to 1904, and again in 1912, Lehrs was responsible for the graphic arts section.

In his first letter to Kollwitz, Lehrs also spoke of the advantages that the presence of her work in the Dresden Museum would entail for an artist as yet largely unknown: "Since our museum, as perhaps you know, constitutes a centre for serious modern art endeavours,

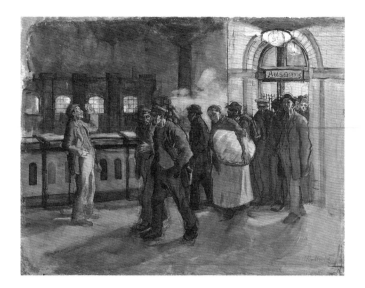

states, because of their rarity, were, in fact, in demand with collectors, but only when the artist was already famous. Of the other work she sent, Kollwitz explained apologetically: "They are almost entirely so inadequate and technically flawed … that I don't think you will find anything worth buying. They are attempts I made for the most part quite some time ago. Prevented by domestic circumstances, I've only recently been able to dedicate myself more to my work."[22] During a trip to Berlin at the end of the year, Lehrs met the artist for the first time in person and took several works away with him.[23] Among others, he chose the first two states of a rejected etching for the third sheet of the *Weavers* cycle, in which the scene of the men conspiring at the table is illuminated impressively by the light of the ceiling lamp (cat. 18).[24] It is entirely reasonable to imagine that Kollwitz, feeling somewhat uncertain about her early work, at that point only showed Lehrs those pieces that seemed to her presentable. She might purposely have withheld the two earlier states of *Conspiracy*, as in the third state she had burnished the top part of the plate, as is quite visible at the border with the reworked part. It is notable that Lehrs only took away four single sheets in addition, among them the newly completed etching *Woman at a cradle* (cat. 49).[25]

The year 1899 would be another very successful one for Kollwitz. Lehrs had invited her to show, among other works, a new etching and the watercolour *Workers coming from the station* (fig. 11), in addition to the *Weavers* cycle, at the 'Große Dresdner Kunstausstellung'.[26] He immediately reported: "Your watercolour was the first sheet to be sold at the exhibition, which opened two days ago. We are having daily jury meetings. Klinger, who is on the graphics jury with me, is captivated by your *Weavers' Revolt*. I am hopeful you'll win a medal."[27] As opposed to her experience in Berlin the year before, in Dresden, to her great pleasure, Kollwitz received a small gold plaque.[28] In 1899 she was also able to show her work in Munich's annual exhibition,[29] in the first exhibition of the Berlin Secession[30] and in the fifth exhibition of the Vienna Secession, the last of which exhibited graphic art from abroad as well.[31] In Munich the artist showed her *Weavers* cycle for the third time in Germany, after Berlin and Dresden. On the occasion of this exhibition, a reviewer remarked appreciatively that she "had quickly made a name for herself" with the series.[32] The two works exhibited in Vienna were acquired by the Albertina, laying a foundation for its Kollwitz collection several years before the Berlin museum. For the invitations to the Secession exhibitions in Vienna and Berlin Kollwitz surely had Liebermann to thank, since he was president of the Berlin Secession and had told none other than Lehrs in a letter of 1901 that he "had had his shoulder to the wheel for years" for the artist.[33] From the outset Kollwitz had been a firm fixture at the Berlin Secession exhibitions and in 1901 became the fifth woman member of the association.[34] With Liebermann Kollwitz had won a second significant patron, in addition to Lehrs – one who facilitated exhibition and sales opportunities as well as contacts to other artists.

A remark Käthe Kollwitz made to Lehrs regarding the Dresden exhibition in 1899 demonstrates how grateful she was for Max Klinger's recognition: "Above all, I am so happy that Klinger likes my work, his favourable opinion meant a lot to me".[35] Kollwitz certainly knew

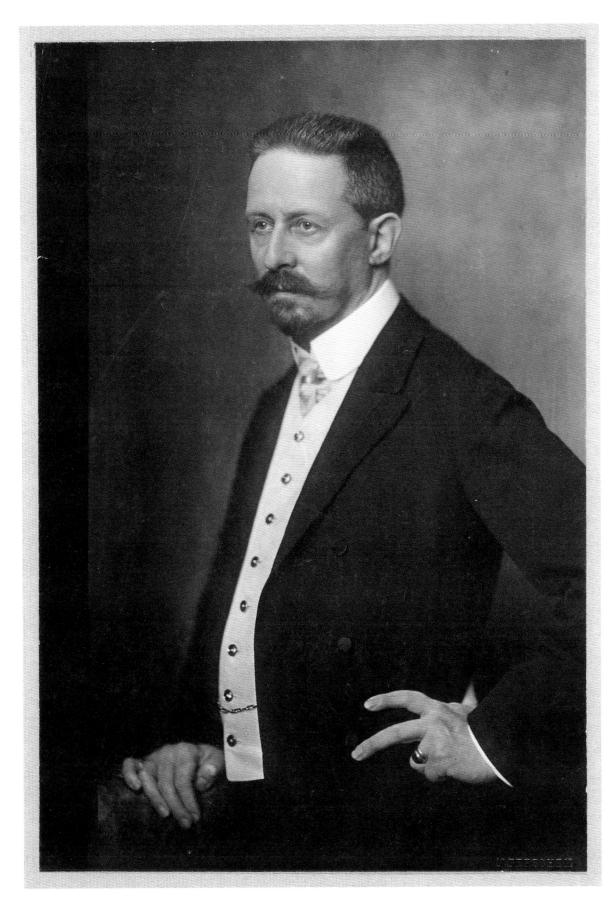

FIG. 12
Nicola Perscheid (1864–1930), *Max Lehrs*, c. 1910,
silver gelatin, 200 × 136 mm, Germanisches
Nationalmuseum, Nuremberg, Deutsches
Kunstarchiv, DKA, NL Lehrs, Max, I,A-2a (0007)

FIG. 13
Philipp Kester (1873–1958), *Käthe Kollwitz*,
1906, gelatin print, 130 × 180 mm,
Stadtmuseum, Munich, inv. no. FM-87/61/114

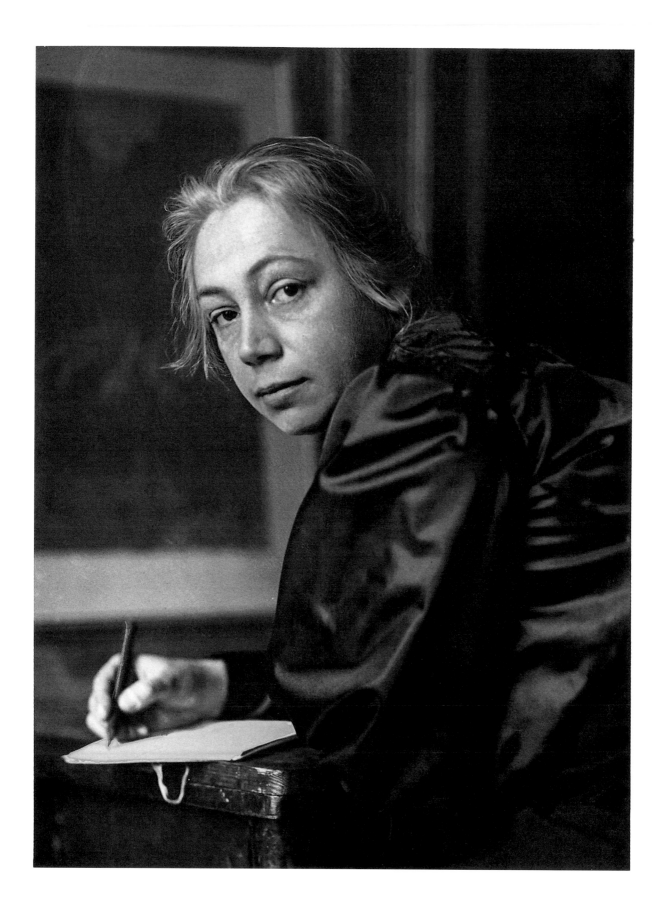

how much Lehrs revered the most significant German Symbolist artist, whose graphic oeuvre he tried to collect in its entirety as far as was possible.[36] Perhaps Klinger's approval was also what spurred the young artist, still uncertain in questions of style, to attempt the Symbolist three-part etching *The Downtrodden* (cat. 28):[37] even the original title, *Life (Das Leben)*,[38] suggests that she was aligning herself in the tradition of Klinger's cycle *A Life (Ein Leben)*[39], completed between 1880 and 1884, and the first of his works she had seen; this encounter had occurred during her student years in Berlin in 1886–87 and excited her tremendously.[40] In this cycle, Klinger depicts the fate of an unmarried woman who falls victim to the hypocritical morality of her time on account of a love affair and is driven to prostitution. The right side of Kollwitz's *Downtrodden* also thematizes prostitution, although the focus is on a young working-class woman forced into prostitution out of poverty. That her situation is not the result of voluntary choice is made clear by the shackles binding her to a post and the hand held shamefully in front of her face. A young procuress exposes the prostitute and demands money from an imaginary punter for sexual services.[41] The left side depicts the parents of a dead child who see no way out of their misery other than suicide. In the middle section an Avenger, as in the rejected final sheet of the *Weavers* cycle *From Many Wounds You Bleed, O People* (cat. 26),[42] bends over a Christ-like corpse representing the suffering people.[43] The size alone of the etching *The Downtrodden* – it is almost 84 cm wide – overshadows all the artist had done up to that point and is one of her most ambitious prints. She wanted quite literally to achieve "a great result".[44] It was not very easy for purely graphic artists to attract attention for their work at the mass exhibitions in Berlin, Munich and Dresden because their pieces were normally quite small. Despite its huge size,

The Downtrodden did not receive much acclaim. Kollwitz cut the plate in two and only showed the left side at the 'Internationale Kunstausstellung' in Dresden in 1901.[45]

She had more success with the next etching she completed, *The Carmagnole* (cat. 38), which was also unusually large. Probably inspired by Charles Dickens's 1859 novel *A Tale of Two Cities*, set during the French Revolution, Käthe Kollwitz depicts ragged figures, mainly women, dancing in ecstasy around a guillotine to the rhythm of a drummer boy, as in the well-known French revolutionary song *Carmagnole*. She transferred the scene from Paris to a German city. In the tall half-timbered houses she meticulously delineated the stones in the infill one by one in an almost Old Master style. The young artist presumably wanted to prove her versatility with this image, featuring more figures than in any of her work thus far and in front of an elaborate backdrop – these houses are the only such urban view in her oeuvre – and she was rewarded with a favourable reception. It also became her 'calling card', the piece that defined her as an artist. In 1906 she posed in front of this work for Philipp Kester, who took the first 'official' photographs of her (fig. 13).[46]

Kollwitz showed *The Carmagnole* in 1901 at the 'Internationale Kunstausstellung' in Dresden, in addition to which Lehrs also "allowed" her to submit the fragment of *The Downtrodden* (cat. 28),[47] a related pencil drawing (cat. 31), a lithographed, coloured *Self-portrait in three-quarters profile to the left* (cat. 6) and the etching *Uprising* (cat. 37).[48] The last-named marked the beginning of her exploration of the theme of her second cycle, *The Peasants' War*.[49] The exhibition, which included 750 paintings, 430 sculptures, 262 drawings and 434 prints, and, in contrast to Berlin and Munich, numerous examples of decorative art as well, was highly praised by the critics. Despite the broad scope of the prints and drawings section, Kollwitz was noticed

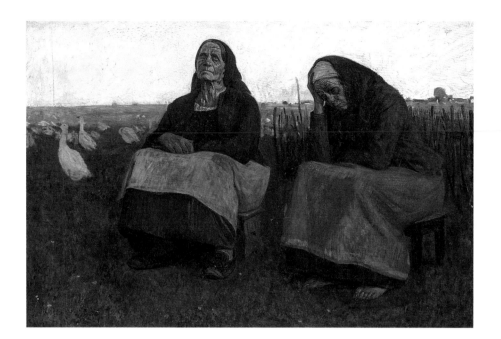

FIG. 14
Leopold von Kalckreuth (1855–1928),
Old Age, 1894, oil on canvas, 116 × 172 cm,
Galerie Neue Meister, Staatliche
Kunstsammlungen, Dresden, gal. no. 2496

by at least one reviewer. Amongst the Berlin artists, who were certainly underrepresented, however, she was for him the undisputed front runner.[50] Because it included the decorative arts, with interior design, jewellery and even women's clothes designed by artists, the exhibition constituted a major attraction for high-society women from all over Europe. Lehrs was able to win some of them over for Kollwitz. He reported to the artist that he had shown her work to "two women art enthusiasts", Lady Spencer-Churchill, Duchess of Marlborough, from England,[51] and her friend Gladys Deacon.[52] Gladys Deacon, reputed to be one of the most beautiful and cultured women in Europe,[53] wanted to find dealers for her in Pairs, of which Kollwitz was justifiably sceptical, since at that point no art dealer – either in Germany or abroad – had yet bought anything from her.[54] After her visit to the exhibition, the Duchess of Marlborough charged a friend of Lehrs's, the American art historian and collector Charles Loeser,[55] to select some works by Kollwitz in Berlin. Lehrs wrote to the artist: "I'd therefore ask you to gather together a nice copy of the Weavers' Revolt, the Peasants' War [the single sheet *Uprising*] and whatever interesting studies you still have to show to Mr Loeser … during his visit".[56] Loeser, actually a specialist in Italian Renaissance drawings, was so fascinated with Kollwitz that he agreed to Liebermann's request to write an article about the

artist for the *Socialistische Monatshefte*.[57] This request had initially been made to Liebermann himself, who had already written studies on Edgar Degas and Jozef Israëls.[58] He presumably did not want to write for a Social Democratic magazine, as it had not been long since he had been mistaken for a Social Democrat on the evidence of his early, unadorned, Naturalistic representations of common people.[59] Loeser's essay appeared after the first article on Kollwitz to appear, written by Lehrs, had been published in the magazine *Die Zukunft* (The Future) in November 1901.[60] Almost contemporaneously, Anna Plehn, a friend of Kollwitz, published another piece in February 1902.[61] When the artist presented her *Weavers* cycle for the first time, in 1898 at an exhibition for women artists, Plehn had commended it in a review[62] and submitted it for Kollwitz at the 'Große Berliner Kunstausstellung'.[63] That the first essays on Kollwitz in 1901 and 1902 were penned by people with whom the artist was personally connected makes clear once again that she was only well known within a small circle. She was all the more thankful for Lehrs's indefatigable commitment. For this reason, and also because her work could not yet be sold on the market, she made over to the Dresden Museum 51 graphic sheets for the symbolic price of 150 marks, and ten others as gifts in 1902.[64] However, it cannot be ruled out that Lehrs had already mentioned to her that

he wanted to publish a catalogue of the graphic work she had hitherto produced, which then appeared in *Die Graphischen Künste* (The Graphic Arts) in early 1903.[65] The knowledge of this planned catalogue might have made the prospect more attractive of giving her early work in as complete form as possible to the Dresden Museum.

Especially at the beginning of her career, favour and encouragement, whatever the source, were very important to Kollwitz. From the 'Internationale Kunstausstellung' in Dresden, Lehrs reported to her that Constantin Meunier, who had made working people his main theme and who was considered the most significant sculptor in Belgium around 1900, had "much admired [your prints during his visit]. He even declared you one of the most compelling talents in Germany and asks you, through me, to submit your works to the exhibition at the Libre Esthètique in Brussels and mention his name and to be sure to visit him if you happen to be in Brussels."[66] Kollwitz, who did indeed show prints at the next exhibition of the Libre Esthètique,[67] answered Lehrs: "That is the best one could wish for, when artists of such stature don't find you unworthy".[68] Directly after the exhibition opening, Lehrs told the artist: "Your contributions were much admired by the [illegible word] artists who were here for the opening or as delegates. Count von Kalckreuth bought the 'Uprising' and would like to have purchased the 'Carmagnole', if he hadn't had to choose between them."[69] Kollwitz answered delightedly: "That Kalckreuth is buying Uprising is especially delightful to me, because I hold him in such tremendous esteem as an artist. His two aged women – I think he calls it old age – made a powerful impression on me …. It is the most beautiful work of his that I know."[70] Leopold von Kalckreuth was among the most respected artists in Germany around 1900.[71] Kollwitz had known his work since her student years

in Munich, 1888–90. In those years the Naturalists, whose main representatives included Max Liebermann and Fritz von Uhde and also von Kalckreuth,[72] were enjoying their first big success with their depictions of the daily life of the common people.[73] For Kollwitz, who before her *Weavers* cycle had already been depicting the life of the working classes in characteristic situations without any social criticism, all three of these artists were important role models.[74] Von Kalckreuth had made a name for himself in the 1890s primarily with large-format images of peasants. Lehrs praised these as an "apotheosis of the rural population, growing up or aging in heavy physical labour",[75] and a reviewer extolled his "simplicity, clarity and strength of expression",[76] as well as his monumentality, on the occasion of the 'Große Berliner Kunstausstellung' of 1897. Von Kalckreuth's particular interest was in women, as in the 1894 painting *Old Age*, which shows two old peasant women with their geese (fig. 14). Kollwitz singled out this painting to Lehrs as she began her cycle *The Peasants' War* (figs. 15–21).[77] Compared to her first series, *A Weavers' Revolt*, this one is characterized by a much greater monumentality of the figures, and in that sense resembles von Kalckreuth's work. The degree to which this artist fascinated Kollwitz in the years 1901–02 is revealed in part by a 1902 drawing for the first sheet of the *Peasants' War* cycle (fig. 22),[78] in which, in contrast to the final version, not only two men at the plough are depicted, but an old peasant woman stands to the side in the foreground and observes the scene as well. This figure, which fills the entire height of the image, resembles, in position and posture, including her cane, the *Goose Boy* in the painting of the same name by von Kalckreuth that Kollwitz might have seen at a collective exhibition at Cassirer in Berlin in 1902 (fig. 23).[79]

Initially Käthe Kollwitz planned her cycle *The Peasants' War* as five coloured lithographs.[80] She

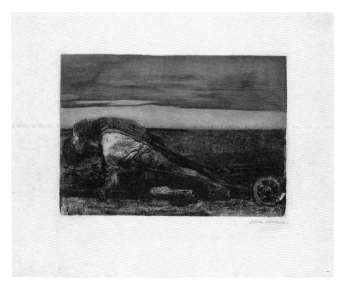

15. *The Ploughmen*, sheet 1 of the cycle *The Peasants' War*

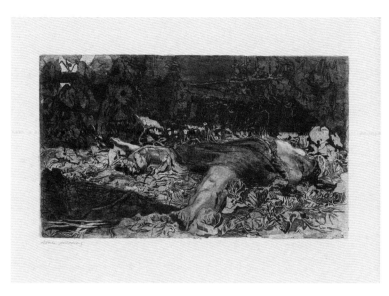

16. *Raped*, sheet 2 of the cycle *The Peasants' War*

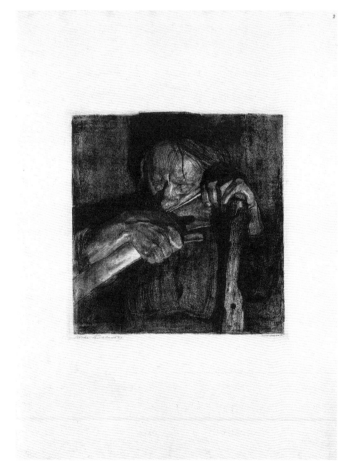

17. *Sharpening the scythe*, sheet 3 of the cycle *The Peasants' War*

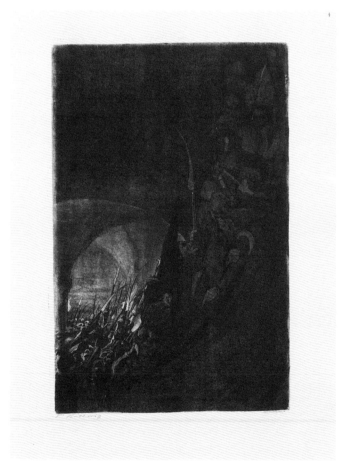

18. *Taking up arms in a vaulted space*, sheet 4 of the cycle *The Peasants' War*

Fig. 17 (detail)

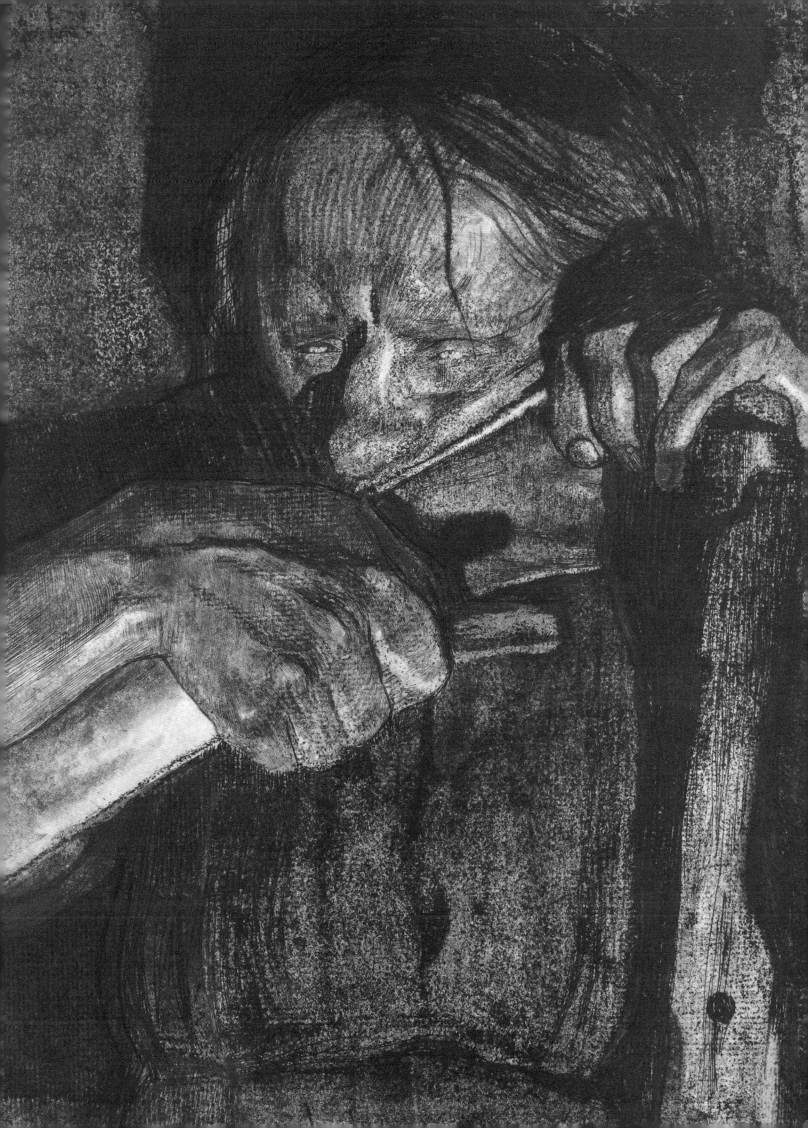

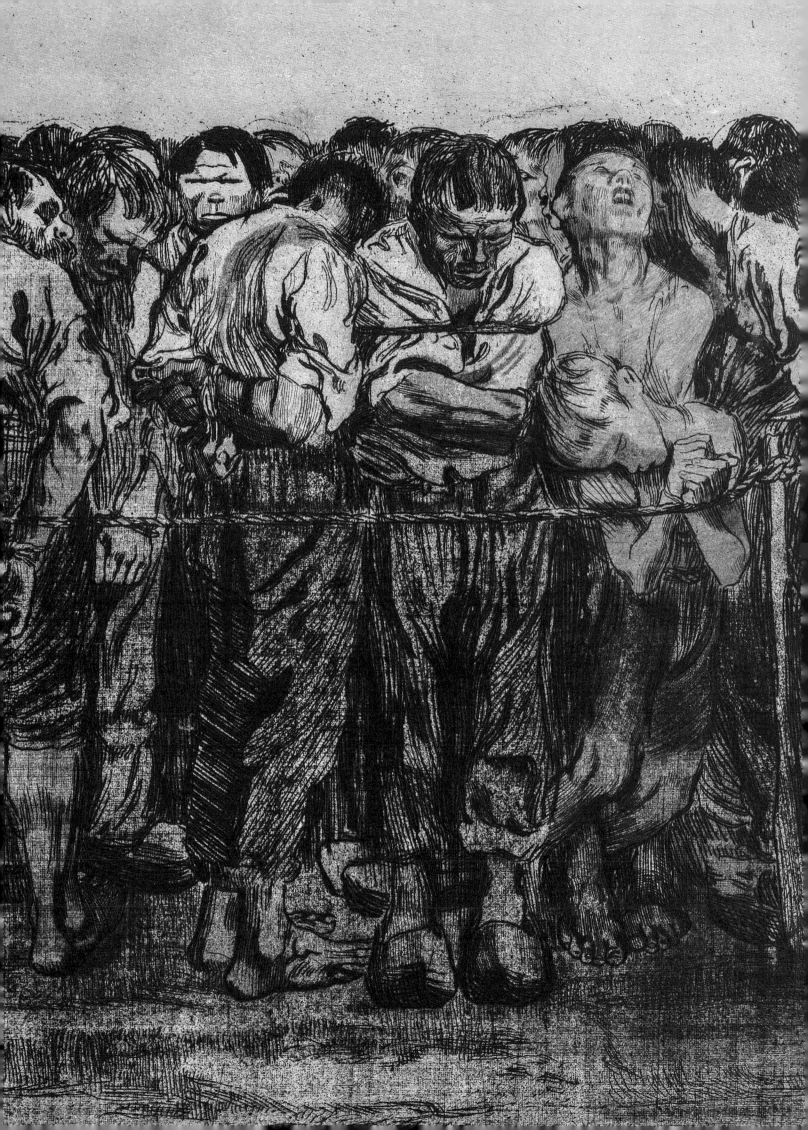

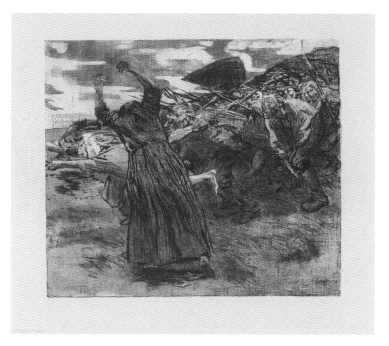

19. *Charge*, sheet 5 of the cycle *The Peasants' War*

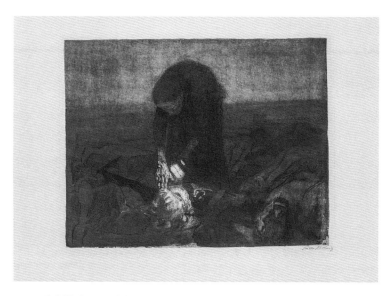

20. *Battlefield*, sheet 6 of the cycle *The Peasants' War*

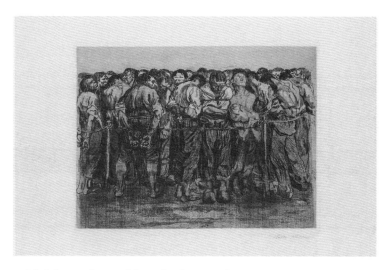

21. *The Prisoners*, sheet 7 of the cycle *The Peasants' War*

Fig. 21 (detail)

35

FIGS. 15–21

15. Käthe Kollwitz, *The Ploughmen*, sheet 1 of the cycle *The Peasants' War,* before mid January 1907, eighth state, proof from the 1908 edition, etching, drypoint, aquatint, lift-ground process, emery, combined needles and soft-ground etching with imprint of Ziegler's transfer paper in brown ink on copperplate paper, 315 × 454 mm (plate), 498 × 629 mm (sheet), Kupferstich-Kabinett, SKD, inv. no. A 1977-259

16. *Raped*, sheet 2 of the cycle *The Peasants' War*, Winter 1907–08, fifth state, proof from the 1908 edition, etching, drypoint, emery, lift-ground process and soft-ground etching with imprint of fabric and Ziegler's transfer paper in brown on copperplate paper, 308 × 528 mm (plate), 451 × 628 mm (sheet), Kupferstich-Kabinett, SKD, inv. no. A 1977-261

17. *Sharpening the scythe*, sheet 3 of the cycle *The Peasants' War,* before mid May 1905, tenth state, proof from the 1908 edition, etching, drypoint, emery, aquatint and soft-ground etching with imprint of hand-made paper and Ziegler's transfer paper in black ink on copperplate paper, 297 × 297 mm (plate), 600 × 427 mm (sheet), Kupferstich-Kabinett, SKD, inv. no. A 1977-260

18. *Taking up arms in a vaulted space*, sheet 4 of the cycle *The Peasants' War*, before mid June 1906, seventh state, proof from the 1908 edition, etching in two colours with drypoint, aquatint and soft-ground etching with imprint of Ziegler's transfer paper in black and grey-brown ink on copperplate paper, 497 × 327 mm (plate), 596 × 443 mm (sheet), Kupferstich-Kabinett, SKD, inv. no. A 1977-262

19. *Charge*, sheet 5 of the cycle *The Peasants' War*, 1902–03, seventh state, etching, drypoint, aquatint, lift-ground process and soft-ground etching with imprint of two fabrics and Ziegler's transfer paper in red-brown ink on copperplate paper, 515 × 592 mm (plate), 573 × 707 mm (sheet), Kupferstich-Kabinett, SKD, inv. no. A 1904-415

20. *Battlefield*, sheet 6 of the cycle *The Peasants' War*, 1907, tenth state, proof from the 1908 edition, etching, drypoint, aquatint, emery and soft-ground etching with imprint of ribbed hand-made paper and Ziegler's transfer paper in green-black ink, on Japan paper, 410 × 531 mm (plate), 552 × 716 mm (sheet), Kupferstich-Kabinett, SKD, inv. no. A 1977-264

21. *The Prisoners*, sheet 7 of the cycle *The Peasants' War*, Spring 1908, fifth state, proof from the 1908 edition, etching, drypoint, emery and soft-ground etching with imprint of fabric and Ziegler's transfer paper in brown ink on copperplate paper, 327 × 428 mm (plate), 450 × 626 mm (sheet), Kupferstich-Kabinett, SKD, inv. no. A 1977-265

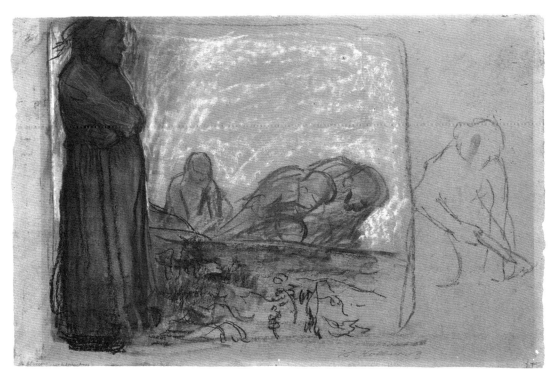

was inspired by Wilhelm Zimmermann's *Allgemeine Geschichte des großen Bauernkrieges* (General History of the Great Peasants' War), which had first appeared in 1841–43. Zimmermann, who at that time, before the 1848 Revolutions, had belonged to liberal circles in Germany, acknowledges in his book the demands made by the peasants in the 1524–25 war, which were in part still pressing in the nineteenth century. When the artist became dissatisfied with her initial lithographic versions – three from the years 1901–02 have survived (cat. 39)[81] – she completed what would later be the fifth sheet of the series, *Charge*, as an etching (fig. 19) over the course of 1902. The woman inciting the peasants on this sheet was inspired by the 'Schwarze Hofmännin', one of the few historically attested women in the Peasants' War, who blessed and urged on the peasants prior to the storming of Weinsberg. Kollwitz had read about her in Zimmermann.[82] As she was working on *Charge*, it seems as though she wanted to dedicate the whole cycle to this woman, historically elusive but featuring in Peasant War novels of around 1900.[83] As with *The*

Downtrodden and *The Carmagnole*, Kollwitz chose a very large format for *Charge*. The artist exhibited it for the first time at the sixth exhibition of the Berlin Secession in late 1902, which was one of the so-called 'Schwarz-Weiß-Ausstellungen' (Black-and-white exhibitions).[84] Since 1901, the Berlin Secession had organized a winter exhibition in addition to the summer one, and at the former, with its expressive name, graphic art was exclusively on display. In a review of the winter exhibition of 1902 the notable critic Hans Rosenhagen, a passionate advocate of the Berlin Secession and friend of Liebermann, Corinth and Slevogt, declared that with this print the artist offered "again something highly intriguing and compelling".[85] Kollwitz reported proudly to Lehrs in spring 1903: "I regard this Peasants' War as my best work and am quite pleased with it".[86] Surely encouraged by its positive reception, she wrote again to Lehrs that she hoped, for the coming winter exhibition of the Berlin Secession, "to have so much done" that she could "alone fill a whole wall". [87] Lehrs, who had visited the sixth exhibition of the Berlin

FIG. 23
Leopold von Kalckreuth (1855–1928),
The Goose Boy, 1897 or earlier, oil on canvas,
120 × 100.5 cm, private collection

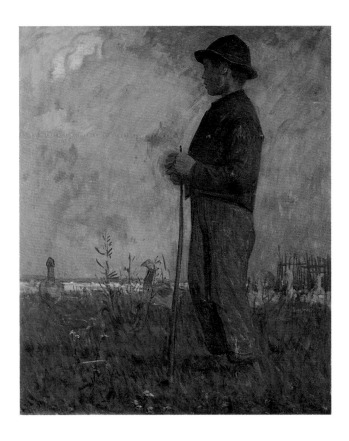

Secession himself, combined his appreciation for the large-format plate with a desire for another new work by Kollwitz shown at the Secession: "Your self-portrait impressed me very much. You will keep a proof for the museum, won't you, just like for every other work, so that your oeuvre remains complete?"[88] He added, as if he were concerned about being relegated by the artist in favour of the Berlin Secession exhibitions: "I would like to invite you now to our Große Ausstellung 1904 [in Dresden], where I am reserving a whole wall for you".[89] Not only the exhibitions of the Berlin Secession meant increasing competition for Lehrs – Kollwitz had already received a wall in her honour there in 1901 – but also, as the artist's renown grew, it became more difficult for him to collect her graphic work in its entirety. Nevertheless he continued to do his best to encourage her.

In 1904 Käthe Kollwitz applied for support for the continuation of her *Peasants' War* cycle from the Verbindung für historische Kunst (Association for Historic Art) with two of her most recent prints, *Charge* and the single sheet *Woman with dead child* (cat. 50),[90] which startled some viewers at first sight with its "uncanny energy". It was regarded as the "embodiment of maternal pain itself"[91] and also impressed audiences with the monumentality of its sculptural form. The conservative Verbindung für historische Kunst was founded in 1854 to promote German historical painting. In 1896 it sponsored a graphic work for the first time, Klinger's cycle *On Death, Part II*,[92] and distributed it to its members as an annual gift. From 1902 the group held competitions for graphic work; in 1904, 43 mainly unknown artists took part.[93] The chairman of the association was Hermann Henrich Meier, the son of the founder of the Norddeutscher Lloyd shipping company. Meier was one of the biggest collectors of graphic art of his time and directed the Bremen Kunstverein (Art

Association), which supports the main art museum in the city, the Kunsthalle Bremen, to this day.[94] Even if there is no hint of it in the correspondence between Lehrs and Kollwitz, we can assume that Lehrs was also involved here in a supporting role, as Meier wrote to him thanking him for "indirectly suggesting the undertaking". [95] Lehrs could further campaign for the artist with the Verbindung für historische Kunst, as this organization held its meeting in Dresden in 1904 and asked him to join the committee "to recommend the selection of prints".[96] On 5 May, he reported to her, "I was tremendously pleased that we pushed through the Peasants' War so smoothly at the histor. Verbindung. It was taken care of in 10 minutes. I had your best work brought in from the museum to give the experts (there weren't many there) an idea of your art."[97] The Verbindung für historische Kunst commissioned Kollwitz to produce the cycle in seven sheets over the following three to four years. Meier had Kollwitz assure him, moreover, that she would give him personally for his collection and also the Dresden Kupferstich-Kabinett a trial proof of each *Peasants' War* sheet, and informed Lehrs of the arrangement.[98] By

1908, following *Charge*, the entire series of etchings was completed. Despite Meier's agreement, Kollwitz did not give any other proof of the *Peasants' War* sheets to Dresden until 1908. The reason for this was that Lehrs became Director of the Berlin Kupferstichkabinett on 1 January 1905 and did not return to his former post in Dresden until 1 July 1908.

During Lehrs's three-and-a-half-year absence from Dresden, not one of Kollwitz's works found its way to the Museum under his successor, Jean Louis Sponsel. She only heard now and then from the curator there, Hans Wolfgang Singer, but perhaps it was this art historian, who had grown up in New York and had close contact with English artists, who made it possible for Kollwitz to exhibit works at the International Society of Sculptors, Painters and Gravers in London in 1899 and 1901; he certainly helped her do this in 1906.[99] In 1907 he corresponded with her regarding his brochure on her work.[100] Here, as also in a previous piece, in the English magazine *Studio,*[101] he made it clear that conservative circles in Wilhelmine Germany had difficulties with her socially critical works.[102] In 1908 he invited the artist to the next 'Große Kunstausstellung' in Dresden, which he was assembling.[103] At this exhibition, the artist showed her *Peasants' War* cycle for the first time almost in its entirety.[104]

In Berlin, Lehrs, with his close contact to the artist, was able to expand the Kollwitz collection there by 57 pieces, after having accustomed the museum to the idea of systematically collecting her work – as he himself remarked in a letter to Käthe Kollwitz.[105] In 1906 alone the artist gave 22 of 47 sheets that came into the Berlin Kupferstichkabinett as gifts.[106] In June 1908, one month before Lehrs's return to Dresden, the Verbindung für historische Kunst delivered the *Peasants' War* cycle to its members,[107] who included, in addition to art associations, princely houses, town halls, private

citizens and a small number of art dealers.[108] Neither the Dresden museums nor indeed any other German museum to speak of belonged to the Verbindung. On the art market, the series was only available through Kunsthandlung Emil Richter. In 1904, this dealership had arranged with the Verbindung für historische Kunst to purchase the plates of the *Peasants' War* cycle, with the provision that the artist transfer the sales rights for the cycle to the gallery. Even before Lehrs returned to his position in Dresden, Kollwitz wrote to him: "I've sent Richter … in Dresden various trial proofs of the Peasants' War sheets. If you still want some trial proofs, they can be provided by Richter … if you don't want to make any acquisitions now, I would be happy to donate the sheets you would like to the museum."[109] In this way, three more proofs of *The Peasants' War* entered the Dresden Museum as the only Kollwitz acquisition of the year;[110] the remaining prints followed in 1911 and 1917.

During Lehrs's years in Berlin, his correspondence with Käthe Kollwitz ceased almost entirely because of their proximity, but was taken up again after his return to Dresden. Gradually the tone of their letters becomes more personal: after Kollwitz's only, up to that point, private visit to Lehrs and his wife in autumn 1910,[111] they close with "Warm Regards". From 1917 onwards, the respective recipients are addressed as (him) "Lieber Herr Geheimrath" (Dear Privy Councillor) or (her) "Liebe Frau Doctor" (Kollwitz's husband was a doctor), or, after her induction into the Preußische Akademie der Künste (Prussian Academy of Arts) in 1919, "Liebe Frau Professor". The two exchanged news of their children and reported on the fates of their enlisted sons after the outbreak of the First World War. But the purpose of the (surviving) letters was almost always business. For the most part, Lehrs wrote to the artist with questions about those of her prints

that were still missing from the Dresden Museum. Though Lehrs had still hoped in the years following his return to be able to collect Kollwitz's entire graphic oeuvre, it was increasingly clear to him that this was unrealistic. Recently, following the appearance of the *Peasants' War* cycle, the artist had become the most famous woman artist in Germany. As a consequence her works were in ever greater demand from both museums and art dealers. Consequently, in late 1910 or early 1911, Kunsthandlung Richter commissioned Johannes Sievers, the directorial assistant at the Berlin Kupferstichkabinett, to compile a second catalogue raisonné of Kollwitz's graphic work, which he did, with Lehrs's consent.[112] A testament to the popularity of the artist's work at this point is the fact that in 1910 Richter doubled the annual stipend that had been guaranteed to Kollwitz up to that point to 1000 marks.[113] In 1912 Richter purchased 200 trial and early-state proofs as well as examples of rare prints by the artist.[114] At this point Richter also owned the rights to sell almost all her graphic work of which the plates had survived, which the firm used to supply exhibitions and museums.[115] For Lehrs it was therefore more and more difficult to close the gaps in his collection of Kollwitz's graphic art.

After her *Peasants' War* cycle, Kollwitz turned to sculpture. As a result, until 1918, her production of prints ceased almost entirely. Only in 1910 did she again complete another largeish number of etchings, among them impressive sheets on the theme of death including the etching *Death and Woman* (cat. 51). After her younger son, Peter, who had volunteered for service, was killed in 1914 at the beginning of the First World War, she spent several years immersed almost exclusively in the planning of a monument to young war volunteers, which, after multiple interruptions and concept changes, was finished in 1932 with the Memorial of the Mourning Parents.[116] In 1916, when Lehrs expressed his interest in new prints,[117] Kollwitz could only respond: "If I had done a new graphic piece I would, of course, have sent it to you".[118] Probably for this reason, with the exception of 1910, there are fewer letters between Lehrs and the artist from 1909 to 1917.

For her fiftieth birthday, in 1917, Kollwitz planned the first ever big exhibition of her drawings.[119] It finally took place in Paul Cassirer's gallery in Berlin[120] and afterwards, with the support of Kunsthandlung Richter, travelled to Königsberg[121] and Dresden,[122] becoming somewhat smaller as works were sold. Since everything was scarce in Germany in the third year of the First World War, Kollwitz could show only 159 drawings, rather than the two or three hundred originally planned.[123] In the context of this exhibition, more letters were sent between Lehrs and Kollwitz than in any other year. Lehrs took the opportunity to expand substantially the museum's existing collection of just a few Kollwitz drawings. Since he could not pay the market price, he asked the artist if he might see the drawings at her house before the exhibition opened.[124] There he selected nine sheets, among them two early self-portraits (cat. 53 and 54) and the atmospheric pen-and-ink drawing *Under the table lamp* (cat. 55), depicting Hans, the artist's eldest son, at the age of about two with a nanny. As donor for all nine sheets, Lehrs recruited Oscar Schmitz, one of the most important Impressionist collectors in Dresden,[125] who also purchased through Lehrs four of the artist's drawings for his personal collection.[126] In addition, Lehrs acquired four drawings from Galerie Ernst Arnold in Dresden, among them one of the most important preparatory studies for *Charge* (cat. 56). Lehrs presented these sheets in the 'New Acquisitions' exhibition in August and September 1917, then in the quarterly exhibition opening in October in honour of Kollwitz's fiftieth birthday.[127] In total, there were at least four anniversary exhibitions for the artist

in 1917: in addition to the travelling exhibition of her drawings and the quarterly exhibition in the Dresden Museum, the Berlin Kupferstichkabinett presented her graphic work "almost in its entirety"[128] and the Kunsthütte in Chemnitz showed 80 of the artist's works.[129] An essay on Kollwitz by Lehrs promised in a letter in 1917 is not known to have materialized.[130] But numerous appraisals of the artist appeared elsewhere on the occasion of her birthday and the associated exhibitions in art magazines and journals.

Seidlitz seized on the occasion of Kollwitz's fiftieth birthday to campaign for the artist's admittance to the Preußische Akademie der Künste in Berlin. A letter that Kollwitz sent to her son in December 1917 following a meeting with him clarifies this: "He is an enormous, nice old gentleman, very elegant, mild and gracious. Among other things, he told me that he had recommended me for the professorship of printmaking at the academy there (replacing Köpping, who died). Of course, he added immediately that in his opinion there was no chance that his suggestion would be taken up … but it is nice of him to care and to campaign for me, as Lehrs does."[131] Seidlitz's recommendation bore some fruit, however. In 1919 Kollwitz became a member of the academy – at her request without teaching duties.

In 1918 Kollwitz turned again to printmaking. By 1922 she had completed her first woodcut series, *War* (cat. 72–78), which, except for the second sheet, *The Volunteers*, featuring Peter and his friend, who was also killed, portrays the pain of those left behind and elucidates the artist's change of heart in the course of the First World War, becoming a pacifist. When Lehrs asked the artist about the price for the series, which he feared he could not afford because of the high inflation prevailing at the time, she reassured him: "Now you know, my dear Privy Counsellor Lehrs, that more than anything I value being well represented in the museum,

if you can't pay so much then I will be completely satisfied with less, there are enough wealthy people who have to pay me high prices".[132]

At the end of 1923 Lehrs retired. At this point, thanks to his dedication, the Dresden Kupferstich-Kabinett owned almost 180 graphic works and 22 drawings by Kollwitz, which were often donated or sold for a purely symbolic price to the Museum. In 1915, on the occasion of his sixtieth birthday, Kollwitz, who accommodated no other museum in a comparable way, had already thanked Lehrs for his ardent support: "You have supported and encouraged more than one artist with your affectionate interest. This is true of me to a great degree, and I would like to tell you now how grateful I am to you for your ever active involvement with my work."[133]

If one were to subject the correspondence between Lehrs and Kollwitz to a comparative appraisal, it would be hampered by the fact that most other correspondence between Lehrs and artists is still unpublished. Only his correspondence with Liebermann has been published in its entirety,[134] and a small part of that with the Prague-born Emil Orlik,[135] which alone encompasses 429 letters from the artist. This relationship, however, does not lend itself to comparison. Such a close friendship bound Orlik to Lehrs and his family that the curator regularly shared his life with him in long letters and reported to him on his many travels through Europe and overseas. On the other hand, clear parallels are found in the correspondence between Lehrs and Liebermann, of which barely one hundred letters have survived. It began in 1892 and ended with Liebermann's death in 1935. As with Kollwitz, it was commenced at Lehrs's initiative, with a request for the artist's works on paper for the Dresden Museum.[136] By contrast to the case of Kollwitz, Lehrs did not make such an intense effort to promote the artist. This was probably not necessary, as

Liebermann was certainly better known in 1892 than was Kollwitz at the start of her correspondence with Lehrs. Of course Lehrs also invited Liebermann to exhibit in the 'Große Dresdner Kunstausstellungen' and showed his work often at the Dresden Kupferstich-Kabinett. At the exhibition held in honour of his seventieth birthday in 1917, Liebermann commented to Lehrs: "I am very pleased to hear that you are organizing an exhibition of my art and I would like to thank you in advance for the great interest you have always taken in my work".[137] Like Kollwitz, Liebermann considered it a sign of his esteem that Lehrs wanted the Museum's collection of his work to be as complete as possible: "My own interest, fully understood, leads me warmly to support your efforts to own my graphic work in its entirety".[138] Liebermann also gave his graphic work to the Dresden Museum for much lower than the market price, or as a gift. Liebermann's answer to Lehrs's congratulations on his seventy-fifth birthday on 22 July 1922 makes it clear why he, and also presumably Kollwitz – both artists lived in Berlin – was so grateful to him: "I have not at all forgotten that the Dresden Kupferstich-Kabinett was the first to collect my graphic work, while the Berlin museum was still 'eating acorns'".[139] Because of his prominent position as the president of the Berlin Secession and the Berlin Academy, there were some other topics he discussed with Lehrs that were not relevant for Kollwitz. The letters of the later years illustrate the highly cultured environment of both writers. Remarkably, Liebermann, who, when Lehrs retired, was among the many who honoured him[140] – the two were even distantly related – composed his letters until the end in a very distant, sober language, unlike Kollwitz. Her letters were increasingly warmer and more personal. After Lehrs's retirement – they wrote regularly from then on twice a year – Kollwitz reported on her travels and her sojourns at health resorts, in even greater detail than she had before on her work, and, from 1933, very openly about the reprisals of the National Socialists. After they came to power, Kollwitz, her husband Karl Kollwitz and Heinrich Mann joined others (as they had in 1932) to add their signatures to a poster propagating an 'Urgent Call for Unity' between the Communist Party and the Social Democratic Party in the last free election, on 5 March. Heinrich Mann and Käthe Kollwitz were then forced to resign from the Preußische Akademie der Künste, because the National Socialists threatened to close the academy if they did not. Kollwitz informed Lehrs of events in a letter of 20 February 1933.[141] It is one of the few times in the letters that Kollwitz's political views are referred to.[142] In the last years – Kollwitz did not know that Lehrs was of Jewish descent[143] – there are repeated references to the increasing discrimination and exclusion of the Jewish population in the 'Third Reich'.[144] She continued to write to Lehrs about her work, which was mainly sculpture. Both had become lonelier, Lehrs because of his almost complete blindness and possibly his Jewish roots, Kollwitz because, under pressure from the National Socialists, she had had to descend the painful path of internal emigration. The artist was certainly all the more grateful for Lehrs's continued interest in her work and for his encouragement in the early years which had helped her achieve greater recognition. On his eightieth birthday she wrote to him once again: "I am a living witness to what you have done for contemporary graphic artists. I will always thank you for what you have done for me."[145]

1 Letter from Kollwitz to Lehrs, 13 January 1924, Bayerische Staatsbibliothek München (BSB), Ana 538 Kollwitz, Käthe.

2 See Berlin 1893a, nos. 2135–36, Berlin 1893b, nos. 128–30. In 1894 Kollwitz took part in an exhibition of women artists in Berlin: see 'Personal- und Atelier-Nachrichten', in *Die Kunst für Alle*, vol. 9, 1893/94, no. 17, 1 June 1894, p. 267.

3 Elias 1893, p. 673.

4 See Berlin 1898, no. 1165. On the *Weavers* cycle see Knesebeck 1998, pp. 118–205.

5 See Braun 2012, p. 428.

6 See W. Schmidt 1960, p. 19, and W. Schmidt 1988, p. 12. Seidlitz obtained Kollwitz's address from Cäsar Flaischlen, who had written to Liebermann for him on 1 June 1898 requesting it; see Braun 2012, p. 221.

7 On Seidlitz see p. 17 in the present volume.

8 Seidlitz 1898, p. 236.

9 See Knesebeck 1998, pp. 72–81.

10 Ibid., p. 9.

11 In 1899, the Berlin Kupferstichkabinett came into possession of Kollwitz's etching *Welcome* (Kn 13) through its subscription to the magazine *Pan*, which had enclosed this original work in a mailing. Ludwig Kaemmerer, directorial assistant at the Berlin Kupferstichkabinett from 1891 to 1903, later falsely claimed that the Berlin museum had purchased the *Weavers* cycle in 1898 at the 'Große Berliner Kunstausstellung' at his insistence, though the receipt showing the purchase had not been attached; see Kaemmerer 1923, p. 48.

12 Extracts from other letters have been published by Werner Schmidt in the only two essays to date on this correspondence; in part, the essays overlap in their content: W. Schmidt 1960 and W. Schmidt 1988.

13 Letter from Lehrs to Kollwitz, 8 June 1898, SKD archive, 01/KK 04 vol. 4, nos. 535–37.

14 See Zimmermann 1901–02, column 33.

15 Letter, 8 June 1898 (see footnote 13).

16 So that he could show them to the collector Michael Berolzheimer, Kollwitz once, in 1910, sent as many as 27 proofs to Lehrs: see her letter to Lehrs, 10 February 1910, SKD archive, 01/KK 04 vol. 15, no. 204.

17 See Lehrs's resignation letter, 22 September 1904, SKD archive, 01/KK 03 vol. 3, nos. 108–09, in which this is expressed as one reason for his departure for Berlin.

18 Letter, 8 June 1898 (see footnote 13).

19 Lehrs's approach set a precedent for his colleagues, according to a commemoration of him in Weixlgärtner 1938, p. 157.

20 Letter from Lehrs to Kollwitz, 24 June 1898, SKD archive, 01/KK 04 vol. 4, nos. 540–42.

21 Both sheets, inv. nos. A 1898-613 and A 1898-614, have been missing since 1945.

22 Letter from Kollwitz to Lehrs, 5 July 1898, SKD archive, 01/KK 04 vol. 4, nos. 543–44.

23 See letters from Kollwitz to Lehrs, 31 December 1898, BSB, Ana 538 Kollwitz, Käthe, and 11 January 1899, SKD archive, 01/KK 04 vol. 4, no. 773.

24 Inv. no. A 1899-166 (Kn 28 II), as well as the sheet inventoried under the title *A Weavers' Revolt. In the Tavern*, inv. no. A 1899-165 (Kn 28 I), missing since 1945; see Cologne 1988, p. 192, no. 126, with references.

25 Kn 40 II a. The other works were the etchings *Scenes from Germinal* (inv. no. A 1899-167, Kn 19 II) and *Four men in a pub* (inv. no. A 1899-169, Kn 15 I a) and the lithograph *Gretchen* (inv. no. A 1899-168, Kn 41).

26 N/T 146; see Dresden 1899, nos. 535 and 970–72.

27 Letter from Lehrs to Kollwitz, 22 April 1899, SKD archive, 01/KK 04 vol. 4, no. 774.

28 Eleven artists, among them the "etcher" Otto Greiner, received large golden plaques; 36 artists received small golden plaques. In addition to the prizeholders there were also honorable mentions; see 'Ausstellungen und Sammlungen', *Die Kunst für Alle*, vol. 14, 1898/99, no. 17, 1 June 1899, p. 270.

29 See Munich 1899, nos. 1926–27.

30 See Berlin 1899, p. 49, nos. 319–21 (mistakenly classified as sculpture).

31 See Vienna 1898, nos. 51 and 54.

32 Wieland 1899, p. 313.

33 Letter from Liebermann to Lehrs, 5 December 1901, in Braun 2012, p. 428.

34 Kollwitz became a member of the Berlin Secession after Dora Hitz, Sabine Lepsius, Ernestine Schultze-Naumburg and Julie Wolfthorn; see Matelowski 2017 and the member lists in the exhibition catalogues of the Berlin Secession, 1900 and 1901.

35 Letter from Kollwitz to Lehrs, 24 April 1899, BSB, Ana 538 Kollwitz, Käthe.

36 When Klinger died in 1920, the Dresden Museum owned around 125 of his drawings and more than 500 of his prints: see letter from Lehrs to Kollwitz, 27 July 1920, SKD archive, 01/KK 04 vol. 24, no. 161.

37 On the significance of Klinger for Kollwitz in general see Knesebeck 2007.

38 N/T 158.

39 *Opus VIII*, see Singer 1909, nos. 127–41.

40 See Kollwitz 2012, p. 737.

41 See Knesebeck 1998, pp. 173–93 and 208.

42 Julius Elias advised Kollwitz to leave out the Symbolist sheet in the *Weavers* cycle when she showed him the series in winter 1897–98, before she presented it to the public; see Elias 1917, p. 546.

43 See Knesebeck 1998, pp. 206–27.

44 Weinmayer 1917, p. 365.

45 See Knesebeck 1998, pp. 222–27.

46 In 1901 she showed a trial proof to Théophile-Alexandre Steinlen in Paris, according to her letter to Lehrs, 16 March 1901. In 1910 she gave a proof to Jean-Louis Forain, according to her letter to Lehrs, 21 March 1910, both BSB, Ana 538 Kollwitz, Käthe.

47 Kn 49bis.

48 See letter from Kollwitz to Lehrs, 16 March 1901, BSB, Ana 538 Kollwitz, Käthe, and Dresden 1901, nos. 908 and 1129–32.

49 On the *Peasants' War* cycle see Knesebeck 1999 and recently Cologne 2017.

50 See Zimmermann 1901, column 34.

51 On Lady Spencer-Churchill, born Consuelo Vanderbilt, see Vanderbilt Balsan 1973.

52 See letter from Lehrs to Kollwitz, 23 September 1901, SKD archive, 01/KK 04 vol. 6, nos. 440–43.

53 See letter from Kollwitz to Lehrs, 6 November 1901, BSB, Ana 538 Kollwitz, Käthe. On Gladys Deacon see Vickers 1987.

54 See letter from Kollwitz to Lehrs, 10 December 1901, BSB, Ana 538 Kollwitz, Käthe. In addition, the gallerist Charles Hessèle in Paris already had works by Käthe Kollwitz on commission; see Knesebeck 2010, p. 101.

55 On Loeser see *Dictionary of Art*, vol. 19, New York 1996, p. 538.

56 Letter, 23 September 1901 (see footnote 52).

57 See letter from Liebermann to Lehrs, 5 December 1901, in Braun 2012, p. 428; see Loeser 1902.

58 See Liebermann 1899 and Liebermann 1901.

59 See Hamburg 2011, pp. 35–36.

60 See Lehrs 1901.

61 See Plehn 1902.

62 See Alp 1898, p. 266.

63 See Kollwitz 2012, p. 741.

64 According to the Kupferstich-Kabinett inventory; see p. 45 in the present volume.

65 See Lehrs 1903.

66 Letter from Lehrs to Kollwitz, 23 September 1901, SKD archive, 01/KK 04 vol. 6, nos. 440–43.

67 Communication from the Musées royaux des Beaux-Arts de Belgique Art ancien, Brussels, to the author.

68 Letter from Kollwitz to Lehrs, 25 September 1901, SKD archive, 01/KK 04 vol. 6, no. 444.

69 Letter from Lehrs to Kollwitz, 29 April 1901, SKD archive, 01/KK 04 vol. 6, nos. 236 and 239.

70 Letter from Kollwitz to Lehrs, 2 May 1901, SKD archive, 01/KK 04 vol. 6, nos. 237–38.

71 Article in the *Berliner Tageblatt*, 1 May 1900, no. 219, printed in Echte/ Feilchenfeldt 2011, pp. 287–88.

72 See Bierbaum 1891, p. 631.

73 See Knesebeck 1998, pp. 74–79.

74 See Cologne 2007 passim.

75 Dresden 1900, p. 5.

76 Schultze-Naumburg 1897, p. 303.

77 Kn 99 VIII b, 101 V b, 88 X b, 96 VII b, 70 VII, 100 X b, 102 V b, figs. 7–10 and 12–13: transferred in 1977 from Kunstbibliothek, Dresden, Vorbildsammlung der ehemaligen Kunstgewerbeschule Dresden; fig. 11: donated by the Verbindung für historische Kunst, 1904.

78 Not in N/T.

79 See Echte/ Feilchenfeldt 2011, pp. 287–94. A similar repoussoir figure to the one in Kollwitz's drawing is found in von Kalckreuth's 1894 painting *The Gleaners*, which was also exhibited at Cassirer; see Echte/ Feilchenfeldt 2011, p. 291.

80 See letters from Kollwitz to Lehrs, 25 September 1901, SKD archive, 01/KK 04

vol. 6, no. 444, and 30 December 1901, BSB, Ana 538 Kollwitz, Käthe.

81 This refers to *The Ploughmen*, of which two copies belong to the Dresden Kupferstich-Kabinett: inv. nos. A 1902-374 and A 1902-373 (verso of present cat. 45); and to *Ploughmen and woman*, inv. no. A 1902-859 (Kn 64) and present cat. 39.

82 See Bonus-Jeep 1948, p. 209.

83 See Knesebeck 1999, pp. 68–70.

84 See Berlin 1902, no. 275.

85 Rosenhagen 1903, p. 190.

86 Letter from Kollwitz to Lehrs, 6 March 1903, BSB, Ana 538 Kollwitz, Käthe.

87 Ibid. In fact, with about 25 works, Kollwitz was able to give an overview of her work to date at the Berlin Secession's winter exhibition in 1903; see Berlin 1903, nos. 334–52.

88 Letter from Lehrs to Kollwitz, 12 March 1903, SKD archive, 01/KK 09 vol. 2, nos. 81–83. Here Lehrs is referring to the *Self-portrait towards left, with neck* (Kn 66). This proves its depiction in connection to Heilbut's review of the Secession exhibition in 1903, p. 112. Lehrs acquired it in 1904 (inv. no. A 1904-419).

89 Letter, 12 March 1903 (see footnote 88).

90 See 'Verzeichnis der zur dreissigsten Haupt-Versammlung der Verbindung für historische Kunst angemeldeten Graphischen Werke, Dresden 1904', Stadtarchiv, Kassel, Bestand B 14, no. 16.

91 Plehn 1904, p. 234.

92 *Opus XIII*, Singer 1909, nos. 230–241.

93 See 'Verzeichnis ...' (see footnote 90).

94 On Meier see Röver-Kann 2007.

95 Letter from H. H. Meier to Lehrs, 29 May 1904, SKD archive, 01/KK 04 vol. 9, nos. 224–25. Perhaps Meier is referring to a visit to Lehrs in 1901 during the 'Internationale Kunstausstellung' in Dresden, which led to his purchasing a drawing from Kollwitz through Lehrs; see Lehrs's letter to Kollwitz, 14 September 1901, SKD archive, 01/KK 04 vol. 6, nos. 436–38.

96 'Verhandlungen der XXX. Haupt-versammlung der Verbindung für historische Kunst abgehalten zu Dresden am 1. bis 3. Mai 1904', p. 6, Stadtarchiv, Kassel, Bestand B 14, no. 16.

97 Letter from Lehrs to Kollwitz, 5 May 1904, SKD archive, 01/KK 04 vol. 9, nos. 218–19. In the end only the Dresden Museum profited from the agreement, as Meier died in 1905.

98 See letter from H. H. Meier to Lehrs, 29 May 1904, SKD archive, 01/KK 04 vol. 9, nos. 224–25.

99 On her participation in 1901 see *Jahrbuch der Bildenden Kunst* 1902, column 140 and, on her participation in 1906, London 1906, nos. 321–22, 328 and 334, as well as two letters from Kollwitz to Singer, 23 September 1905 and 13 November 1905, Collection EWK, Bern.

100 See Singer 1908.

101 See Singer 1902, p. 4.

102 See also Weisbach 1905, pp. 91–92; on the question in general see Knesebeck 1998, pp. 9–11.

103 See Schumann 1908, p. 539.

104 See Dresden 1908, nos. 1550 55. *The Prisoners* was missing, which Kollwitz did not finish until after the deadline for the Dresden exhibition; see her letter to Singer, 19 February 1908, Collection EWK, Bern.

105 See letter from Lehrs to Kollwitz, 2 February 1911, SKD archive, 01/KK 04 vol. 16, nos. 126–28.

106 See Berlin 1995, p. 10.

107 See the letter attached to 'Verbindung für historische Kunst', Stadtarchiv, Nuremberg, C 7/I no. 730.

108 See H.-W. Schmidt 1985, pp. 254–58.

109 Letter from Kollwitz to Lehrs, 3 June 1908, SKD archive, 01/KK 04 vol. 13, no. 135.

110 They are all among the losses of 1945.

111 See Lehrs's house guestbook, 1883–1938, BSB,, Ana 538 Kollwitz, Käthe.

112 See letter, 2 February 1911 (see footnote 105).

113 See letter from Kollwitz to Lehrs, 1 November 1910, SKD archive 01/KK 04 vol. 15, nos. 401–02. According to a record of her annual income from 1901 to 1916, the artist's earnings, which were mostly between 2,000 and 3,000 marks until 1908, had risen by 1912 to 6,717 marks; see Kollwitz 2012, p. 802.

114 See Bohnke-Kollwitz 1992, p. 60.

115 See Knesebeck 2002, vol. 1, pp. 31–32. According to a card from Kollwitz to Wilhelm Bongards, 10 June 1912, Richter supplied the exhibition of the Kunstvereins für Rheinland und Westfalen: "The Düsseldorf exhibition has been supplied by my printer art dealer Richter, Dresden Prager Street. I would ask you to contact them if you are interested in a purchase": Collection EWK, Bern.

116 See Cologne 1999 and Seeler 2016, nos. 27 B and 28 B.

117 See letter from Lehrs to Kollwitz, 10 October 1916, SKD archive, 01/KK 04 vol. 21, no. 280.

118 Letter from Kollwitz to Lehrs, 23 October 1916, SKD archive, 01/KK 04, vol. 21, nos. 281–82.

119 See Kurth 1917, columns 309–10.

120 See Berlin 1917.

121 See Königsberg 1917.

122 See Dresden 1917, nos. 454–538.

123 See, among other sources, a letter from Kollwitz to Lehrs, 19 March 1917, SKD archive, 01/KK 04, vol. 22, nos. 73–74. Kollwitz clarified that there was no money for exhibition compartments and therefore less wall space was available.

124 See letter from Lehrs to Kollwitz, 21 February 1917, SKD archive, 01/KK 04, vol. 22, nos. 65–66.

125 Inv. nos. C 1917-33 to 41; see cat. 53–55 and 58. On Oscar Schmitz see Biedermann 2006.

126 See letter from Lehrs to Kollwitz, 24 April 1917, SKD archive, 01/KK 04 vol. 22, no. 81.

127 See letter from Lehrs to Kollwitz, 30 June 1917, SKD archive, 01/KK 04 vol. 22, nos. 85–86.

128 Beth 1917, p. 70.

129 See *Werkstatt der Kunst*, vol. 16, 1916–17, no. 42, 16 June 1917, p. 513.

130 See letter from Lehrs to Kollwitz, 1 March 1917, SKD archive, 01/KK 04 vol. 22, nos. 69–70.

131 Bohnke-Kollwitz 1992, p. 160.

132 Letter from Kollwitz to Lehrs, 7 December 1922, SKD archive, 01/KK 09 vol. 5, nos. 127–28.

133 Letter from Kollwitz to Lehrs, 30 June 1915, BSB, Ana 538 Kollwitz, Käthe.

134 See Braun 1989/90.

135 See Orlik 1981.

136 Even if Lehrs's first letter has not survived, it can be reconstructed from Liebermann's answer on 20 January 1892; see Braun 1989–90, p. 84.

137 Letter from Liebermann to Lehrs, 4 July 1917, ibid., p. 98.

138 Letter from Liebermann to Lehrs, 17 December 1913, ibid., p. 93.

139 Letter from Liebermann to Lehrs, 24 July 1922, ibid., p. 102.

140 See letter from Liebermann to Lehrs, 24 August 1924, ibid., p. 102.

141 See letter from Kollwitz to Lehrs, 20 February 1933, BSB, Ana 538 Kollwitz, Käthe.

142 See also letter from Kollwitz to Lehrs, 28 March 1919, BSB, Ana 538 Kollwitz, Käthe.

143 See Walk 1988, p. 220. Max Lehrs was christened as a Protestant in the Jerusalem parish in Berlin at sixteen years of age. I owe this information to Michael Zimmermann of the Protestant regional archive in Berlin. Handwritten above the entry there it reads: "foreign descent, Jewish". That Kollwitz did not know of Lehrs's Jewish parentage until his death is proven by the penultimate letter to him, 24 June 1938, in which she writes of a commission for a Jewish gravestone in Cologne-Bocklemünd for the couple Franz and Doris Levy: "According to Jewish law, nothing of human beings or their form is allowed on a gravestone": BSB, Ana 538 Kollwitz, Käthe. On the gravestone see Seeler 2016, no. 34 B.

144 See letter from Kollwitz to Lehrs, 1 January 1935, BSB, Ana 538 Kollwitz, Käthe.

145 Undated letter from Kollwitz to Lehrs, postmarked July 1935, BSB, Ana 538 Kollwitz, Käthe.

"Without question the most compelling personality in the field of printmaking":[1] Käthe Kollwitz's work and its museum reception

AGNES MATTHIAS

In July 1902, in the Hall of New Acquisitions of the then Königliches Kupferstichkabinet (Royal Museum of Prints, Drawings and Photographs) in Dresden, a selection of works by north German artists was presented. The Director, Max Lehrs, introduced this small special exhibition in an article in the newspaper *Dresdner Anzeiger* on 6 July 1902. Alongside names that have since been forgotten, more famous artists such as Hans Olde, Max Liebermann and Karl Stauffer-Bern were mentioned; but a long passage of the text was dedicated to "Stauffer's exceptional student, Käthe Kollwitz".[2] The exhibition offered "a limited selection of her best works, from the first, still somewhat tentative and conventional attempts of her student years in Munich to her latest large plate, the 'Carmagnole'".[3]

Lehrs intended, with this exhibition, to review the acquisitions of the artist's works that had been initiated at the Museum in 1898 – what is now called the Kupferstich-Kabinett already owned 80 of them in 1902 and, under his aegis, would continue to be pursue their acquisition vigorously.[4] The central theme of this opening essay is Lehrs's reaction to Kollwitz's graphic oeuvre – Lehrs being a knowledgeable scholar and connoisseur of Old Master prints – in both its technical and formal development.

After receiving her cycle *A Weavers' Revolt*, the Museum's first Kollwitz acquisition, he wrote appreciatively to the artist, focusing immediately on the workmanship of the sheets: "There is an austere, masculine spirit in these prints that far outstrips all what we are otherwise, unfortunately, used to finding in 'women's work' with all its weaknesses".[5] In his 1902 article he again defined her "will and ability" as "masculine"; in his view, her capacity "to give artistic form to her ideas with such seriousness and passionate commitment"[6] was extraordinary for a woman. There may be an element of apologia in these words, however, which were composed at a time when, in Germany, an academic education in the arts was reserved for men only; collecting the works of a woman would seemingly require a justification of this kind.[7]

Kollwitz was not allowed to study at a public academy, but she received a solid artistic education lasting several years financed by her father. After her first course in Königsberg under Rudolf Mauer, she studied in Berlin in 1886 at the Berliner Künstlerinnenschule (Berlin School for Women Artists) with Stauffer-Bern, as mentioned above. In 1887 she had private lessons in Königsberg with Emil Neide, who worked at the academy there teaching courses in plasterwork and life drawing. From 1888 to 1890 she attended Ludwig Herterich's painting course at the Münchner Künstlerinnenschule (Munich School for Women Artists).[8]

With the adjective 'masculine' Lehrs was attempting to capture Kollwitz's evident talent and the skills she had perfected in the course of her studies in original graphic art, a field which had up to that point been dominated by men. For Lehrs, she was, among "the

FIG. 24
Title page, *Die Graphischen Künste*, vol. 26, 1903

by Woldemar von Seidlitz, chief councillor at the Directorate General of the Royal Collections of Art and Science in Dresden as a "pioneer".[13] Seidlitz not only pointed out Lehrs's achievements in the study of early German and Dutch engravings, but also emphasized that since the 1880s he had recognized and encouraged the "very recent upsurge"[14] of original works on paper. Among the contemporary artists whose work he sought to collect, Seidlitz mentioned "Frau Kollwitz"[15] – the only woman he mentioned. Similarly Max Lehrs in his 1912 outline 'Zur Geschichte des Dresdner Kupferstichkabinetts' (On the History of the Dresden Kupferstich-Kabinett) included Käthe Kollwitz as the only woman alongside Max Liebermann, Emil Orlik and Leopold von Kalckreuth as representative of the new graphic movement.[16]

"The artists need not begrudge us this bookkeeping activity"[17] – cataloguing and canonizing

What Lehrs saw and valued so much in Kollwitz's work may be gleaned from the notes to be found on the first state of her (probably) 1891–92 etching *Three workers at a tavern table* (cat. 34).[18] For future revision, she noted in pencil: "The whole thing must absolutely not appear black and blocky", and, "middle figure good, figure on right more precise".[19] Even clearer is the phrasing – in poetic imagery – in which she expressed her search for the right form to produce the desired effect: "Buoyant soft breathing, without its becoming woolly"[20] (fig. 25). The thick texture of the hatching scored into the plate with the etching or drypoint needle embeds the three figures at the table in a gloomy, smoky atmosphere. Fully master of her medium, Kollwitz achieved the lighter effect she desired in the second state (cat. 35).

These two specimens were part of a larger purchase in 1902, amounting to a total of 61 sheets.[21] Among them were early etchings, some in several states, but

current etchers in Berlin, without question the most compelling personality in the field of printmaking".[9] He had already spoken of her "forceful drawing style" and her "confident mastery of the form"[10] in 1899. In 1901 he referred to her "free, energetic handling of the etching needle"[11] in an article about the artist in the magazine *Die Zukunft* (The Future).

This last text, slightly modified, would serve as the introduction to a catalogue raisonné of the graphic works of the then thirty-five-year-old based on the Dresden Museum's holdings and published in 1903 in the leading magazine *Die Graphischen Künste* (The Graphic Arts; fig. 24).[12] The material it presented revealed the development of the artist from her first attempts at etching through to the mature results she had achieved in intaglio and planographic printing. The text amounts to an art historical critique of her talent by Lehrs.

On the occasion of Lehrs's transfer in 1905 to the Berlin Kupferstichkabinett, where he took up the post of Director (until June 1908), he was characterized

FIG. 25
Detail from Käthe Kollwitz, *Three workers at a tavern table*, 1891–92 (?), Kupferstich-Kabinett, SKD, inv. no. A 1902-827 (cat. 34)

also unique prints, experiments with algraphy (using an aluminium plate in the place of a lithographic stone) and recently completed coloured lithographs. The inventory of 26 graphic works collected up to that point underwent a substantial expansion; for Lehrs the basis for the compilation of the catalogue raisonné, comprising more than fifty entries, was complete.

Lehrs depended on the "assistance of the artist"[22] for dates and sequencing of the sheets between 1890 and 1902, most of which were undated. He downplayed the scholarly demands associated with the catalogue with somewhat false modesty: it should be "nothing more … than an attempt to compile the material for later scholarly treatment of an oeuvre catalogue".[23] "It is always awkward to put together a catalogue of works by living etchers, because one cannot offer anything that is complete or whole, and because most artists do not readily surrender for public consumption their older plates or those discarded as failed attempts",[24] he continued. In fact, he missed out some twelve works unknown to him at the time, and certain descriptions of content and dates were later discovered to be inaccurate.[25] Leaving aside these minor defects, given its relatively early and systematic compilation the catalogue raisonné consolidated the inclusion of Kollwitz's graphic work in the art historical canon. Edvard Munch was over forty when Gustav Schiefler catalogued his graphic work up to 1906. Max Liebermann and Lovis Corinth

were sixty and over sixty, respectively, by the time their work was catalogued. Kollwitz was aware and suitably appreciative of Lehrs's commitment: "Thank you very much for the work you've done with me", she wrote to Lehrs after the publication in *Die Graphischen Künste*, "I feel quite honoured, the Käthe Kollwitz edition makes such a distinguished, respectable impression".[26] Lehrs wrote straight back in reply to this letter noting a self-portrait he had come across in the 'Schwarz-Weiß-Ausstellung' (Black-and-white exhibition) of the Berlin Secession, which he wanted in order to complete the collection of the Kupferstich-Kabinett: "You will keep a proof for the museum, won't you, just as for every other work, so that your oeuvre remains complete?"[27]

A sheet with two self-portraits was among the first works purchased from the artist, in 1899 (cat. 3). Completed in 1892, this etching, indebted to the prevailing Naturalism, was among her first attempts in the medium, in the period when Kollwitz was dedicated to so-called *Griffelkunst* ('Stylus Art'). She was especially influenced in these endeavours by Max Klinger's etchings. We may see as a practical and representative expression of her experimentation with different graphic media the test lines drawn here with a fine etching needle in the lower section of the image area, as well as the numbered trials with emery (sandpaper) showing varying degrees of granularity; these technical exercises appear alongside a fragmentary self-portrait with her head resting on her arm.[28]

A Weavers' Revolt (cat. 13–22) inspired Lehrs to become more targeted in his acquisitions. In a letter dated 24 June

"She shows mastery of the form and full confidence from her very first etchings. The small trial plates with heads, hand studies, etc., some of which have been exhibited though they were not intended for public view, are directly reminiscent of Wilhelm Leibl."[33] *Woman at a cradle* (cat. 49), dated c. 1897, should also be seen in this context, already demonstrating the technical mastery that Kollwitz had achieved in self-study. She would utilize this mastery in the coming years the better to communicate the messages she sought to express. She combined delicate drypoint, which she used for the face and hands of the woman and the child's small face, with the hard, dark strokes of line etching. With the sections along the floor crisscrossed with scratches made with emery, she disengages from the representational elements of the figurative scene, printed in blue. Lehrs probably took this trial proof of the second and final state, partially reworked in green chalk, with him after his visit to her studio in Berlin in January 1899. It was shown together with the *A Weavers' Revolt* series and other works in the May exhibition at the Dresden Museum. In 1902, Lehrs was able to purchase an associated study of the female figure done in pen and Indian ink. A reproduction of the drawing and an original etching of *Woman at a cradle* were used to illustrate the catalogue raisonné the following year (fig. 28).[34]

This exploration of varied textures with which to depict different surfaces combined with etching with the needle subsequently intensified. An example of the way this interest evolved is the 1903 etching *Woman with dead child* (cat. 50). Here the mother-and-child subject is comparable to that of *Woman at a cradle*, though the message, as well as the free, abstract execution of the intertwined bodies of the mother and son, is its complete opposite.[35]

In 1901 Kollwitz used soft-ground etching (*vernis mou*) for the first time, for *Hamburg tavern* (cat. 41). This

1898, he asks Kollwitz not only for already completed etchings but also for material that seemed important to him for a general understanding of her graphic art.[29] Promptly, on 5 July 1898, Kollwitz sent him two state proofs of the last two sheets of the *Weavers' Revolt* cycle. *Storming the Gate – Attack* and *End* were her first works to be inventoried at the royal Kupferstich-Kabinett in Dresden, but they have been missing since 1945 (figs. 26 and 27).[30] Numerous rejected versions of *Need* and *Death*, both first done as etchings then as lithographs, were part of the 1902 acquisition.[31] This also included other early prints such as *Sheet of studies* (cat. 32), in etching and drypoint – Kollwitz's first etching, dating from 1890–91. The plate features various motifs brought together as on a sketchpad and arranged around a child's head; some of them can be traced to Fritz von Uhde's 1884 painting *Let the Little Children come to Me*.[32]

For Lehrs, these early attempts attested to the already confident handling of the etching techniques to which Kollwitz was introduced by Rudolf Mauer in Königsberg in winter 1890–91. Stylistically and thematically, Lehrs situated her among the Naturalists:

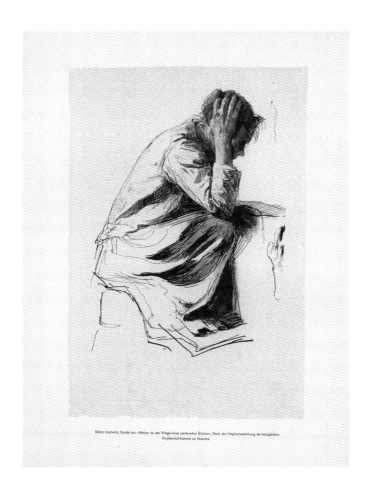

FIG. 28
Reproduction of the lost pen drawing
inv. no. C 1902-13, *Woman at a cradle*, in
Die Graphischen Künste, vol. 26, 1903, p. 56

Käthe Kollwitz, Studie zur »Mutter an der Wiege ihres sterbenden Kindes«. Nach der Originalzeichnung im königlichen Kupferstichkabinet zu Dresden.

technique allows not merely a drawing but also the structure of paper or fabric to be transferred to the printing plate. "A series of rough, violent lines"[36] gives the traditional scene its earthy character, according to Hans Wolfgang Singer, curator of the Dresden Kupferstich-Kabinett, who published a small monograph on the artist in 1908. Kollwitz laid a sheet of paper on the soft etching ground and then sketched dancing men with a laughing woman on it. The ground stuck to the sheet along the drawn lines and was then lifted away from it along with the paper. The areas laid bare in this manner were then etched, and the sketchy strokes of the drawing were thus reproduced in the print.

In *Woman with dead child*, Kollwitz used soft-ground etching and emery to model the naked bodies with shadowy surfaces. This was accomplished by pressing the partial imprint both of ribbed hand-made paper and of grainy Ziegler's transfer paper on to the etching ground. Only rarely did she use the roulette, in addition, to create surfaces, as in *Death and Woman* of 1910 (cat. 51). In the contemporaneous *Pregnant*

woman (cat. 52), the voluminous body, clothed in a dark dress, is modelled in aquatint, a process for producing continuous tone which Kollwitz had often used since *A Weavers' Revolt*. This sheet, which Lehrs at the time entitled *Woman with shawl*, was displayed in the March exhibition in 1911, just after its purchase, alongside Max Klinger and Eugen Kirchner. On this occasion Lehrs praised it as one of "the artist's best works".[37]

Lehrs documented Kollwitz's working processes by collecting various states, seeking to reflect her remarkable range of artistic media. For instance, in 1902 he expanded the collection of states of *The Carmagnole* (cat. 38) to include the second and third, having purchased the first and fifth the year before. Thus successive additions to the scene, done with an etching and a drypoint needle, of a crowd dancing around a guillotine could be studied at the Dresden Museum in as many stages of development as possible (fig. 29).[38] "Very probably no woman has ever managed to give her ideas artistic form with such seriousness and passionate commitment,"[39] he wrote of this work in the *Dresdner Anzeiger*. Even years later Lehrs continued to 'complete' earlier purchases with further states, trial proofs and variations. In October 1910 he asked Kollwitz to send him a previously unknown etching from her group of works inspired by Zola's *Germinal*, which he had seen at the Berlin Kupferstichkabinett: "It's very important to me finally to obtain this sheet that is still missing from our otherwise complete collection of your etchings, and I warmly encourage you to undertake a thorough search of the drawers in your atelier".[40] She quickly responded to his request by sending two trial proofs of *Fight in the pub* (fig. 30) as a gift, so that Lehrs, satisfied, wrote: "Thank you very much for the two trial proofs for 'Germinal', which have dispelled my concerns as to the completion of our collection".[41]

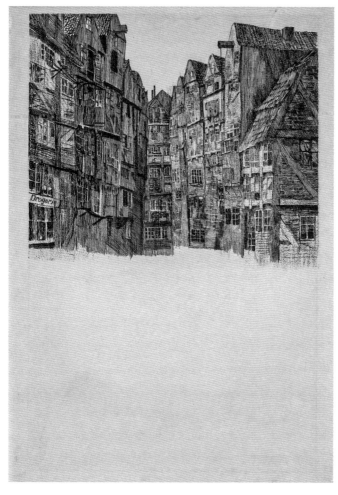

FIG. 29
Käthe Kollwitz, *The Carmagnole*, before mid
March 1901, first state, etching, drypoint,
aquatint, with brush etching and emery in
black ink, reworked with yellow body colour
on copperplate paper, 588 × 412 mm (plate),
554 × 390 mm (sheet), Kupferstich-Kabinett,
SKD, inv. no. A 1901-792

There were numerous prints, either given by
Kollwitz or purchased in 1901–02, on which the artist
had drawn changes for the next state in pencil, chalk or
charcoal. Among these, the various proofs of the states
of the tripartite etching *The Downtrodden* are striking;
the combination of printed, drawn and redrawn
elements not only gives them a hybrid character but
makes them unique (cat. 27 and 28). The composition
can be traced to an unrealised allegorical final sheet
for *A Weavers' Revolt*. Iconographically and stylistically,
the middle section with a man's corpse lain out is
reminiscent of a drawing by Max Klinger of the dead
Christ (fig. 31).[42] Kollwitz later distanced herself from
this work, and Lehrs, too, counted it among her "less
successful".[43] Nonetheless he documented the complex
creative processes behind this etching, which is distinct
from Kollwitz's previous work if only by virtue of its
unusual format, nearly one metre in length. In 1917
he was able to purchase a preparatory drawing of the
family group on the left side of the work (cat. 31).

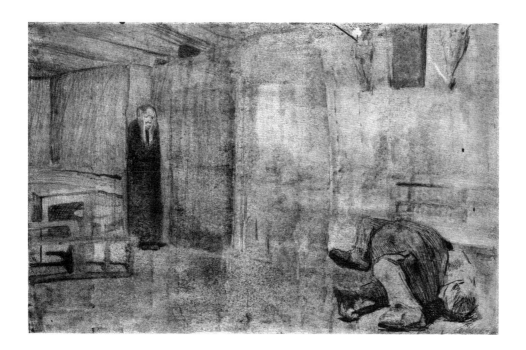

FIG. 30
Käthe Kollwitz, *Fight in the pub*, rejected
work from the series inspired by Zola's
novel *Germinal*, 1904 (?), etching, with
emery and soft-ground etching with
Ziegler's transfer paper in brown on
copperplate paper, 339 × 535 mm (plate),
331 × 520 mm (sheet), Kupferstich-
Kabinett, SKD, inv. no. A 1911-40

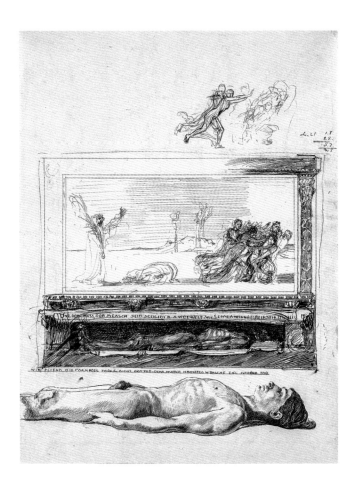

first time in lithography. The portrait of her son Hans (cat. 43), in which the child's face was rendered in delicate chalk lines framed in black applied by brush, was inspired by the interplay of drawing and plain surface in Edvard Munch's *Self-portrait* of 1895 (fig. 32);[46] she would return to this in later lithographs, such as *Female nude, half-length, with pole* and *Bust of a working woman with blue shawl* (cat. 46 and 44).[47]

Following her first visit to Paris, colour would play a central compositional role in Kollwitz's lithographs. In the fragment *Woman arranging her hair* (cat. 45), a unique proof that she donated to the Dresden Kupferstich-Kabinett in 1902, she used three colours with brush and chalk.[48] A green tone stone that imbues the scene with an atmospheric light is used again in *Female nude, from behind, on green cloth* (cat. 48). While here she created a soft, painterly atmosphere of light, *Woman with orange* (1901) testifies to the influence of the artists' group Les Nabis in its stronger, planar execution and the simplification of the figure (cat. 42).[49] The intimacy of the scene derives from the complex play of light: the woman's face is only partially illuminated by the lamp; her forehead is in shadow; the intensely glowing orange of the fruit stands out against her dark dress. This effect is achieved with the unusual combination of planographic printing and intaglio. "I'm doing lithography alongside the etching and have high hopes for the results of mixing the two techniques – to experiment I have only one press of my own at the moment,"[50] Kollwitz related to Lehrs in August 1901. Here she printed a grey-black copperplate to define the woman's features over a pink tone plate, using aquatint to create a granular structure, and over an orange tone stone. For *City outskirts* (cat. 40), drawn with lithographic crayon, Kollwitz turned to algraphy, using a granular aluminium plate instead of the lithographic stone. The white highlights forming

"A few technically interesting experiments"[44] – lithographs, algraphy and colour

Dresden's copy of *Hamburg tavern* and the fifth state of the large etching *The Carmagnole*, both completed in 1901, were printed on a coloured paper, as Kollwitz had often done in her early work. The brown tones intensified the intimate atmosphere of the former, while the reddish-brown hue of the latter underscored its gloomy, threatening mood. Kollwitz's two visits to Paris, in 1901 and 1904, and current French art influenced her explorations with colour in printing as well. In March 1901 she described to Lehrs a visit to Théophile-Alexandre Steinlen's studio: "Steinlen showed me exquisite works, beautiful graphically and colouristically in equal measure The colouristic way these people work with copper and stone – especially copper – is totally new and exciting for me. That my whole stay in Paris – short as it was – was abundantly inspiring, I don't need to tell you. I do hope that what I've brought back with me from Paris will be noticeable in my work."[45] Around 1896 Kollwitz worked for the

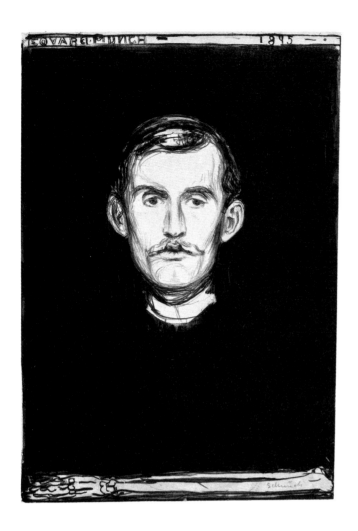

FIG. 32
Edvard Munch (1863–1944), *Self-portrait*, 1895,
chalk and brush lithograph with scraper
on lithograph paper, 460 × 317 mm (cut),
Kupferstich-Kabinett, SKD, inv. no. A 1912-661

on the stone it gets leathery and inartistic."[54] Despite these misgivings concerning lithography, *Taking up arms in a vaulted space* (cat. 39), the rejected fourth sheet from the *Peasants' War* cycle and the last entry in Lehrs's catalogue, is a dynamic, emotional composition executed with chalk and brush on stone. It depicts an angry mob moving diagonally upward. The drama of the scene results from the clever use of two stones, in light green and orange, that complement the black drawing.

"... complete our Kollwitz portfolio as far as is possible"[55] – collection policy and competition

When he published his catalogue raisonné in 1903, Max Lehrs seemed hopeful about fulfilling the goal of a complete set of Kollwitz's oeuvre. The pace of acquisitions abated, however, during the time immediately preceding his transfer to Berlin on 1 January 1905, and then came to a standstill until his return in July 1908; his commitment to Kollwitz benefited the Berlin Kupferstichkabinett in the interim.[56] Also to the detriment of the Dresden acquisitions was the publication in 1913 of a new catalogue of Kollwitz's etchings and lithographs by Johannes Sievers at the Kupferstichkabinett in Berlin.[57] Having been recommended by Lehrs, Sievers revised and updated his catalogue for Hermann Holst, director of the dealership Emil Richter in Dresden, who had published Kollwitz's graphic works since 1910.[58] Lehrs was critical of the undertaking nevertheless and expressed the fear that the catalogue was probably only intended to increase the price of some of the rarer prints.[59] Here one can discern the scholarly impulse that had been the motivation for his catalogue. This, with its preponderance of trial proofs and unique prints, presented material that was not accessible to the market, unlike later publications. However, Sievers's

the figures' contours were printed with a copperplate in an experimental process; the coloured lights in the background were put in by hand with tempera.

Lehrs concluded his catalogue with three lithographs from the second major cycle that Kollwitz worked on between 1901 and 1908, *The Peasants' War*.[51] He catalogued under no. 48, as a "trial stone for a new cycle",[52] *Peasants ploughing*, a subject which, along with the two following sheets, would ultimately be rejected for the cycle.[53] The cycle was planned first as a series of lithographs but in the end became one of etchings. The change of medium was probably due to difficulties with lithographic printing, which the artist described to Lehrs in a letter in March 1903: "In the last weeks I unfortunately got wrapped up in a lithograph, forgetting my experiences last winter. Again without success. When I can work directly from nature on the stone or on transfer paper, as in my self-portrait, it works, but when I want to flesh out a composition

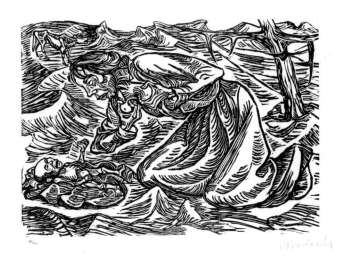

FIG. 33
Ernst Barlach (1870–1938), *Kneeling woman
with dying child*, 1919, woodcut in black ink
on laid paper, 228 × 448 mm (image),
369 × 445 mm (sheet), Kupferstich-
Kabinett, SKD, inv. no. A 1948-188

catalogue served as the basis for his expansion of his own in 1917, including works prior to 1912 that had previously not been listed. In reference to a 'quarterly exhibition' planned for July, but postponed until October, in celebration of the artist's fiftieth birthday, he wrote to her: "Although I'm not planning to exhibit everything you've ever entrusted to the copper plate, I would like to take this opportunity to complete our Kollwitz portfolio as far as is possible. For this reason, I've enclosed a list of the Sievers numbers that are still missing and would ask that you once more have a look in your cabinets and folders to see if you can find one or other of these sheets that you could give us."[60] He bolstered his request with the reminder that the Dresden Museum was "the very first to take an interest in collecting your etchings".[61]

But it was not only the retrospective purchase of older works that Lehrs pursued in his last years as Director. He showed a lively interest in the artist's current production as well.[62] Towards the end of the 1910s, this was concentrated on lithography, but with the start of the new decade, under the influence of Ernst Barlach (see fig. 33), she discovered for the first time the oldest printing technique of all, the woodcut.[63] "I truly long finally to find peace of mind with the woodcut,

to realise that this form is the one meant for me. At the moment it is only a devout wish,"[64] she wrote in August 1920. Ultimately, her third large cycle was in woodcut, the seven-part *War*. She had been looking in vain for a compositional solution to this theme in etching and lithography since 1918. The topic was heavily charged for her personally after the loss of her son Peter in battle in 1914. With pared-down, expressionistic images she turns the spotlight on war's victims – the volunteers going off to war, the mourning parents, the worried mothers and abandoned widows (cat. 72–78). On three sheets she cut the figures as blocky units out of the wood; the four other scenes are in white line, negative woodcuts. The cuts appear raw and angular in the wood; only a few lines delineate bodies and faces, making the anger and grief immediate. Lehrs quickly expressed his interest in this new field of artistic experimentation: "I cannot deny that I am very eager to see your woodcuts, especially as I cannot imagine what you will make of this technique."[65]

Kollwitz completed the *War* cycle in autumn 1922. The Dresden Kupferstich-Kabinett received, as a gift from the artist, five single sheets, one of them in two states. The Dresden banker Charles Walter Palmié

undertook to finance the purchase of the complete set. In summer 1923, Kollwitz sent the seven woodcuts to Dresden, but they were not inventoried until 1924, after Max Lehrs had left the directorship.

The "first completed woodcut",[66] however, *In Memoriam Karl Liebknecht* (cat. 70), Kollwitz submitted to Lehrs in January 1921. It was accompanied by two rejected versions, an etching and a lithograph, with unusually specific reference to the latest political events: "It is a memorial to Karl Liebknecht, to the fierce grief that filled the working classes when their warrior was murdered".[67] At the same time she asked for his assessment of them, which Lehrs gave her – without, however, referring to their political content: "The memorial to Liebknecht is very compelling in its expression and in any case much better than either of the previous attempts on copperplate and stone. I am always very grateful to you when you save such attempts for us so that we can keep your portfolio as complete as possible."[68]

He presented all three versions (see also cat. 68 and 69) in the Museum's July exhibition in 1921, guided by the same didactic idea that had inspired the entire Kollwitz collection, remarking: "The most cohesive is probably the final version in woodcut, although it is the artist's first display of her abilities with this technique as yet unfamiliar to her".[69] Subsequently, he asked for yet another state of the woodcut, with the lines of text added later to the lower edge ('The living to the dead man. In memory of 15 January 1919'), "since we only have this one without it and I find the effect better with it".[70]

This sheet is exemplary of Lehrs's approach regarding the inimical, recurrent question of social critique or political content in Kollwitz's work. He did not completely gloss over this aspect, writing repeatedly of the "intense gravity of her art",[71] and he addressed it indirectly in his first article about her, though evasively falling back on generalization: "The serious in life is admittedly not everyone's concern, and that explains why only a relatively small circle of private art lovers feel the intense attraction of her etchings, inherent in every honest work of art. It would be regrettable if, because of her work's social content, she found favour only among people for whom artistic content does not matter, for whom criticizing and the current trend are the main thing."[72]

The "artistic content", however, was what he, as an art historian, valued most. He viewed his "bookkeeping activities" primarily as "researching and discovering everything … and [describing] various proof states, etching stains and slips of the needle".[73] By a precise analysis of the means Kollwitz used to achieve the effects of her art, he aimed to make these effects apparent and comprehensible. To the end, Lehrs would continue to use the adjective 'masculine' in reference to Kollwitz's work, which had since become well-known and appreciated. However, one of his last essays on the artist, written in December 1922, contains a shift of position, in which he defines her exceptional status as stemming not from her gender, but rather from the quality of her art. Käthe Kollwitz was no longer in "her preferred field a genius" as a woman but – and here he refers to the *Peasants' War* cycle with *Charge* (cat. 56) – there were simply no artists, male or female, who compared to her for "elemental rage, unprecedented strength and artistic power".[74]

NOTES

1 Lehrs 1902, p. 2.

2 Ibid.

3 Ibid.

4 Sixteen sheets of the 85 works acquired up to 1902 have been lost since 1945.

5 Letter from Lehrs to Kollwitz of 24 June 1898, SKD archive, 01/KK 04 vol. 4, nos. 540–42.

6 Lehrs 1902, p. 2.

7 The names of only a few other women can be found in the Dresden inventories around the turn of the century, such as Mary Cassatt or Kollwitz's colleagues Cornelia Paczka-Wagner and Marianne Fiedler.

8 On education see Knesebeck 1998, pp. 30–63.

9 Lehrs 1902, p. 2.

10 Lehrs 1899, p. 1.

11 Lehrs 1901, p. 351.

12 See Lehrs 1903; on the magazine *Die Graphischen Künste* see Tröger 2011.

13 Seidlitz 1905, p. 113.

14 Ibid., p. 119.

15 Ibid., p. 120.

16 See Lehrs 1912, p. 8.

17 Lehrs 1903, p. 60.

18 For the date see Kn 10.

19 See inv. no. A 1902-827.

20 Ibid.

21 Fifty-one sheets were purchased for 150 marks and inventoried on 7 June 1902; ten were given as gifts. Fourteen of these sheets have been missing since 1945.

22 Lehrs 1903, p. 60.

23 Ibid.

24 Ibid.

25 Comparing Lehrs's 50 entries with the catalogue raisonné by Alexandra von dem Knesebeck, twelve works are missing.

26 Letter from Kollwitz to Lehrs, 6 March 1903, Bayerische Staatsbibliothek, Munich (BSB), Ana 538 Kollwitz, Käthe.

27 Letter from Lehrs to Kollwitz, 12 March 1903, SKD archive, 01/KK 09 vol. 2, nos. 81–83. The self-portrait was not acquired until 1904; see inv. no. A 1904-419, Kn 66.

28 The emery is partially pressed into the hard etching ground and rubbed with a burnisher. The ground is perforated variously depending on the grain. The acid eats into the metal in the open areas, so the emery's structure is reproduced.

29 See the letter from Lehrs to Kollwitz of 24 June 1898, SKD archive, 01/KK 04 vol. 4, nos. 540–42.

30 See Cologne 1988, p. 192, nos. 131 and 132. The complete cycle arrived in June 1898, but was not inventoried until January 1899 with consecutive numbers, after Woldemar von Seidlitz financed the acquisition.

31 *Need* was purchased in a total of nine versions and states; four sheets (inv. nos. A 1902-831, A 1902-832, A 1902-834 and A 1902-835) have been missing since 1945.

32 Kollwitz's inspiration from the painting, today in the Museum der bildenden Künste, Leipzig, was first discussed by Knesebeck: see Cologne 2007, pp. 3–4.

33 Lehrs 1902, p. 2.

34 The drawing had the inventory number C 1902-13 (N/T 141); see Dittrich 1987, p. 66, no. 654.

35 On Kollwitz's technique see Knesebeck 2002, pp. 17–22.

36 Singer 1908, p. 48.

37 Lehrs 1911, p. 2.

38 A 1901-792 (Kn 51 I), given by the artist in 1901; the other sheets are inv. nos. A 1901-791 (Kn 51 V a 2), A 1902-856 (missing) and A 1902-857 (missing).

39 Lehrs 1902, p. 2.

40 Letter from Lehrs to Kollwitz, 14 October 1910, SKD archive, 01/KK 04 vol. 15, nos. 393–94. This work ties in with Kollwitz's exploration, begun in 1888, of themes drawn from Emile Zola's novel *Germinal*.

41 Letter from Lehrs to Kollwitz, 18 November 1910, SKD archive, 01/KK 04 vol. 15, nos. 403–04; inv. nos. A 1911-40 (Kn 84 I), given by the artist in 1911, and A 1911-41 (missing).

42 This was a compositional sketch for the etching *Death as Savior* as sheet 10 of the cycle *On Death, Part One*, 1889, inv. no. C 1896-4. Klinger's male figure goes back to Hans Holbein's painting *The Body of the Dead Christ in the Tomb*, 1521–22 (Kunstmuseum Basel).

43 Lehrs 1903, p. 59.

44 Ibid.

45 Letter from Kollwitz to Lehrs, 16 March 1901, BSB, Ana 538 Kollwitz, Käthe.

46 The sheet was gifted to the Dresden Kupferstich-Kabinett in 1911.

47 See Carey/ Griffiths 1984, p. 64.

48 This sheet, dated by Kn 47 between 1899 and 1900, is seen today in conjunction with Kollwitz's first visit to Paris, and therefore dated 1901; see Hansmann 2010, p. 139.

49 See Knesebeck 2010, pp. 98–101.

50 Letter from Kollwitz to Lehrs, 29 August 1901, BSB, Ana 538 Kollwitz, Käthe.

51 *The Peasants' War* was never acquired in full under Lehrs; single sheets were added to the collection in 1904, 1908, 1911 and 1917.

52 Lehrs 1903, p. 67.

53 Today entitled *The Ploughmen*; see Kn 63.

54 Letter from Kollwitz to Lehrs, 6 March 1903, BSB, Ana 538 Kollwitz, Käthe.

55 Letter from Lehrs to Kollwitz, 22 January 1917, SKD archive, 01/KK 04 vol. 22, nos. 53–54.

56 In 1906 he recorded 47 works for the collection there, 22 of them gifts from the artist, twelve anonymously donated; see Berlin 1995, p. 10.

57 On Sievers see Berlin 1995, p. 19, fn. 21. Between 1909 and 1913, 99 works were inventoried, 73 as gifts, mainly anonymous.

58 See Sievers 1913.

59 See the letter from Lehrs to Kollwitz, 21 October 1910, SKD archive, 01/KK 04 vol. 15, nos. 398–400.

60 Letter, 22 January 1917 (see note 55 above).

61 Ibid.

62 Kollwitz's interest in printmaking had diminished between 1913 and 1918 as a result of intensified experimentation with sculpture; see on her sculpture Seeler 2016.

63 Kollwitz had seen woodcuts by Ernst Barlach in June 1920 in an exhibition at the Berlin Secession; see Kollwitz 2012, p. 476.

64 Letter from Kollwitz to Lehrs, 3 August 1920, SKD archive, 01/KK 04 vol. 24, nos. 162–63.

65 Letter from Lehrs to Kollwitz, 6 August 1920, SKD archive, 01/KK 04 vol. 24, no. 164.

66 Postcard from Kollwitz to Lehrs, 22 January 1921, SKD archive, 01/KK 04 vol. 25, no. 64. In point of fact, the first woodcut Käthe Kollwitz made was *Two dead persons*, completed before July 1920; see Kn 158.

67 Postcard, 22 January 1921 (see footnote 66).

68 Letter from Lehrs to Kollwitz, 17 February 1921, SKD archive, 01/KK 04 vol. 25, no. 67.

69 Lehrs 1921, p. 1.

70 Letter from Lehrs to Kollwitz, 28 October 1921, SKD archive, 01/KK 04 vol. 25, no. 256.

71 Ibid.

72 Lehrs 1903, p. 60.

73 Ibid.

74 Lehrs 1922, p. 2.

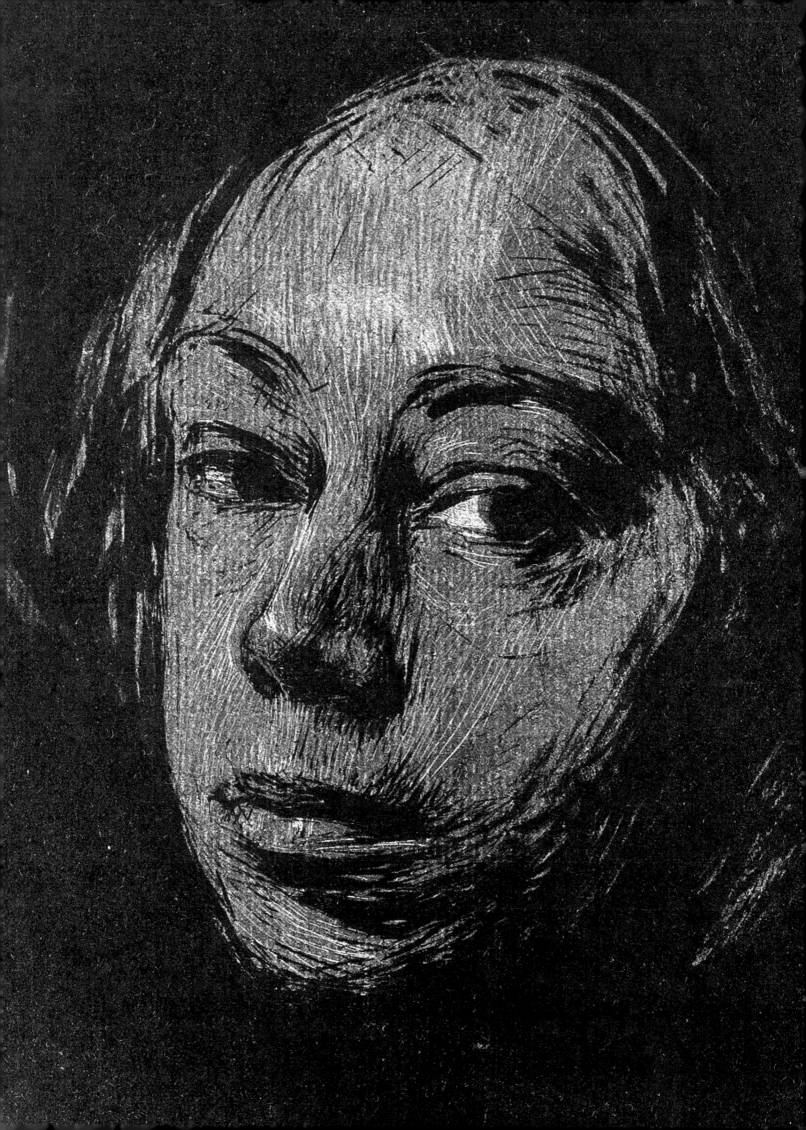

"I want to be true, genuine and undyed":[1]
The self-portraits of Käthe Kollwitz

HANNELORE FISCHER

Käthe Kollwitz's work includes over one hundred self-portraits – in the form of drawings, prints and sculptures. Whether in pen and ink, charcoal and crayon, as etching, lithograph or woodcut, in stone or in bronze, they play a significant role in her creative output. The first self-portraits were done during her studies in Munich, the last in 1940 after the death of her husband Karl. This "visual form of a conversation with herself"[2] grants us intimate insights into all the phases of her life and work and illustrates her masterful abilities in drawing, printmaking and sculpture.

Kollwitz's self-portraits are mirror images of her soul and document the artist's constant and intense self-interrogation. They are among the works she saw as intertwined with her "most personal life".[3]

Two early pen-and-ink drawings from around 1889, when she completed her two-year course of studies in painting with Ludwig Herterich at the Münchner Künstlerinnenschule (Munich School for Women Artists), show that she took up the theme quite early (cat. 1 and 53). In the first, she confidently presents herself standing in front of an easel, her hand on her lapel, a pose more familiar in male artists. The drawing is signed with her maiden name, Schmidt, and already reveals her extraordinary talent. The second sheet is a demonstrative close-up, hinting at Kollwitz's exploration of etching, begun in 1890. "I've started etching and to that end have done a mass of preparatory exercises in pen,"[4] she wrote to a friend in 1891. Practical aspects underlie her choice of artistic

media: her marriage to Karl Kollwitz was approaching, and the move to Berlin meant tight living quarters and initially no money for a studio – but she could draw in the smallest of spaces.[5]

With the presentation of *A Weavers' Revolt* at the 'Große Berliner Kunstausstellung' in 1898 Kollwitz became suddenly well known and was encouraged not only by Max Lehrs but also by her colleague the painter Max Liebermann. Her becoming a member of the Berlin Secession opened up numerous exhibition opportunities in Germany and abroad and contacts with other members such as Théophile-Alexandre Steinlen and Auguste Rodin.

Under the influence of her first trip to Paris in 1901, one of her extremely rare coloured self-portraits was completed (cat. 6), a pen and brush lithograph. This experimental sheet was never printed as an edition, and exists only in proofs of the various states. Two of them are held at the Kupferstich-Kabinett – fine examples of Max Lehrs's admirable acquisition policies. For her face, emerging from the dark, the artist created lights using various tools to scratch away areas from the brown tone stone.

Another self-portrait, probably done during her second stay in Paris in 1904, a crayon and brush lithograph in three or four colours, documents her increasing interest in sculpture (fig. 34).[6] Its pronounced modelling of form can be regarded as a first step towards working in three dimensions, since during her two-month study abroad in the French capital Kollwitz

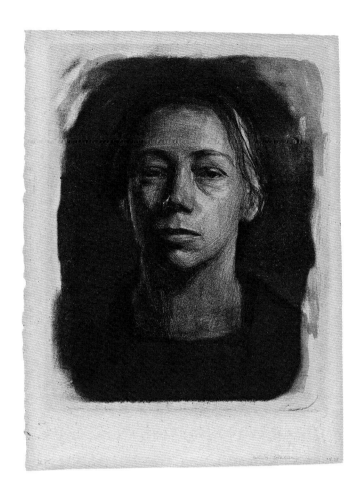

FIG. 34
Käthe Kollwitz, *Self-portrait en face*, c. 1904,
crayon and brush lithograph in four
colours with spraying, on grey cardboard,
440 × 334 mm (image), 535 × 395 mm (sheet),
Käthe Kollwitz Museum Köln (Cologne),
inv. no. 70300/0500601

into the mirror. The softness of the charcoal in contrast with the heavy shadowing achieved by illumination from the lower left creates a sensuous impression seldom found elsewhere in her work.

In the etching, her tendency to emphasize the effects of aging on her facial features is already emerging. Tired, her eyes shadowed by deep rings, looking critically in the mirror with a hint at her white hair, at the age of 44 the artist looks significantly older than she is in the 1911 *Frontal self- portrait* (cat. 60) or a similar composition from the same period (fig. 36).[10] She depicts herself here just as she often portrayed the working-class women from her neighbourhood, whose faces were marked by hard work, birthing and many deprivations. This physiognomic assimilation can be interpreted as empathy and identification with these women who modelled for her, but also as an expression of her own psychological sensitivities. Her "self images", as she often called them, testify to an honest self-interrogation that refrained from any idealization of her own face. This is how her prominent facial features appear not only in the explicit self-portraits, but also in the so-called 'secret' ones. Again and again, Kollwitz returned to herself as model, slipped into roles and turned up in the most various scenes, sometimes only recognizable at second glance. In the course of her artistic creation she generalized her features. She expanded the undeclared self-portraits to represent a general female type – especially when she fully identified with the theme she was working on (figs. 37 and 38).[11]

In the 1910s, Käthe Kollwitz's interest in sculpture developed to the point that she wanted to bring to an end her work in print media and continue only as a sculptor. This is apparent in her drawings as well, such as her charcoal portraits (cat. 60). "The smearing of the charcoal line plays a significant role in the drawings of Kollwitz. It serves to correct the lines but also helps to

attended the Académie Julian in order to learn the basics of sculpture.

Following the highly complex etching series *The Peasants' War*,[7] finished in 1908, in which she used from five to seven intaglio techniques, one of her best known self-portraits (cat. 7),[8] scored into the soft ground of a copper plate, seems by contrast a mere finger exercise. Calm and concentrated, the artist regards herself in a mirror. She supports her head in her hand – a recurring pose in her self-portraits and described by family, friends and colleagues as typical of her. She often assumed this pose for photographic portraits as well (see fig. 1, p. 12).

As in many self-portraits, here too Kollwitz varied the interaction of head and hand. The gesture of her spread fingers supporting her high forehead and shadowing her right eye, in its chiarsoscuro effects, reflects the artist's brooding absorption. A moment of concentrated attention is depicted, repeated in a charcoal drawing dating to approximately the same period (fig. 35).[9] Her right hand supports her head as Kollwitz stares intently

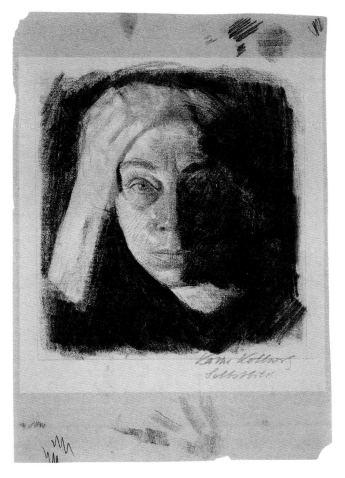

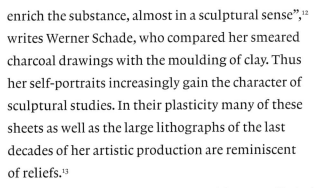

FIG. 35
Käthe Kollwitz, *Self-portrait, en face*, c. 1910,
charcoal on grey-blue hand-made Ingres
paper, 285 × 260 mm, Käthe Kollwitz Museum
Köln (Cologne), inv. no. 70200/9501601

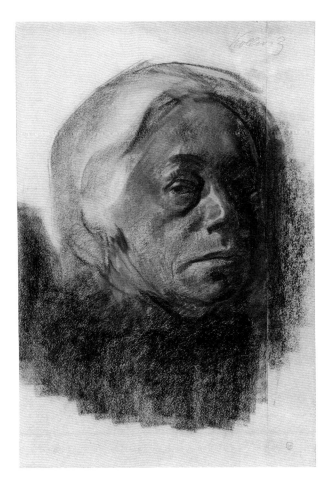

FIG. 36
Käthe Kollwitz, *Self-portrait*, c. 1911, charcoal
and black crayon, smeared and heightened
in white on brown paper, 406 × 276 mm,
Käthe Kollwitz Museum Köln (Cologne),
inv. no. 70200/9400801

enrich the substance, almost in a sculptural sense",[12] writes Werner Schade, who compared her smeared charcoal drawings with the moulding of clay. Thus her self-portraits increasingly gain the character of sculptural studies. In their plasticity many of these sheets as well as the large lithographs of the last decades of her artistic production are reminiscent of reliefs.[13]

At the beginning of the First World War, Kollwitz's eighteen-year-old younger son, Peter, was the first of his regiment to be killed in battle. He had volunteered for service. In her diary she summarized the consequences of this twist of fate: "From that moment I began to be old. The approach to the grave. That was the break. Bending to such a degree that standing up straight is no longer possible."[14] From her pain at the early death of her son, a quiet thoughtfulness emerges, depicted expressively in her self-portraits, as in her 1922–23 woodcut *Frontal self-portrait* (cat. 9). Her silent grief over the loss makes the artist's gaze appear tired and weary. The sheet displays a much greater abundance and variety of line than her earlier woodcuts. Some lines approximate etching, for example the cross-hatched areas on the right side of her nose. She foregoes contouring on the left side of her face and allows the lines following the grain of the wood to taper off into the material, without precisely defining the borders. With broad, soft cuts she indicates the strands of hair framing her face. Some time had passed since the end of the War when she was working on this sheet, but the exploration and processing of her experience would continue for many years.

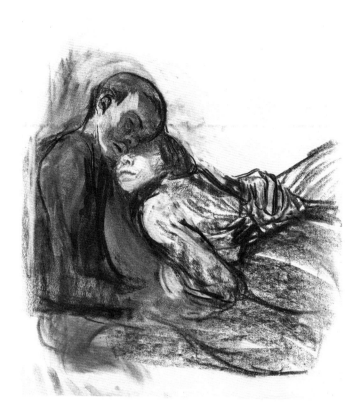

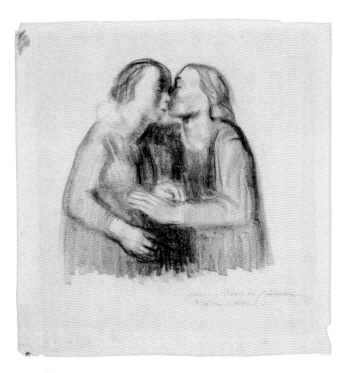

In the years of the Weimar Republic Kollwitz increasingly became a public figure. She was involved in numerous associations such as the Internationale Arbeiterhilfe (International Workers' Relief) or the League for Human Rights, where she met Albert Einstein, with whom she maintained friendly contact.

Kollwitz's sixtieth birthday in 1927 was the occasion of numerous honours, demonstrating that she enjoyed prestige far beyond art circles. This was the year she completed her *Self-portrait in profile* (cat. 11). While in her younger years the artist still consulted her own image as a form of self-reflection and self-assertion, as her experience of life expanded her desire grew to represent her personality concisely and to explore human experience on the basis of the events of her own life. Corresponding to this principle of 'essentialism', Kollwitz developed a repertoire of styles and themes with which to formulate basic assertions about life both in her personal and in her more generalized self-portraits.

This survey of self-portraits concludes with a lithograph from 1934 (cat. 12), encompassing forty-five years in the artist's life. The crayon and brush drawing transferred on to lithographic stone was made during a time of great hardship. In Kollwitz's later self-portraits her own fate recedes in favour of a generalizing impulse that allows the viewer a stronger identification with the image. In the face of the fascist threat, this portrait possesses a very particular poignancy. In an unusually close frame, she presents her face in a pensive expression. Despite the extreme close-up, the self-portrait seems reserved, the eyes as 'windows to the soul' appear almost closed. The empty gaze, directed inward, testifies to her constant exploration of aging and death and her forced resignation from the Preußische Akademie der Künste (Prussian Academy of Arts) in February 1934, which also

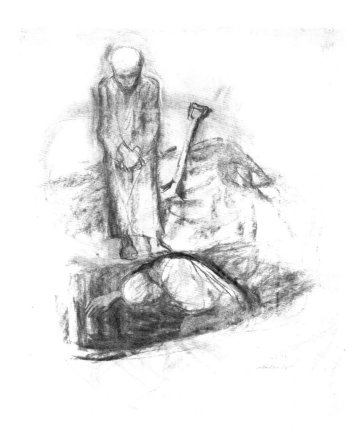

FIG. 39
Käthe Kollwitz, *There I stand digging my own grave*, 1943 (?), charcoal on cardboard, 580 × 450 mm, Käthe Kollwitz Museum Köln (Cologne), inv. no. 70200/8306201

"It is hard for me to get used to the idea that I, whose participation was once considered an honour, now have to remain silent"[16] and "*Such* silence around me. – All this has to be faced!",[17] she remarked, also in 1936.

In November 1943 Kollwitz's Berlin apartment on Weißenburger Street was destroyed by an air raid – she had lived there 51 years. Many of her works, among them all the early paintings and numerous drawings, were lost. Many works on paper, however, were saved from the apartment by the family and were viewed and signed by her from her refuge in Nordhausen.

Kollwitz wrote to her son Hans about this in December 1943: "Everything bearing my 'handwriting' and vitally linked to my life I would like to know to have been preserved …. It is similar to something that has often been said to me: Why do you make such large editions of your prints? … And to that I say: Because I would like to work for a large public."[18]

For the final months of the War she found two rooms in Rüdenhof with a view of the Moritzburg castle that Prince Ernst Heinrich von Sachsen had made available to her. There she died three weeks before the end of the war, on 22 April 1945. What was presumably her last drawing is another self-portrait, dated 1943 by another hand, with the title *There I stand digging my own grave* (fig. 39).[19]

left its mark. "One keeps silent inside oneself,"[15] she wrote in her diary in 1936.

Kollwitz's life took a dramatic turn during the period of National Socialism. She was not among the artists whose work was shown at the exhibition 'Degenerate Art' in 1937 – for that she had become too famous and internationally respected – but her pieces were repeatedly removed from exhibitions or exchanged at the instigation of the Reichskulturkammer (Ministry of Culture). The fact that she did not emigrate, but remained at the centre of the horror, earned her Ernst Barlach's greatest respect.

NOTES

1 Entry of 26 December 1914; Kollwitz 2012, p. 180.
2 Jutta Bohnke-Kollwitz in her introduction to the artist's Diaries: Kollwitz 2012, p. 9.
3 Letter from Kollwitz to Hans Kollwitz, 1 May 1917: Bohnke-Kollwitz 1992, p. 152.
4 Letter from Kollwitz to Paul Hey, 26 February 189: Kollwitz 1966, p. 20.
5 See cat. 3, 4, 36 and 62.

6 Kn 85 II A.
7 See pp. 32–35 in the present volume.
8 Kn 109.
9 N/T 688.
10 N/T 690 and 691.
11 N/T 559 and 1134.
12 Schade 1995, p. 25.
13 See ibid. p. 29.
14 Entry of 12 October 1917: Kollwitz 2012, p. 334.

15 Entry of November 1936: ibid., p. 687.
16 Letter from Kollwitz to Anni Karbe, 13 February 1937: Kollwitz 1981, p. 118.
17 Entry of November 1936: Kollwitz 2012, p. 687.
18 Letter from Kollwitz to Hans Kollwitz, 10 December 1943: Bohnke-Kollwitz 1992, p. 228.
19 N/T 1286.

Chronology

1867
Käthe Kollwitz is born as Käthe Schmidt on 8 July in the Prussian city of Königsberg (today Kaliningrad, Russia).

1881–1886
Her father recognizes his daughter's talent; from age fourteen, she has private drawing lessons with the engraver Rudolf Mauer and the painter Gustav Naujok in Königsberg.

1 April 1883
At twenty-eight years of age, Max Lehrs (1855–1938) becomes Karl Woermann's assistant at the Dresden Kupferstich-Kabinett.

1886–1890
In 1886 Kollwitz studies at the Berliner Künstlerinnenschule (Berlin School for Women Artists) with Karl Stauffer-Bern. In 1887, she takes private lessons in Königsberg from the painter Emil Neide. From 1880 to 1890 she attends Ludwig Herterich's painting classes at the Münchner Künstlerinnenschule (Munich School for Women Artists).

1890
After finishing her studies in Munich, she returns to Königsberg, where she learns etching techniques from Rudolf Mauer and first takes the working classes as the subject of her art.

1891
She marries Karl Kollwitz, a doctor, and moves to Weißenburger Straße in the working-class neighbourhood of Prenzlauer Berg in Berlin.

Reading Max Klinger's theoretical essay *Malerei und Zeichnung* (Painting and Drawing), which calls for a new aesthetic assessment of *Griffelkunst* ('Stylus Art'), encourages Kollwitz in her shift towards etching. On the basis of earlier drawing already made she starts work on etchings inspired by Emile Zola's novel *Germinal*.

1892
Birth of Kollwitz's first son, Hans.

1893
Unofficial debut of Gerhart Hauptmann's *Die Weber* (The Weavers) in Berlin. The play motivates Kollwitz to start work on the cycle *A Weavers' Revolt*.

1 April 1896
Max Lehrs becomes Director of the Dresden Kupferstich-Kabinett.

1896
Kollwitz's second son, Peter, is born. She completes first lithographs.

1897
She finishes the cycle *A Weavers' Revolt*.

1898
She achieves breakthrough with *A Weavers' Revolt* at the 'Große Berliner Kunstausstellung'. Though recommended by the jury, whose members included Adolph von Menzel and Max Liebermann, Kollwitz is denied a gold medal by Emperor Wilhelm II. She attracts the attention of the chief councillor at the head office of Dresden's Königliche Sammlungen für Kunst und Wissenschaft (Royal Collections of Art and Science), Woldemar von Seidlitz, who encourages Max Lehrs to contact the artist. Written correspondence begins between Lehrs and Kollwitz on 8 June 1898.

The June acquisition by the Dresden Museum of *A Weavers' Revolt* and some earlier sheets is the first purchase of her graphic work by a public collection.

1899
At the instigation of Lehrs, Kollwitz is awarded a small golden plaque at the 'Große Kunstausstellung Dresden'. In Berlin, two of Kollwitz's etchings appear in the first exhibition of the Berlin Secession.

1898–1903
Kollwitz is awarded a lectureship in drawing and graphic printing techniques at the Berliner Künstlerinnenschule (Berlin School for Women Artists).

1899–1902
Continuous acquisitions by the Dresden Kupferstich-Kabinett; by 1902, a total of 85 sheets has been purchased.

1901
Kollwitz is accepted into the Berlin Secession and remains a member until 1913. On the recommendation of Lehrs, her prints are shown at the 'Internationale Kunstausstellung' in Dresden.

Wilhelm Zimmermann's book *Der große deutsche Bauernkrieg* (The History of the German Peasants' War) animates Kollwitz to begin exploring this historical material.

She makes a short trip to Paris. The use of colour in French graphics inspires her to make her own experiments in this direction.

Lehrs's essay 'Käthe Kollwitz' appears in the Berlin magazine *Die Zukunft* (The Future).

July 1902
Kollwitz's graphic work appears in the 'New Acquisitions' exhibition of the Kupferstich-Kabinett together with the work of other artists.

1903
Lehrs publishes the first catalogue raisonné of the artist's graphic oeuvre in the Viennese journal *Die Graphischen Künste* (The Graphic Arts).

1904
At the thirtieth general meeting of the Verbindung für historische Kunst (Association for Historic Art) in Dresden, *The Peasants' War* is commissioned from Kollwitz by the members (completion by 1908).

She participates in the 'Große Kunst-ausstellung' in Dresden, with Lehrs's support.

Kollwitz spends two months in Paris and studies sculpture, among other things, at the Académie Julian.

1907
Kollwitz receives the Villa Romana Prize, established by Max Klinger, enabling her to spend several months in Florence.

1905–08
In January 1905 Lehrs becomes Director of the Berlin Kupferstichkabinett, where he continues acquiring Kollwitz's graphic work for the museum there, from 1906. On 1 July 1908 he returns to his previous post as Director in Dresden.

1908–10
Kollwitz contributes a total of fourteen prints to the weekly political satirical magazine *Simplicissimus*. Her first sculptures date from 1909.

March 1911
She is prominently represented in the 'Neuerwerbungsausstellung' at the Kupferstich-Kabinett, with numerous new etchings and lithographs.

1913
Co-founder of the Frauenkunstverband (Women's Art Association), of which she is a member until 1923.

1914
Kollwitz's son Peter, who had volunteered for the Army, is killed in Flanders at eighteen years of age. Her first plans for a memorial for her son (not completed until 1932 with the erection of *The Mourning Parents* at the military cemetery Roggevelde near Diksmuide).

Kollwitz becomes a member of the board of the Freie Secession, an offshoot of the Berlin Secession.

1917
On her fiftieth birthday, Kollwitz is honoured in many ways. In Dresden, as part of its annual sales in Lennéstraße, the Künstlervereinigung (Artists' Association) presents an exhibition of her drawings collected by the Galerie Paul Cassirer and shown previously in Berlin and Königsberg. The Kupferstich-Kabinett dedicates a room to the artist in its 'Neuerwerbungsausstellung' of August–September and subsequently gives her a solo exhibition in its 'Vierteljahresausstellung' (Quarterly Exhibition).

1918–22
Work continues on the cycle *War*.

1919
Kollwitz becomes the first female member of the Preußische Akademie der Künste (Prussian Academy of Arts) in Berlin and at the same time Professor of Printmaking.

1920
Influenced by Ernst Barlach, Kollwitz works in woodcut for the first time; among her woodcut projects is *In Memoriam Karl Liebknecht*.

July 1921
Numerous prints by Kollwitz are presented in the 'Neuerwerbungsausstellung' at the Kupferstich-Kabinett.

1922
Her prints are shown in the February 'New Acquisitions' exhibition at the Kupferstich-Kabinett; exhibition of Kollwitz self-portraits in December.

1923
Max Lehrs retires from the directorship of the Kupferstich-Kabinett; he continues to correspond with Kollwitz privately.

1929
Kollwitz is the first woman to receive the *Pour le mérite* order for arts and sciences.

April 1931
Seven lithographs are on display in the 'New Acquisitions' exhibition at the Kupferstich-Kabinett.

1933
As a result of her support for the manifesto 'Urgent Call for Unity' in favour of merging the Social Democratic Party and the Communist Party of Germany to prevent an election victory for the National Socialists, Käthe Kollwitz is forced to resign from the Preußische Akademie der Künste.

1934
Work begins on the series *Death*.

12 November 1938
Max Lehrs dies.

1940
Karl Kollwitz dies.

1943
Käthe Kollwitz is evacuated from Berlin to Nordhausen in the Harz; her apartment in Berlin is destroyed in an air raid.

1945
On 22 April she dies at Rüdenhof in Moritzburg near Dresden, where she had moved the previous year at the invitation of Prince Ernst Heinrich of Saxony.

1960
Exhibition of the Kollwitz collection of the Kupferstich-Kabinett after the return of its holdings from the Soviet Union. Seventy-five sheets, among them ten drawings, are considered casualties of war.

1989
At its re-opening, the Käthe Kollwitz Museum Köln (Cologne) presents the Dresden Kollwitz collection. A catalogue prepared by Werner Schmidt, Director of the Dresden Kupferstich-Kabinett from 1959, is published.

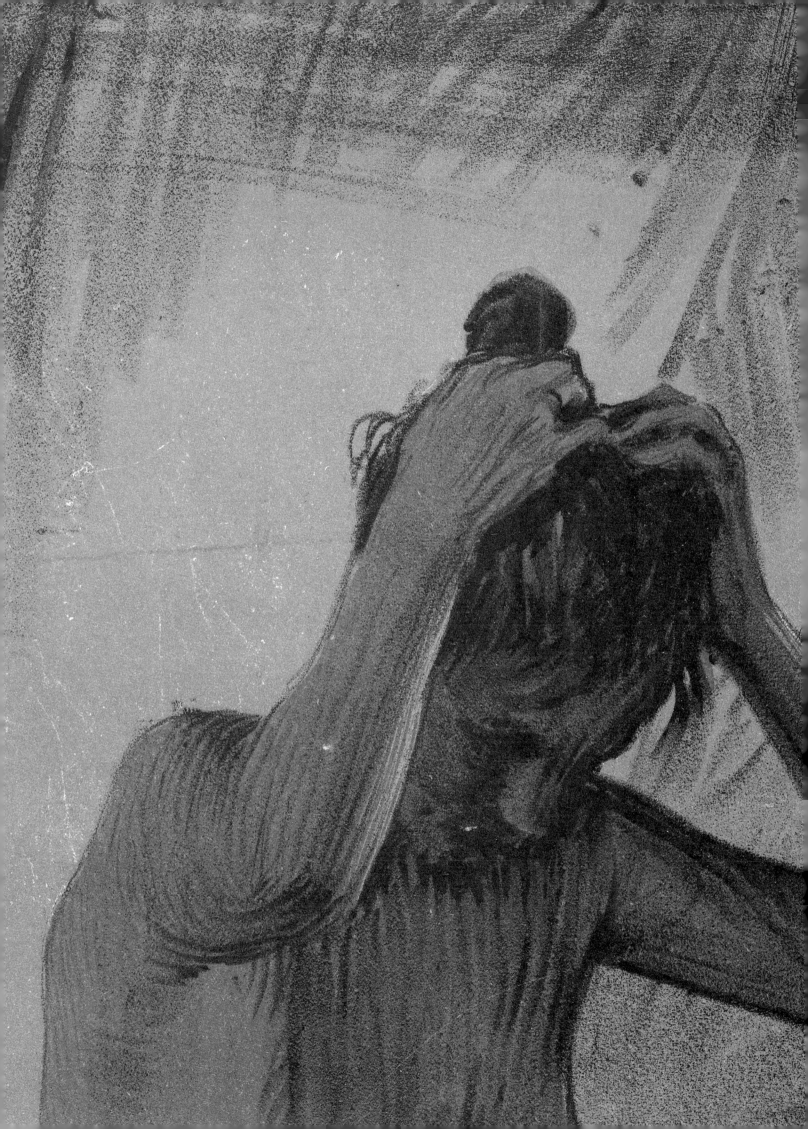

Catalogue

AGNES MATTHIAS

NOTE TO THE CATALOGUE

The dimensions of sheets are given in millimetres, height before width. Titles, dates and information on the technique used in the prints follow the catalogue raisonné by Alexandra von dem Knesebeck, with few exceptions. Information on the drawings comes predominantly from the catalogue raisonné of Kollwitz's drawings by Otto Nagel and Werner Timm; occasionally, titles and dates have been modified. The abbreviations 'Kn' and 'N/T', with the corresponding catalogue number, refer to the publications mentioned above (for which see the bibliography).

Inscriptions on the sheets are included regardless of who wrote them, but those of no relevance here have not been reported.

Within the thematic groupings the entries are arranged in general chronologically.

Staatliche Kunstsammlungen Dresden has been abbreviated as SKD.

An explanation of the techniques Kollwitz used for her prints, as described in the catalogue, is given in a glossary, pp. 169–70.

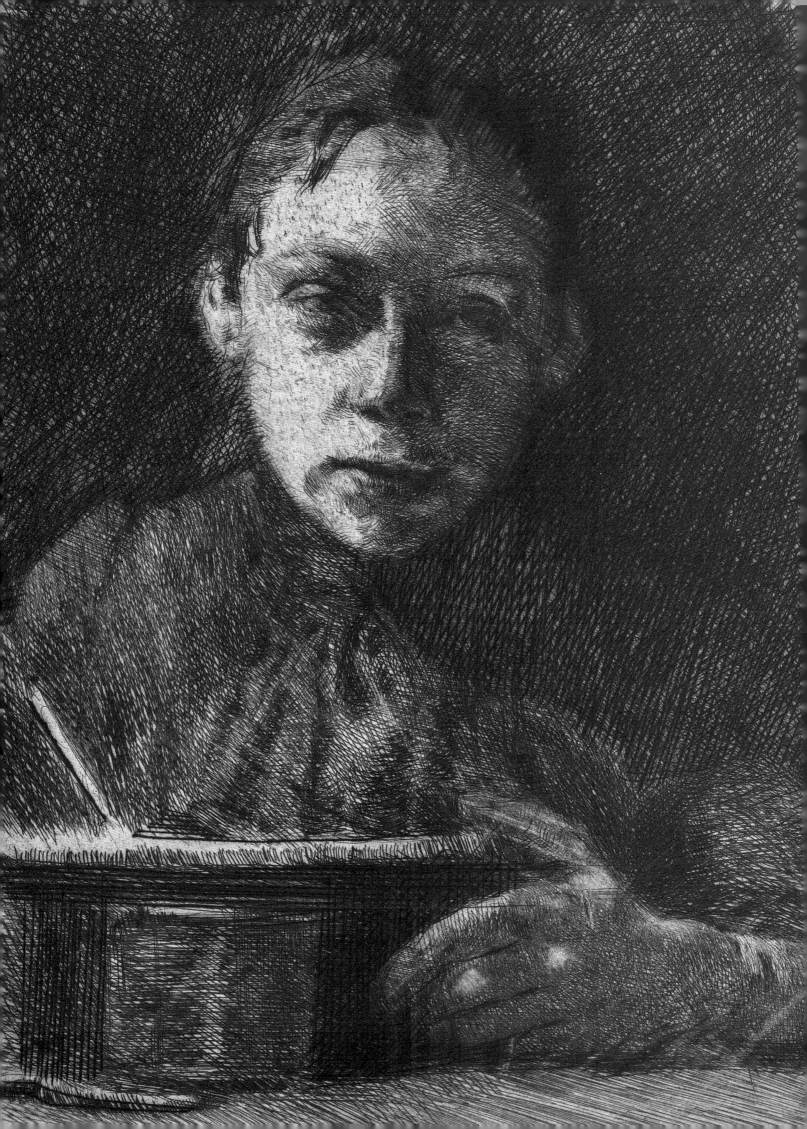

I. Self-portraits

As a medium for self-inquiry, but also for the communication of her own image to others, the self-portrait is a central theme in Käthe Kollwitz's creative work. More than a hundred distinct self-portraits are known, produced over a period of around fifty years. The earliest date from her student years in Munich, beginning in 1888; the last was completed in 1943. Here, key works from all three phases of her intense exploration of this subject are presented – from her early works, up until 1893; from the time of her achieving recognition after 1898; and the years of the Weimar Republic.[1]

The artist drew her face in pen and pencil, in charcoal and chalk, on paper or on lithographic stone, or scored her distinctive features into the etching plate with a needle, or carved them into the woodblock with a knife. In her sheets she unites autobiography, for example representing her grief over her son's death in the First World War, with strictly artistic curiosity, as in the modelling of her face through light and shadow (cat. 2 and 6).

Aside from a few half-figure or head-and-shoulders representations, portraits of her face and head dominate, with a focus on expression and mood. A recurring element is the hand, which holds an etching needle, as in the early, programmatic *Self-portrait at a drawing board* (cat. 4), is laid on her breast in a gesture of self-assurance (cat. 3), or supports her head in a contemplative posture (cat. 7). The gaze, mainly frontal, meeting the observer directly, is at the same time turned inward: the mirror, serving as an aid, reflects it back again and again at the artist herself in the act of drawing or etching.

This exploration of her own physiognomy undertaken by Kollwitz as a form of constant, critical self-reflection had also fascinated Max Lehrs. In December 1922 he presented a selection of self-portraits of the then 55-year-old artist in a room dedicated to their display, commenting: "It is of exceeding interest to follow the features of this unique person from her youth until today, as her hair, faded by an abundance of experience, surrounds her distinctive head with its solemn, compassionate eyes like a halo".[2]

Cat. 4 (detail)

1

Self-portrait, 1889

Pen and black ink and brown wash on
Bristol board, 312 × 242 mm
Signed and dated upper right in black:
Schmidt / 1889 (date partially cut off)
Purchased from the Kollwitz family estate,
2000
Käthe Kollwitz Museum Köln (Cologne),
inv. no. 70200/00013
N/T 12

Signed with her maiden name, Schmidt, this is among the artist's
earliest self-portraits. The position of the head in three-quarter
profile corresponds with the somewhat later Dresden pen drawing
(cat. 53), though in the present sheet she has chosen a broader view.
The character of the line is also different. The face and hand, the
latter guided to the breast, were drawn in pen in short, hatched
lines, the upper body and the surrounding space with wide
brushstrokes of brown wash. At the time, Kollwitz was still attending
the painting class taught by Ludwig Herterich at the Münchner
Künstlerinnenschule (Munich School for Women Artists); thus the
light rectangle in the background on the left may represent
an easel.

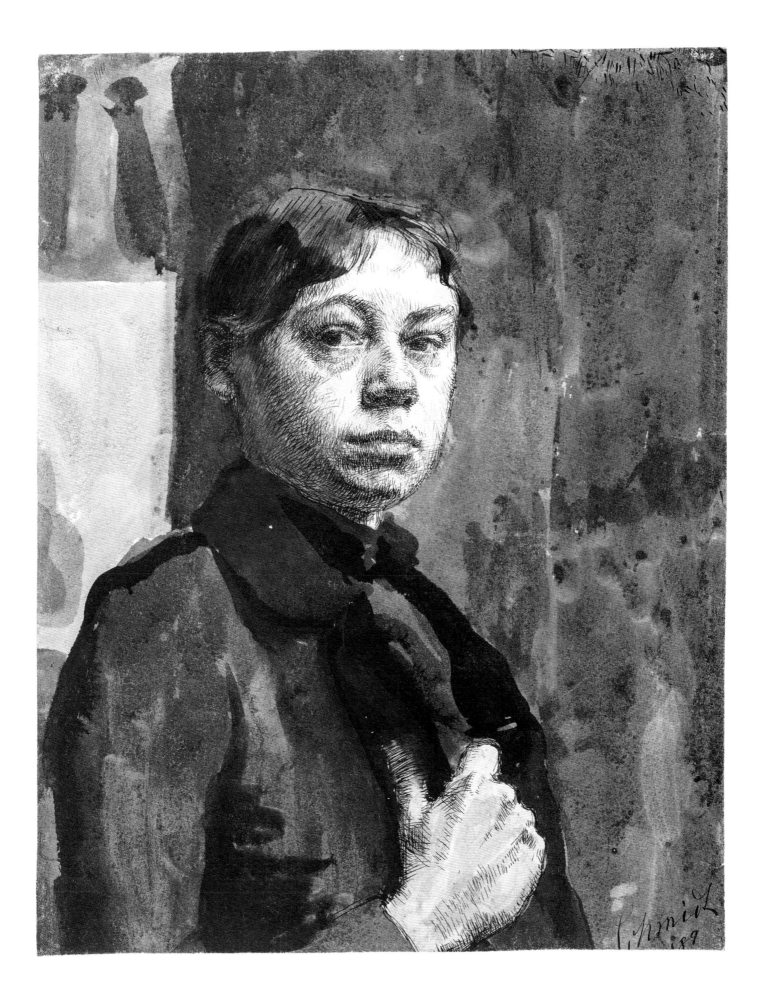

2

Two self-portraits, c.1891–92

Pen and black ink, with some wash, on yellow-
grey hand-made paper, 415 × 304 mm
Purchased from Galerie Ernst Arnold,
Dresden, on the occasion of the 'Große
Berliner Kunstausstellung', 1906
Staatliche Museen zu Berlin,
Kupferstichkabinett, inv. no. F 910
[Kollwitz SZ 6]
N/T 30

This pen-and-ink drawing, in the Berlin Kupferstichkabinett since
1906, illustrated the first catalogue of Kollwitz's graphic work,
compiled by Max Lehrs and published in the magazine *Die Graphischen
Künste* in 1903.[3] It is precisely the fragmentary character of the study that
demonstrates the artist's talent for drawing: she models the bust and
the head supported by the hand with sparingly placed parallel and cross
hatching, using the brush to create forceful accents.

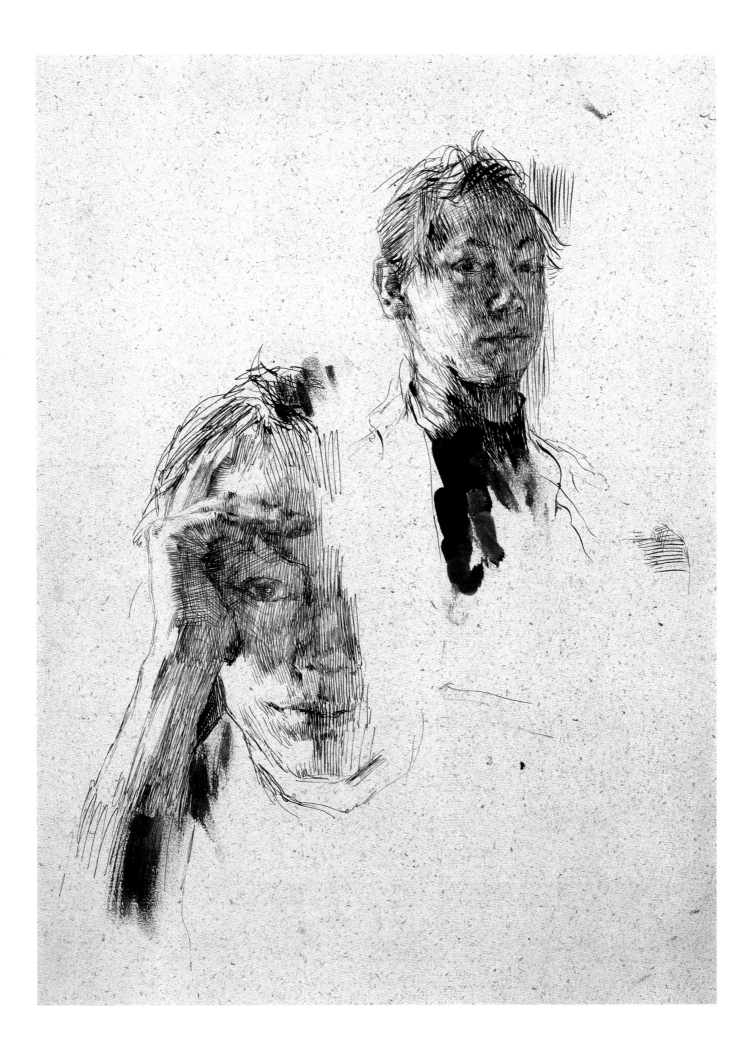

3

Two self-portraits, 1892

One of three prints
Etching, drypoint and emery in black ink on
white China paper, mounted on copperplate
paper, 348 × 149 mm (plate), 389 × 233 mm
(sheet)
Inscribed lower left in reverse in the plate: *1 /
2 / 3 / 4 / 5 / zu 3* [?] / *6. 5 ½ min.* (the numbers of
minutes probably refer to the length of time
the plate may be exposed to the mordant)
Purchased from the artist by Woldemar
von Seidlitz, Dresden, for the Kupferstich-
Kabinett, 1899
Kupferstich-Kabinett, SKD, inv. no. A 1899-162
Kn 12

Test strokes and numbered trials using
marks made with emery accompany
the two self-portraits on the plate, as
the artist explores the different effects
of various graphic instruments under
different conditions. This early sheet,
one of the first acquired by the Dresden
Kupferstich-Kabinett, already makes
manifest her effortless manipulation of
the etching needle. In the three-quarter-
length portrait, Kollwitz depicts herself
shortly before the birth of her son Hans.
The lower, fragmentary image shows her
adopting a characteristic pensive position
with her head supported by her hand.

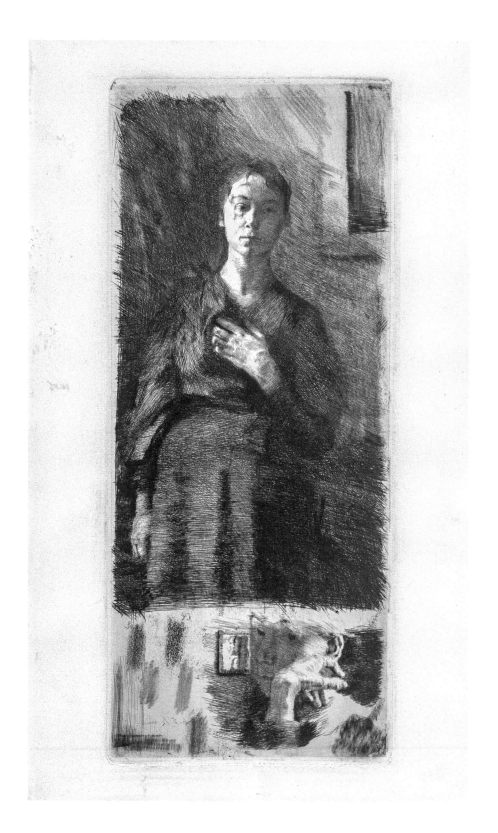

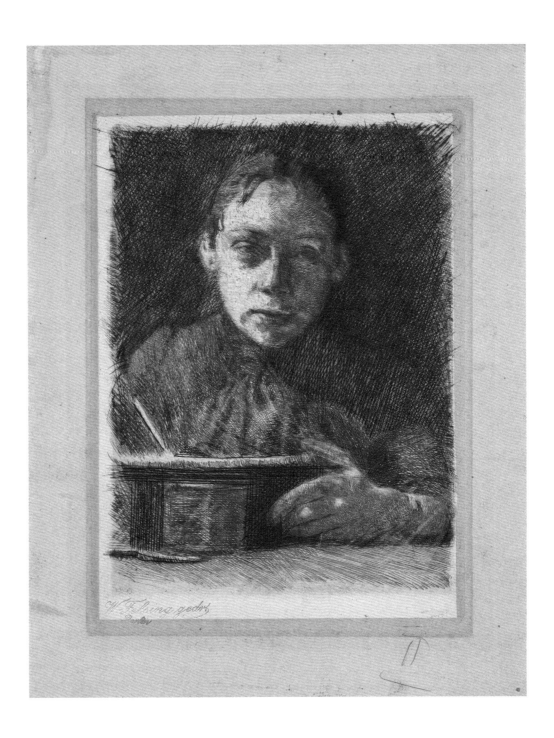

4

Self-portrait at a drawing board, 1893 (?)

Second state
Etching and drypoint in black ink on white
China paper, mounted on copperplate paper,
150 × 111 mm (plate), 188 × 149 mm (sheet)
Inscribed lower right in pencil: *II*; lower left
beneath the image, embossed seal: *W. Felsing
gedr.* [printed] / *Berlin*[4]
Purchased from the artist, 1902
Kupferstich-Kabinett, SKD, inv. no. A 1902-826
Kn 22 II

This programmatic early self-portrait reprises Rembrandt
van Rijn's *Self-portrait drawing at a window,* dated c. 1648.[5]
Kollwitz poses as an artist with an etching needle in her hand.
The concentrated, slightly questioning expression with which
she looks up from her work at the printing plate is underscored
masterfully by the light falling from the side.

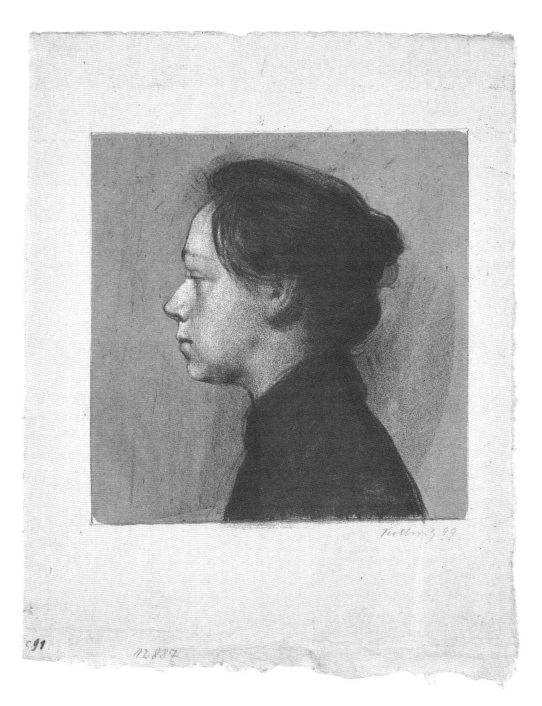

5

Self-portrait in profile to the left, January 1899

Third state, presumed unique
Crayon and brush lithograph in three
colours of stone, light brown, dark brown and
orange-brown, on hand-made Japan paper,
150 × 150 mm (image), 242/251 × 196 mm (sheet)
Signed and dated lower right under the image
in pencil: *Kollwitz 99*
Purchased from a private collection, Dresden,
1954
Kupferstich-Kabinett, SKD, inv. no. A 1954-19
Kn 44 III

The Kupferstich-Kabinett owns three versions of this lithograph self-portrait in profile. The first state, in which only the face and ear appear, in lithographic crayon, is documented in two sheets purchased or donated in 1902, one of them printed in brown, the other in black.[6] The third state, not purchased until 1954, is presumed unique. In addition to the supplementary orange-coloured tone already used for the second state, here Kollwitz employs a third stone in dark brown for the face, hair and high-necked blouse.

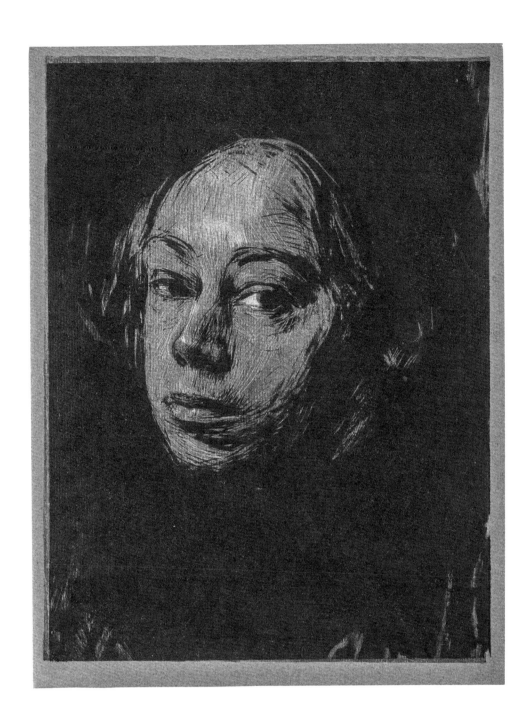

6

Self-portrait in three-quarters profile to the left, 1901

Fourth state
Brush-and-pen lithograph with the use of
scraper and scraping needle on black drawing
stone and brown tone stone with scraped-in
lights, on light-blue smooth ribbed hand-
made paper, 271 × 205 mm (stone),
287 × 218 mm (sheet)
Purchased from the artist, 1901
Kupferstich-Kabinett, SKD, inv. no. A 1901-795
Kn 52 IV

In this three-quarter-view self-portrait, Kollwitz concentrates
fully on the depiction of the head, surrounded in black with
no hint of neck or upper body. The effect of the scraper and
scraping needle recalls the flickering flame of a candle whose
light falls on the face, movingly composed with multiple pen-
strokes and a few brushstrokes. Unlike the second copy of this
fourth state, which also reached the Kupferstich-Kabinett in
1901, here an additional tone stone was used.[7]

7

Self-portrait, hand on forehead, before mid June 1910 (?)

Second state
Etching, drypoint, a few etched spots
seemingly made with emery, in black ink on
copperplate paper, 155 × 138 mm (plate),
447 × 315 mm (sheet)
Signed lower right below the image in pencil:
Käthe Kollwitz; inscribed in pencil lower left
below the image: *OFelsing Berlin gedr.* [printed],
and lower left: *84*, and lower right: *1*
Purchased from a private collection, Dresden,
1954
Kupferstich-Kabinett, SKD, inv. no. A 1954-21
Kn 109 II c

Art historians typically interpret this self-portrait, characterized
by its contemplative expression, in the context of the artist's
'melancholy self-portrayal',[8] which is already found in her early
work. The head resting on the hand is reminiscent of the position
of the allegorical figure of Melancholy in Albrecht Dürer's 1514
copperplate engraving *Melencolia I*. The work may reflect a creative
crisis described in her diary by the artist when 43 years old, and a
period of coming to terms with her aging.[9]

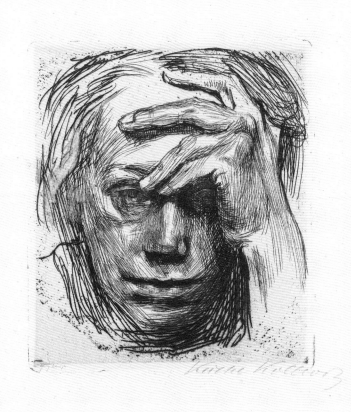

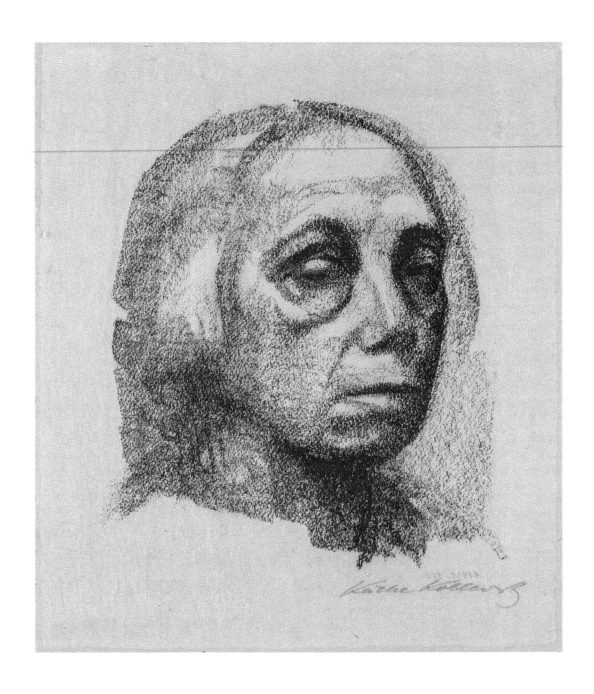

8

Small self-portrait, 1920

First state, as published by Emil Richter, 1920
Black crayon lithograph (transfer from a
drawing on copperplate paper) on very thin
hand-made Japan paper, 233 × 208 mm (image),
301 × 267 mm (sheet)
Signed lower right below image in pencil: *Käthe
Kollwitz*
Purchased from the artist and donated to the
Kupferstich-Kabinett by Amélie Aulhorn,
Dresden, 1920
Kupferstich-Kabinett, SKD, inv. no. A 1920-590
Kn 162 I b

The artist, then 53 or 54 years old, did not draw this self-portrait
directly on the lithographic stone, but rather on a sheet of
copperplate paper, which was then transferred to the stone.
The granular structure of the crayon stroke is a result of the
copperplate paper's surface. Facial contours and eyes were
carved out with powerful strokes, while the hair, left cheek
and neck are rendered more two-dimensionally.

9

Frontal self-portrait, 1922–23

Fourteenth state, prior to publication in
Ludwig Kaemmerer's book of 1923
Woodcut in black ink on thick soft coarse
hand-made Japan paper, 151 × 156 mm (image),
286 × 268 mm (sheet)
Signed, inscribed and dated lower right below
the image in pencil: *Käthe Kollwitz / Selbstbild*
[self-portrait] *1923*
Gift of the artist, 1923
Kupferstich-Kabinett, SKD, inv. no. A 1923-35
Kn 193 XIVa

There are only three distinct self-portraits of the artist in
woodcut, among them this one for the monograph by Ludwig
Kaemmerer published in 1923, *Käthe Kollwitz. Griffelkunst und
Weltanschauung*.[10] At that period of high inflation, the work
was priced at an exorbitant 231,000 marks, beyond the means
of the Kupferstich-Kabinett. The artist therefore donated a
luxury edition with this print to the museum.[11] The book was
lost in the Second World War, although the square-format self-
portrait, carved into the wood with only a few cuts, survived.

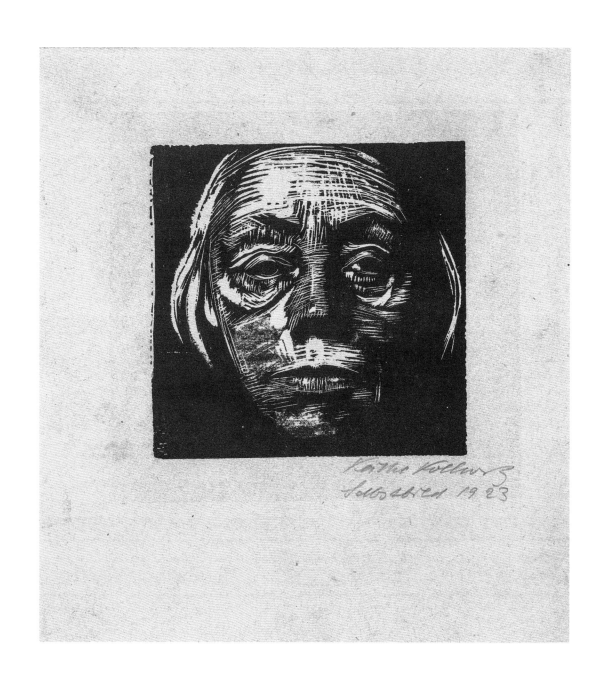

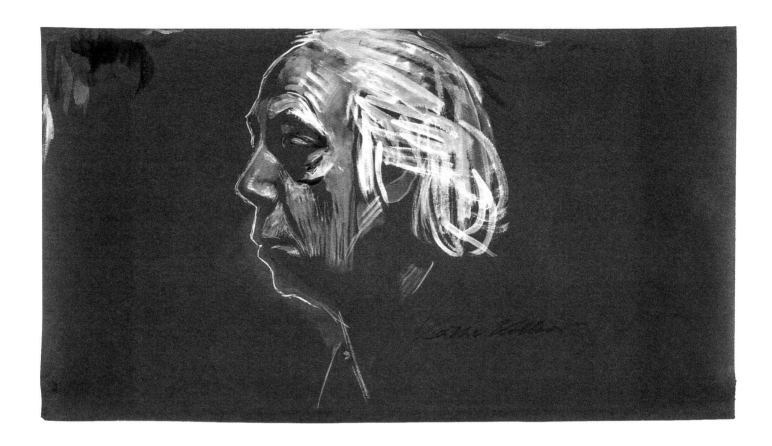

10

Self-portrait in profile to the left, 1924

Brushed in opaque white, with black wash
in places, on dark-green coloured paper,
260 × 473 mm
Signed lower right in pencil: *Käthe Kollwitz*
Purchased on the art market, 1990
Käthe Kollwitz Museum Köln (Cologne),
inv. no. 70200/90008
N/T 1001

This large-format self-portrait in profile, impressive in its
stark contrast between light and dark, is one of two that were
undertaken in the context of the artist's preparations for
a woodcut that was completed in the spring of 1924.[12] The
monumental head was produced with a brush in opaque white,
partially applied flat, partially linear, accentuated with black wash.
The white on a dark background anticipates the effect of a white
line woodcut as well as representing the appearance of the artist,
whose hair by that time had turned white.

11

Self-portrait in profile, Spring 1927

Edition published as the annual gift for the members of the Kunstverein Kassel (Kassel Art Association), 1929
Black crayon lithograph (transfer from a drawing on ribbed hand-made paper) on yellowish brown, firm, smooth, machine-made Japan paper, 320 × 297 mm (image), 524 × 382 mm (sheet)
Signed and dated lower right below the image in pencil: *Käthe Kollwitz 1927*
Purchased from a private collection, Weimar, 1967
Kupferstich-Kabinett, SKD, inv. no. A 1967-381
Kn 235c

The chain lines and laid lines of the hand-made paper on which Kollwitz drew this self-portrait, then transferred it to the stone, are especially recognizable in the areas where the broad side of the crayon was applied.

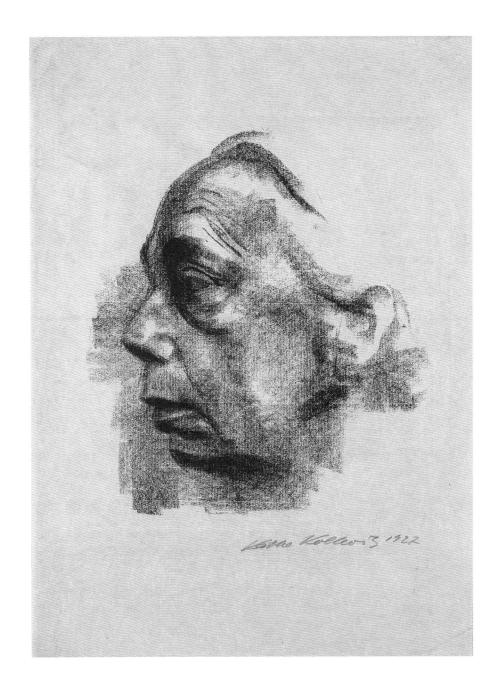

12

Self-portrait, Spring 1934

Edition of 80 numbered proofs
Crayon and brush lithograph in black ink
(transfer) on hand-made paper, 208 × 187 mm
(image), 378 × 270 mm (sheet)
Signed, inscribed and dated lower right below
image in pencil: *Käthe Kollwitz / Selbstbild*
[self-portrait] *1934*
Donated from the collection of Hans Theo und
Hildegard Richter, Dresden, 1998
Kupferstich-Kabinett, SKD, inv. no. A 1998-170
Kn 263b

This sheet is one of the artist's last lithographic self-portraits. Her face,
viewed from the front, entirely fills the closely cropped image area.
Kollwitz's typical head-on-hand gesture is barely suggested by the finger
on her forehead.

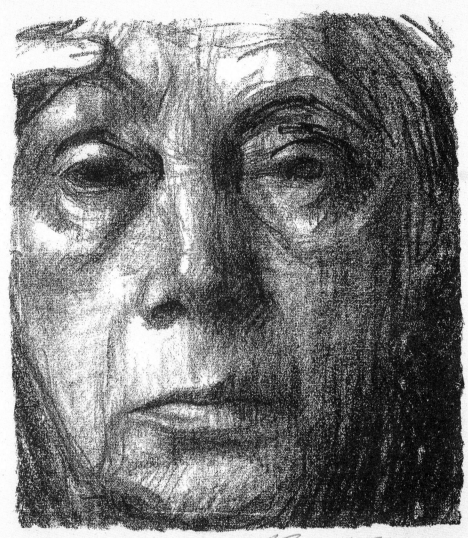

Karin Kollwitz
Selbstbild 1934

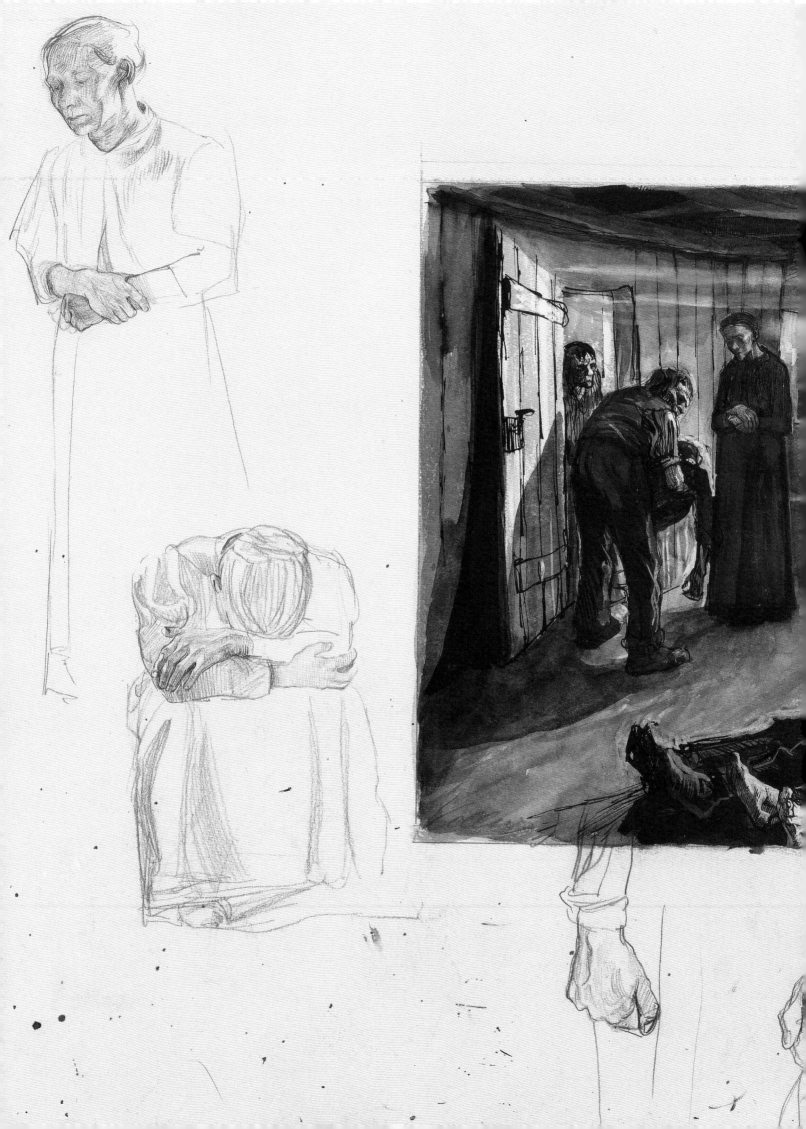

II. An early start

A Weavers' Revolt and the origins of
the Dresden Kollwitz collection

It was with *A Weavers' Revolt*, her first major cycle, which she successfully exhibited at the 'Große Berliner Kunstausstellung' in 1898, that Kollwitz first came to the attention of Woldemar von Seidlitz and Max Lehrs. When the Dresden Kupferstich-Kabinett then acquired six sheets of the cycle, along with proofs of corresponding earlier states, the foundation was laid of the first museum collection of the artist's work. The drawings and prints in this section illustrate both this institutional starting-point and the development by the artist of the theme of *A Weavers' Revolt*.

The cycle was inspired by Gerhart Hauptmann's drama *The Weavers*, the subject of which was a revolt by Silesian weavers in 1844. Performance of the play was initially banned. Kollwitz attended its eventual premiere at the Freie Bühne theatre in Berlin in February 1893, and would characterize the occasion as a "milestone in my work".[13] Her engagement with the material of the play, however, brought about a free interpretation of its contents. In *Need* (cat. 15) and *Death* (cat. 17) she depicts the plight of the impoverished weavers, who then unite in a *Conspiracy* (cat. 19) to find

a means of escape from their predicament. She depicts the *March of the Weavers* (cat. 20) in front of the factory owner's house, which is attacked in *Storming the Gate – Attack* (cat. 21). The suppression of the revolt by the authorities is not represented; instead, Kollwitz shows the dead being recovered after the rebellion has been violently crushed in *End* (cat. 22).

The first three sheets originated as lithographs, the last three as etchings. Kollwitz herself attributed this decision to her as yet imperfect skills in the technique of etching.[14] Rejected versions of the first three subjects testify to her struggle to find convincing compositional solutions. The cycle was completed in 1897, but the exact dates of the individual sheets are very difficult to reconstruct.

Originally, *From Many Wounds You Bleed, O People* (cat. 26) was planned as an emblematic final print, but was not included in the cycle. A few years later Käthe Kollwitz revisited the middle section of the composition, with the corpse of a man laid out to be viewed, for the large-format etching *The Downtrodden* (cat. 27–29).

13

Need, between 1893 and 1897

Rejected print from sheet 1 of the cycle
A Weavers' Revolt
Third state
Etching, drypoint, aquatint and emery in
black ink on copperplate paper, 295 × 403 mm
(plate), 289 × 401 mm (sheet)
Inscribed lower right in pencil: *III*
Purchased from the artist, 1902
Kupferstich-Kabinett, SKD, inv. no. A 1902-833
Kn 23 III

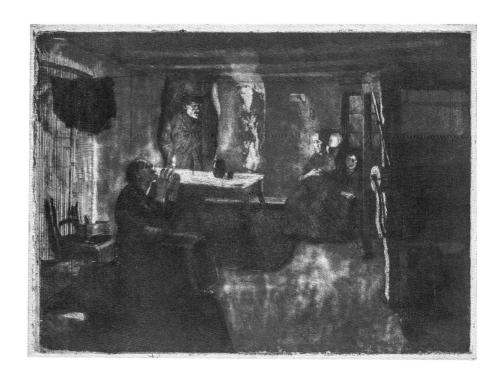

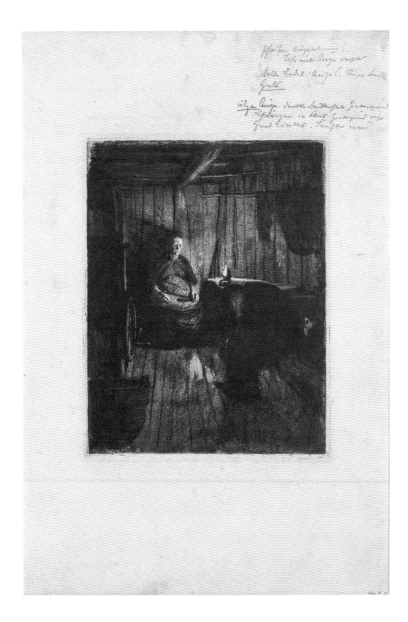

14

Need, between 1893 and 1897

Rejected print from sheet 1 of the cycle
A Weavers' Revolt
Third state
Etching, drypoint, aquatint, emery and
burnisher in black ink, reworked with pencil
and charcoal or crayon, on copperplate paper,
286 × 228 mm (plate), 505 × 343 mm (sheet)
Inscribed upper right in pencil: *schleifen:
Augenbraue I./ Tiefe unter Auge rechts/ Kalte
Nadel: Auge I. Stirn. Backe/ Hals/ ätzen: Auge.
dunkle Backenseite Hintergrund/ Schwärzen in
Kleid. Hintergrund rechts/ Hand links, Fenster
neu* [polishing: eyebrow I. / Depth under the
right eye/ drypoint: eye I. Forehead. Cheek/
neck/ to be etched: eye. Dark side of the
cheek background/ blackness in the dress.
Background right/ hand left, window new]
Gift of the artist, 1902
Kupferstich-Kabinett, SKD, inv. no. A 1902-371
Kn 24 III

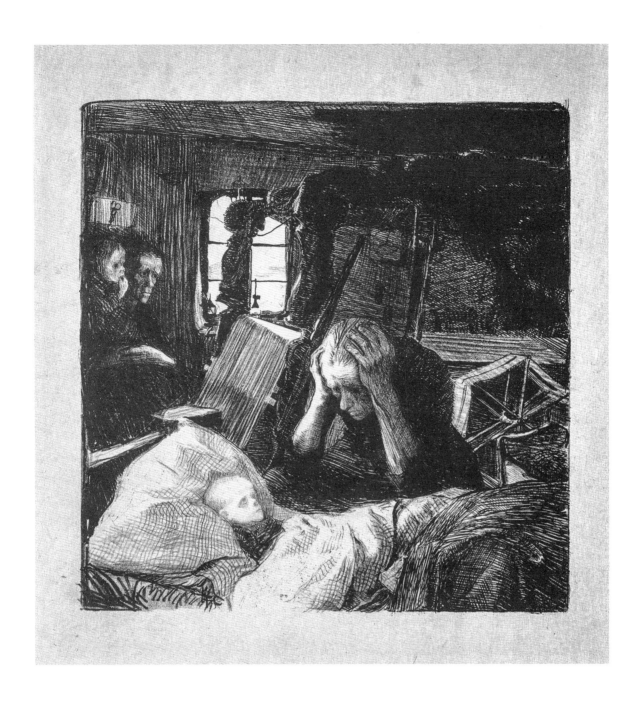

15

Need, between 1893 and 1897

Sheet 1 of the cycle *A Weavers' Revolt*
Second state
Crayon and pen lithograph with scraper and
scraping needle in green-black ink on beige
China paper, mounted on copperplate paper,
154 × 153 mm (image), 189 × 179 mm (sheet)
Purchased from the artist by Woldemar
von Seidlitz, Dresden, for the Kupferstich-
Kabinett, 1899
Kupferstich-Kabinett, SKD, inv. no. A 1899-156
Kn 33 II

Kollwitz drafted the first sheet of *A Weavers' Revolt* initially in
four etched versions, differing distinctly from one other. The
humble sitting room is shown in a broader frame in the first draft
(cat. 13), while in the second attempt (cat. 14) the room is smaller
and the number of people reduced. Light falls on the pregnant
woman in the background, while the figure of the man seated in
a position of despair sinks into half-darkness. The Kupferstich-
Kabinett originally owned all three states of this rejected work;
that Kollwitz was not satisfied with the third state either is clear
from the corrections noted on the sheet.[15] Both of the subsequent
etchings with the mother shifted to the foreground at the child's
bed correspond to the composition of the final sheet (cat. 15),
ultimately executed as a lithograph.

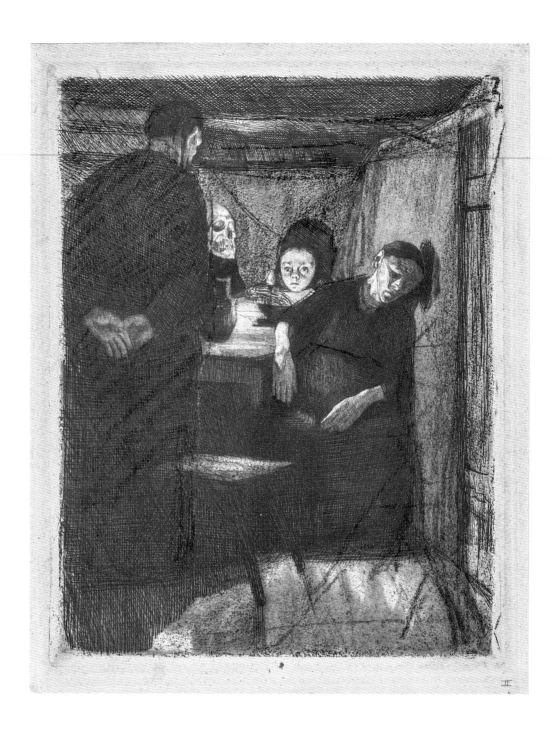

16

Death, between 1893 and 1897

Rejected version of sheet 2 of the cycle
A Weavers' Revolt
Second state
Etching, drypoint, aquatint, emery and
burnisher in brown, reworked with pencil
and charcoal, partial white heightening,
on copperplate paper, 231 × 181 mm (plate),
251 × 199 mm (sheet)
Inscribed lower right in pencil: *II*
Purchased from the artist, 1902
Kupferstich-Kabinett, SKD, inv. no. A 1902-840
Kn 27 II

The Dresden Kupferstich-Kabinett has the only holding of
two states of this version of *Death*, completed as an etching
and acquired in 1902.[16] Kollwitz drew over this second state in
pencil and charcoal, only to reject it in the end. The lithograph
(cat. 17) was completed in reverse with a nearly identical
composition: Death sits at the family table and reaches for
the arm of the exhausted mother.

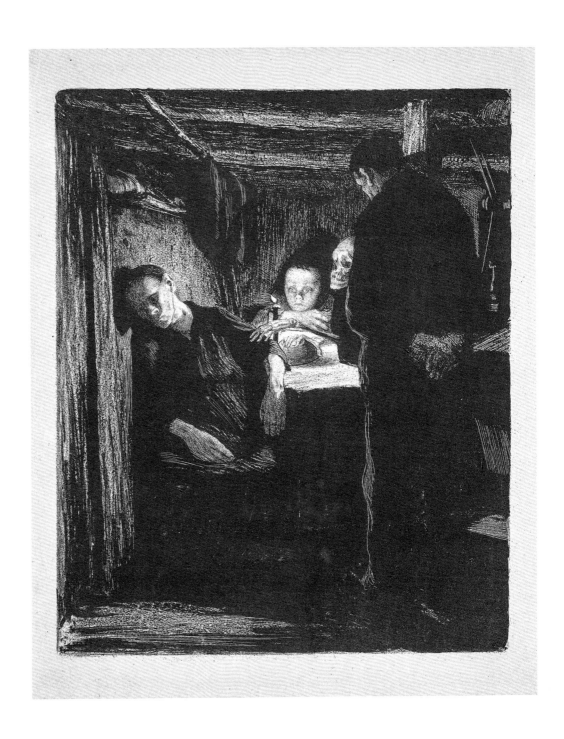

17

Death, between 1893 and 1897

Sheet 2 of the cycle *A Weavers' Revolt*
Proof from original stone
Crayon, pen and brush lithograph, scraper and
scraping needle in green-black ink on beige
China paper, mounted on copperplate paper,
223 × 185 mm (image), 450 × 316 mm (sheet)
Purchased from the artist by Woldemar
von Seidlitz, Dresden, for the Kupferstich-
Kabinett, 1899
Kupferstich-Kabinett, SKD, inv. no. A 1899-157
Kn 34 A a

18

Conspiracy, between 1893 and 1897

Rejected first version of sheet 3 of the cycle
A Weavers' Revolt
Second state
Etching, drypoint and emery in brown on
copperplate paper, 296 × 180 mm (plate),
334 × 217 mm (sheet)
Gift of the artist, 1899
Kupferstich-Kabinett, SKD, inv. no. A 1899-166
Kn 28 II

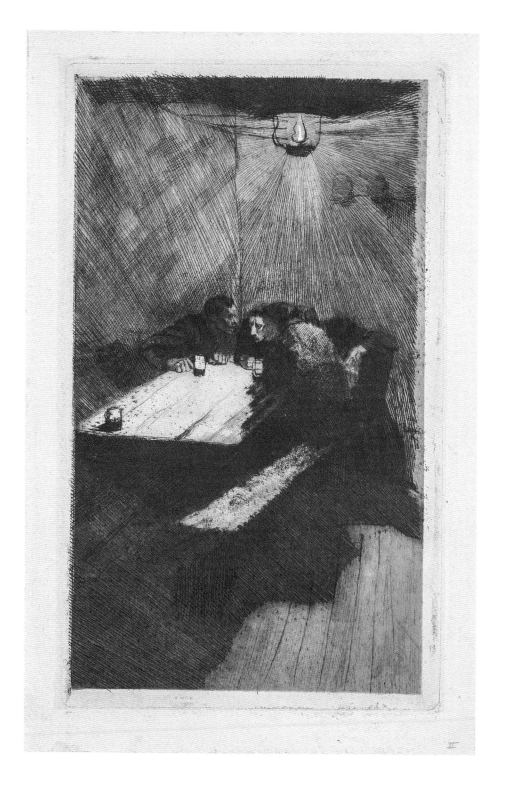

19

Conspiracy, between 1893 and 1897

Sheet 3 of the cycle *A Weavers' Revolt*
Proof from original stone, first state
Crayon lithograph, scraper and scraping
needle in green-black ink on beige China
paper, mounted on copperplate paper,
274 × 168 mm (image), 450 × 316 mm (sheet)
Purchased from the artist by Woldemar
von Seidlitz, Dresden, for the Kupferstich-
Kabinett, 1899
Kupferstich-Kabinett, SKD, inv. no. A 1899-158
Kn 35 A I

With only minor modifications and in
reverse, Kollwitz transformed *Conspiracy*,
initially an etching like *Need* and *Death*,
into a lithograph. In both sheets the
lamp on the ceiling, lending the scene
a conspiratorial mood, illuminates the
circle of men sitting close together at the
table. In total, the Dresden collection
included four sheets of this rejected
version in three different states; one of
them is now missing.[17]

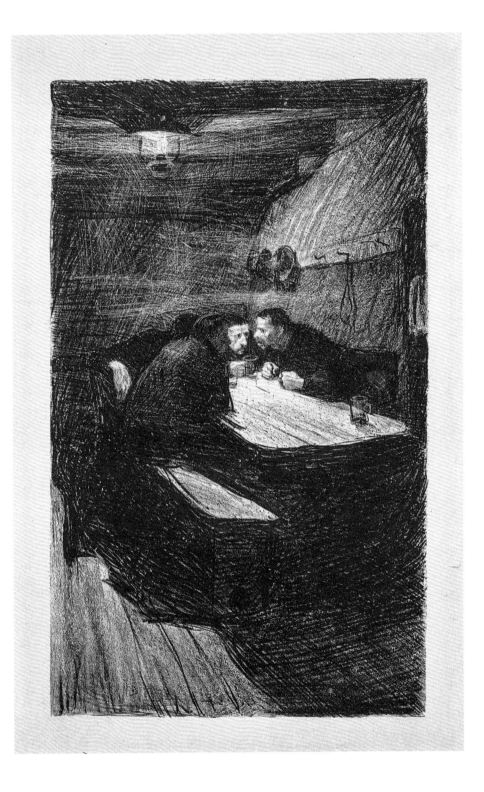

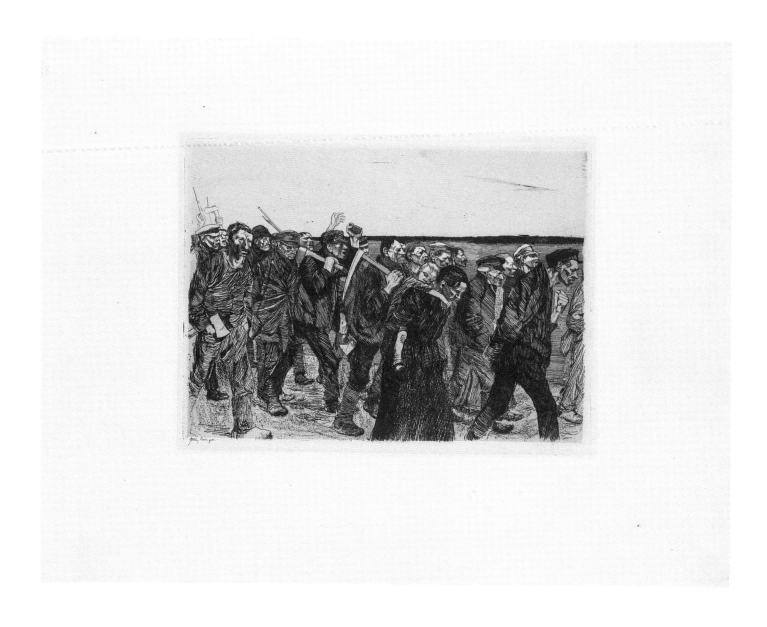

20

March of the Weavers, between 1893 and 1897

Sheet 4 of the cycle *A Weavers' Revolt*
Second state
Etching and emery in black ink on copperplate paper, 216 × 295 mm (plate), 390 × 500 mm (sheet)
Inscribed lower left below image in pencil: *OFelsing Berlin gedr.* [printed]
Purchased from the artist by Woldemar von Seidlitz, Dresden, for the Kupferstich-Kabinett, 1899
Kupferstich-Kabinett, SKD, inv. no. A 1899-159
Kn 36 II a

March of the Weavers, executed as an etching, seems like a preparatory study for *Uprising* (cat. 37), completed in 1901. Armed with sickles and axes, the weavers march to the house of their exploitative employer. Aside from a few raised fists, there is little sense of revolutionary protest: the composition has nothing of the dynamic movement of the later sheet, where the peasants seem to spring from the page.

21

Storming the Gate – Attack, between 1893 and 1897

Sheet 5 of the cycle *A Weavers' Revolt*
Second state
Etching and emery in brown on copperplate
paper, 238 × 295 mm (plate), 384 × 500 mm
(sheet)
Inscribed lower left in pencil: *OFelsing Berlin
gedr.* [printed]
Purchased from the artist by Woldemar
von Seidlitz, Dresden, for the Kupferstich-
Kabinett, 1899
Kupferstich-Kabinett, SKD, inv. no. A 1899-160
Kn 37 II a

The only known first state of this scene, depicting the angry mob at the door of the factory owner's house and women tearing up stones from the pavement, is missing.[18] It was given to the Kupferstich-Kabinett in July 1898, after the acquisition of the whole cycle (including the present second state) was concluded.

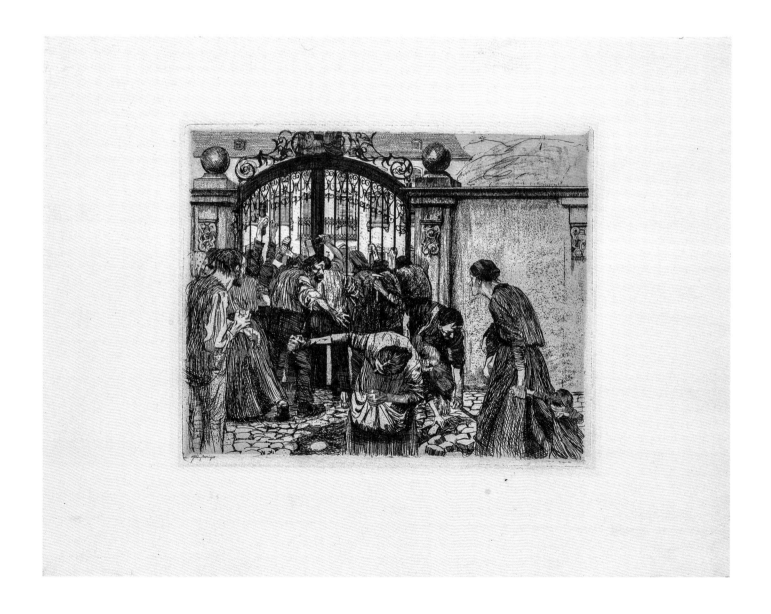

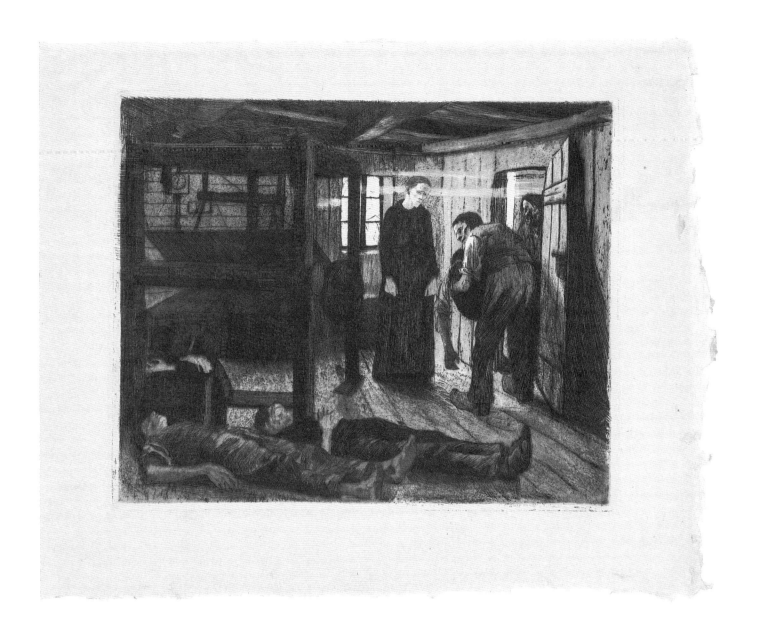

22

End, between 1893 and 1897

Sheet 6 of the cycle *A Weavers' Revolt*
Second state
Etching, aquatint, emery and burnisher
in black ink on Japan paper, 247 × 307 mm
(plate), 327 × 400/412 mm (sheet)
Purchased from the artist by Woldemar
von Seidlitz, Dresden, for the Kupferstich-
Kabinett, 1899
Kupferstich-Kabinett, SKD, inv. no. A 1899-161
Kn 38 II a

Together with the proof of the first state of *Storming the Gate – Attack* the artist donated the first state of the *End* to the Dresden collection; it is believed to have been the only one, as for *Storming the Gate*, and is now missing.[19] It would have shed light on the development of the subject as shown in the second state.

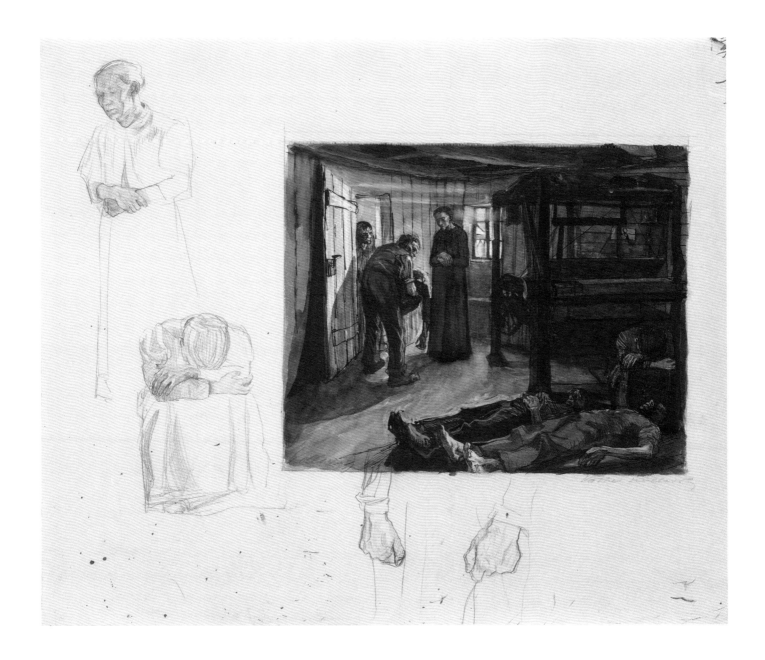

23

End, 1897

Preparatory drawing for the etching *End*,
sheet 6 of the cycle *A Weavers' Revolt*
Pencil, brush and pen in black ink and brown
wash, heightened in white, on thick drawing
paper, 409 × 492 mm
Signed lower right below the image in pencil:
Käthe Kollwitz
Donated by the Dresden Museumsverein
(Museum Association), 1918
Kupferstich-Kabinett, SKD, inv. no. C 1918-21
N/T 133

This reversed preparatory drawing for the etching *End* entered
the collection in 1918 as a gift from the Dresden Museumsverein
(Museum Association). It differs from the print in details such as
the position of the hands of the woman at the door, which here
are folded over her belly. Kollwitz sketched balled-up fists, which
she would be given in the final state, in a study at the bottom edge
of the drawing. The plume of white dust produced in the etching
by smoothing the surface with a burnisher is recreated in the
drawing by the application of a white tempera, which also serves to
emphasize the contours of the lifeless body on the ground.

24

Reclining male nude,
between 1893 and 1897

Study for the middle section of the rejected
final print of the cycle *A Weavers' Revolt*
Presumed unique
Etching, drypoint and aquatint in black ink
on copperplate paper, 130 × 180 mm (plate),
199 × 247 mm (sheet)
Inscribed lower middle in pencil: *Ton aus
dem Hintergrund mit Finger über den Akt gezogen.*
[Shade of the background drawn with finger
across the nude]
Purchased from the artist, 1902
Kupferstich-Kabinett, SKD, inv. no. A 1902-841
Kn 30

These two studies (cat. 24 and 25) were preparations for the
left and middle parts of the final, ultimately rejected, *Weavers*
sheet *From Many Wounds You Bleed, O People*. The male figure
explores the physiology of a dead body. In the tripartite final
composition (see cat. 26), the corpse lying outstretched with a
crown of thorns recalls Christ taken down from the cross. The
corpse recalls a motif from Max Klinger (see fig. 31), which in
turn can be traced back to Hans Holbein's painting, *The Dead
Christ*, of 1521–22 (Kunstmuseum Basel). Kollwitz rendered
the bound woman (cat. 25), here still awkwardly executed,
particularly on her right side, more precisely in the final sheet,
shaping her contours so as to characterize her physical pain.

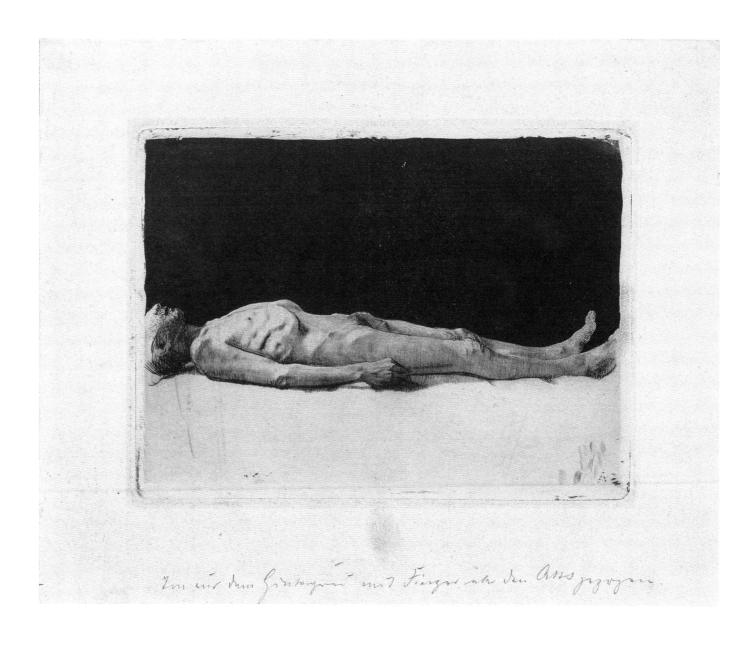

25

Bound woman, between 1893 and 1897

Study for the bound woman in the rejected
final print of the cycle *A Weavers' Revolt*
Presumed unique
Etching, drypoint and aquatint in black ink
on copperplate paper, 188 × 133 mm (plate),
220 × 159 mm (sheet)
Inscribed lower left in pencil: *Stichelversuch*
[trial with the burin]; verso: inscribed upper
middle in pencil: *Vor dem Selbstbildnis* [before
the self-portrait]
Purchased from the artist, 1902
Kupferstich-Kabinett, SKD, inv. no. A 1902-844
Kn 31

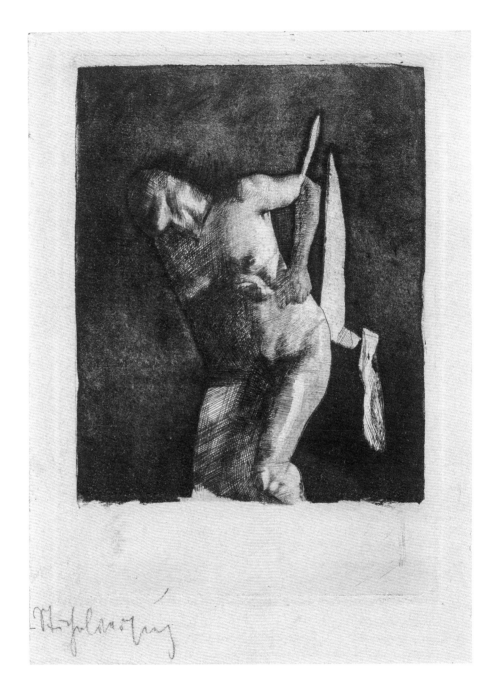

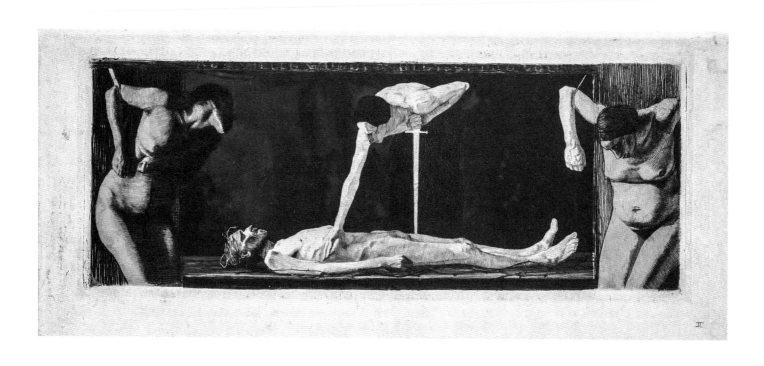

26

From Many Wounds You Bleed, O People, between 1893 and 1897

Planned as the final print of the cycle *A Weavers'
Revolt*, not included
Second state, very rare
Etching, drypoint, aquatint and burnisher in
black ink on firm Japan paper, 129 × 335 mm
(plate), 168 × 384 mm (sheet)
Inscribed lower right in pencil: *II*
Purchased from the artist, 1902
Kupferstich-Kabinett, SKD, inv. no. A 1902-843
Kn 32 II a

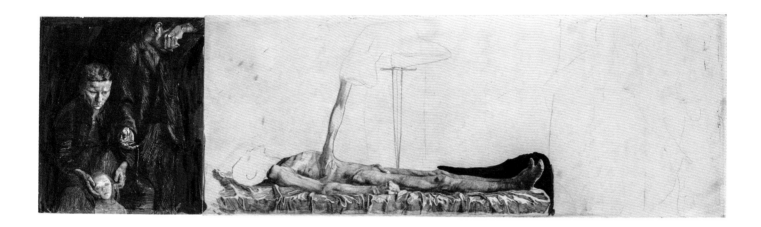

27

The Downtrodden, before May 1900

First state
Etching, drypoint, aquatint and burnisher in black ink, reworked in pencil and black ink on copperplate paper; two sheets mounted together, 230 × 198 mm (left sheet), 234 × 631 mm (right sheet), 230/234 × 828 mm (full sheet)
Signed upper left on the left-hand sheet in pencil: *Kollwitz*
Purchased from the artist, 1901 and 1902
Kupferstich-Kabinett, SKD, inv. no. A 1901-794 and A 1902-852
Kn 49 I

In the three-part etching *The Downtrodden* Kollwitz used a more symbolic visual language to depict the misery of the working classes. This sheet stands out from the majority of her work for its unusual size alone.[20] The composition in the centre, with a male corpse laid out to view as a personification of the oppressed, can be traced back to Max Klinger's influence. The avenging figure bending over him with a sword grasps at a wound in his side reminiscent of the corresponding wound of Christ.

Flanking this scene to the left is a working-class family of three. The despair of the father, who, turning his head away, hands his wife a rope, indicates that the child in her arms is not asleep but dead.

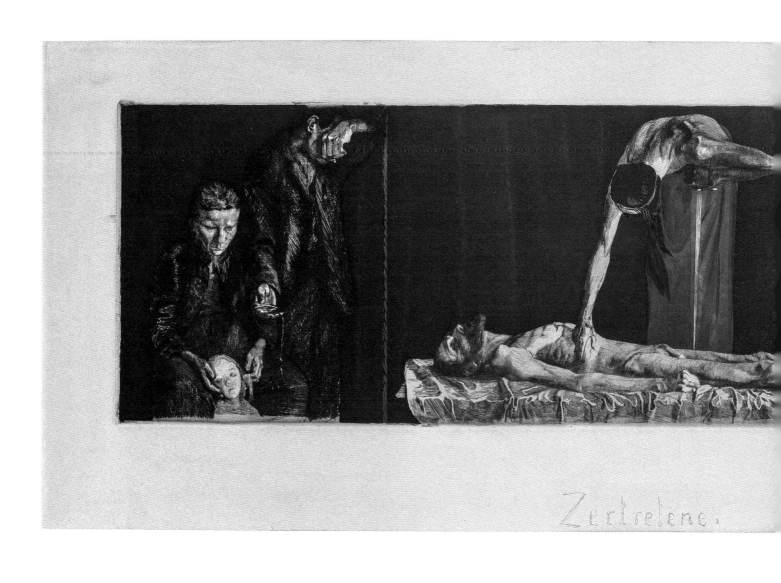

Zertretene.

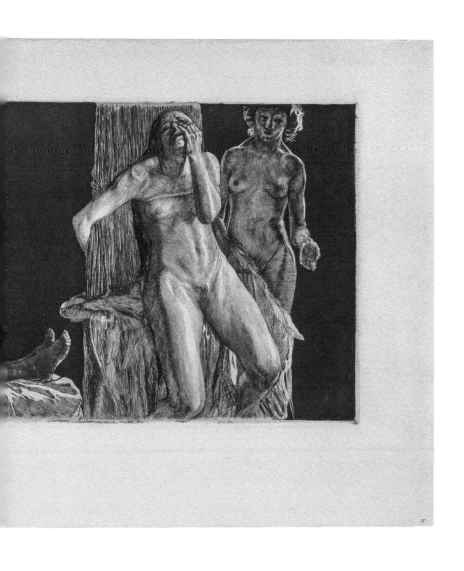

28

The Downtrodden,
before May 1900

Second state
Etching, drypoint, aquatint and burnisher
in brown ink reworked with black ink and
opaque white on copperplate paper, 239 ×
836 mm (plate), 356 × 943 mm (sheet)
Inscribed upper middle in pencil: *Zertretene*
[Downtrodden]
Purchased from the artist, 1902
Kupferstich-Kabinett, SKD, inv. no. A 1902-854
Kn 49 II

On the right two naked women, the one in front bound to a post,
the other stretching her hand out addressing the observer, raise
the issue of prostitution arising from proletarian poverty.

Kollwitz developed the composition in three steps: the
reworked Dresden sheets show the artist's complex creative
process, which ended, however, in the division of the printing
plate.

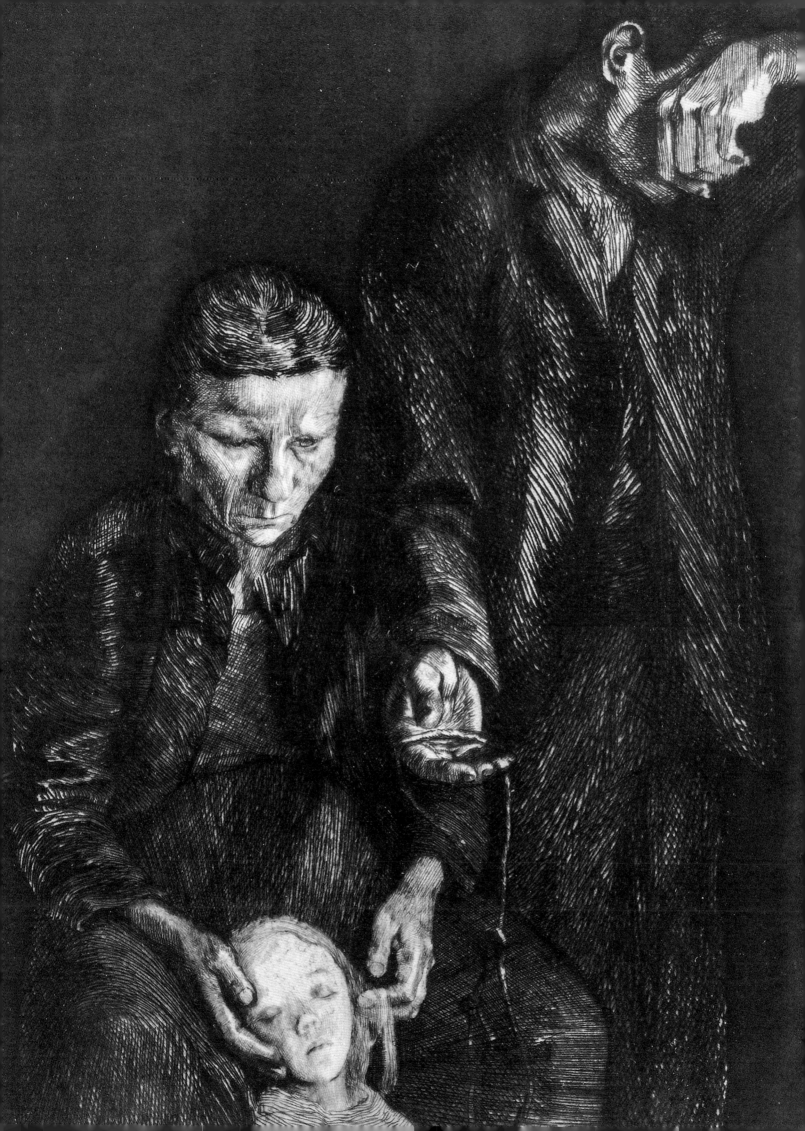

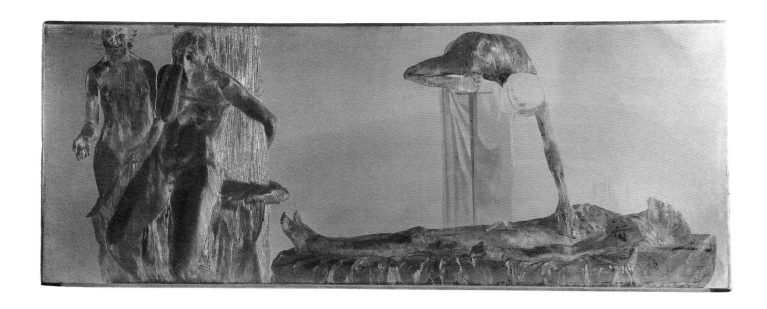

29

The Downtrodden,
before May 1900

Copperplate, steelfaced, 241 × 635 mm
On permanent loan from the Kollwitz estate
Akademie der Künste, Berlin,
Kunstsammlung, inv. no. 356
(printing plate no. 20)
Kn 49

Shortly after finishing this ambitious etching, Kollwitz distanced herself from it, cutting the printing plate in two. She found acceptable only the left-hand side, with the working-class family, to which she gave the title *The Downtrodden – Poor Family*. This left side of the plate would be destroyed but several editions were printed from it up until 1921.[21] The middle and right sections of the plate, on the other hand, are among the few printing plates of Kollwitz's to have survived. In the fine relief of its surface wrought with etching, drypoint, aquatint and burnisher, this copperplate provides insight into Kollwitz's highly skilled handling of graphic techniques.

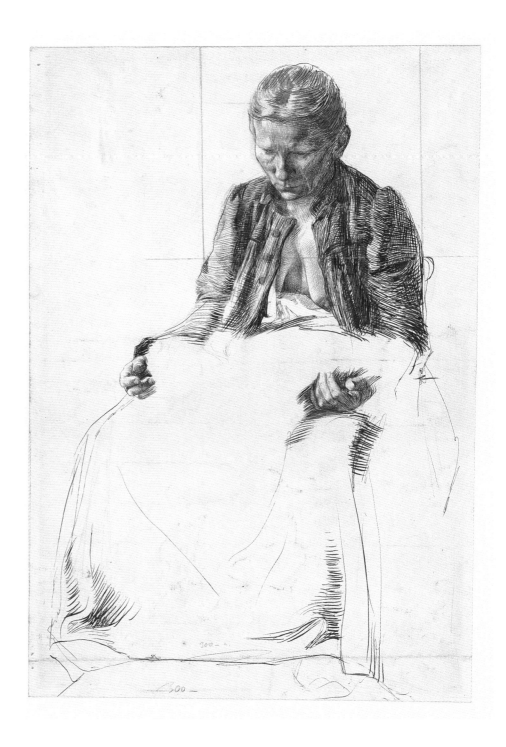

30

Seated mother, c. 1900

Preparatory study for the etching
The Downtrodden
Pencil, pen in black ink, partial wash, on hand-made paper (lined), head and shoulder section cut out and later reinserted, 460/465 × 322/326 mm
Inscribed lower left towards middle in pencil:
300-/ 300-
Purchased from Galerie Ernst Arnold, Dresden, on the occasion of the 'Große Berliner Kunstausstellung', 1906
Kupferstich-Kabinett, SKD, inv. no. F 911
[Kollwitz SZ 7]
N/T 160

Kollwitz prepared the etching *The Downtrodden* with only a few drawings; three of these are dedicated to the mother and child group. In the present study, purchased in 1906 by the Berlin Kupferstichkabinett, the position of the woman's hand and exposed breast suggest that she should be holding an infant in her arms, but the space is empty. The working woman's head and shoulders with her worried facial features were cut out of the pen, ink and wash drawing and then later reinserted.

31

Head of a child in its mother's hands, 1900

Pencil on wove paper, 208 × 208 mm
Signed and dated lower right in pencil:
Kollwitz/ Kollwitz I. 1900
Purchased from the 'Internationale
Kunstausstellung Dresden 1901', 1901
Kupferstich-Kabinett, SKD, inv. no. C 1901-15
N/T 162

The drawing is focused on the mother's lap. Kollwitz changed the composition (see cat. 30), replacing the original infant with a little girl's head resting in her mother's hands; this solution was adopted for the final etching (in reverse to the drawing; see cat. 28). The child's delicate, transparent-seeming features are traced in fine pencil strokes, while the mother's hands are more powerfully delineated.

This sheet, inventoried in 1901, was the first drawing purchased from the artist by the Dresden Kupferstich-Kabinett. In 1902 the acquisition of a second drawing followed, *Female nude, half-figure with raised arm*, which has been missing since 1945.[22] This, too, was produced in the context of *The Downtrodden* and depicts the head and upper body of the woman bound to the post.

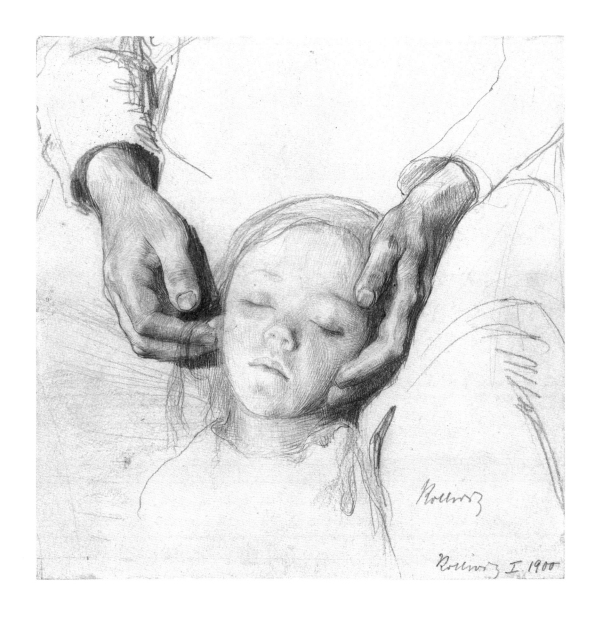

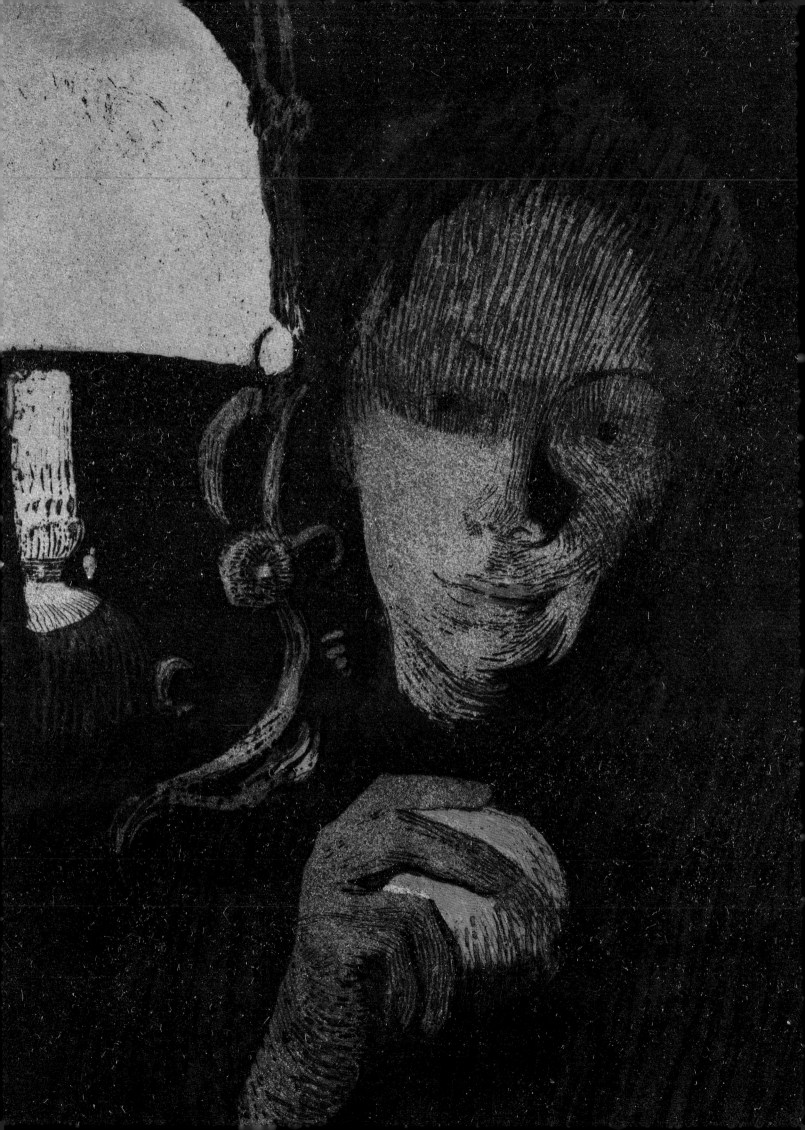

III. Graphic experiments
Trial proofs, states, textures and colour

Characteristic of Kollwitz is her experimental approach to her graphic work, which launched her to the forefront of artistic practice in this field around 1900. From the beginning, Max Lehrs, who would compile the first catalogue raisonné of her etchings and lithographs, requested trial proofs and proofs of early states of her prints for the Dresden collection. The artist regarded these sheets mainly as reference for her ongoing work, but the rare and in some cases unique proofs (as was realised at the time) provide valuable insight into her artistic creative process.

Kollwitz was briefly instructed in etching technique by Rudolf Mauer in Königsberg in 1890–91; from about 1896 she taught herself the finer points of intaglio and lithography and from 1920 woodcutting as well. Her earliest etched practice sheets already reveal attempts with media such as emery to produce continuous tones or cross and parallel hatching for various degrees of shadowing (cat. 33 and 34). On numerous trial prints there are handwritten notes with corrections and reworkings with tempera or crayon, which are then incorporated into the copperplate in the next state (cat. 34 and cat. 36). Kollwitz sporadically attempted the unusual combination of intaglio and planographic printing (cat. 40 and 42). Between 1898 and 1905 colour began to play a role in her work, appearing principally in her lithographs (cat. 44, 45 and 48).

Kollwitz proved her mastery in the textures she achieved in intaglio for the modelling of bodies or the inflection of tonal areas behind them (cat. 52). In addition to emery, she used the roulette tool and an aquatint process. She achieved a characteristic effect with *vernis mou*, or soft-ground etching, pressing different papers into the soft ground so that their texture would be transferred to the plate (cat. 41 and 50).

The selection presented here reveals Kollwitz gradually developing the visual solutions she sought and their highly complex facture.

32

Sheet of studies, 1890–91

One of three prints
Etching and drypoint in black ink on
copperplate paper, 179 × 128 mm (plate),
179 × 128 mm (sheet)
Purchased from the artist, 1902
Kupferstich-Kabinett, SKD, inv. no. A 1902-812
Kn 1

Käthe Kollwitz's first etching unites
various elements copied from Fritz von
Uhde's 1884 painting *Let the Little Children
come to Me* arranged around a child's
head on the printing plate. Although her
stroke is still somewhat tentative, she
shows she can impart three-dimensional
form to her subjects by skilful variation
in the thickness of the lines. Only three
proofs of this study sheet are known.

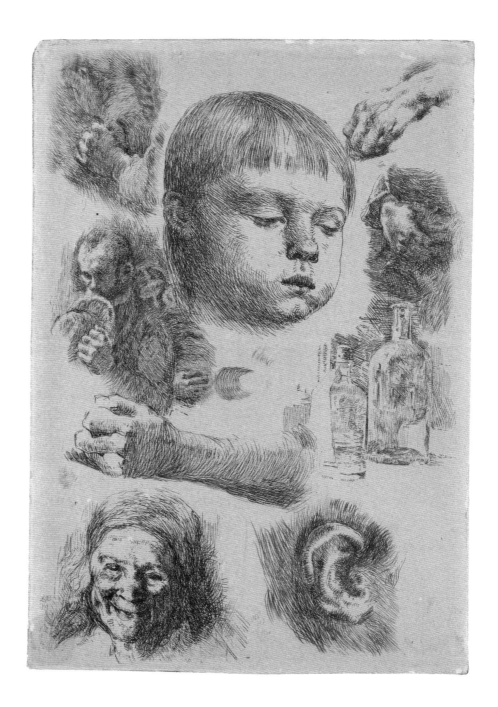

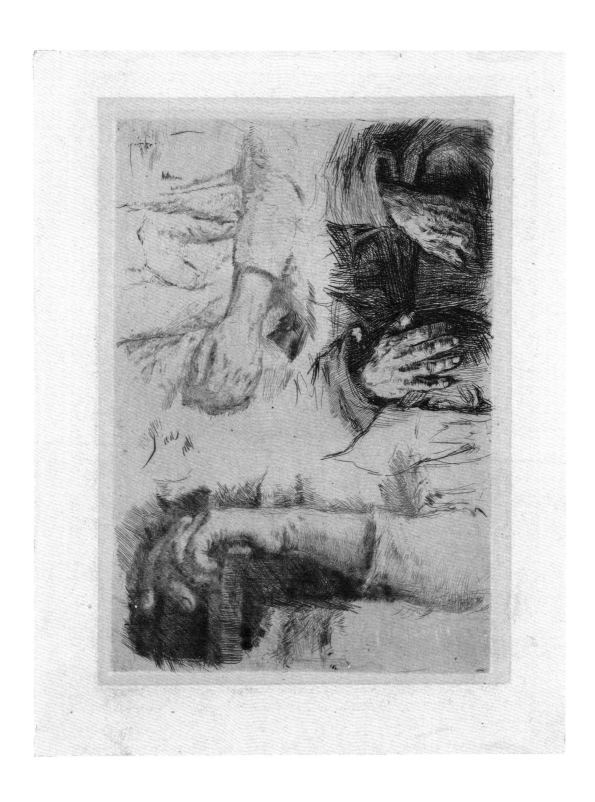

33

Hand studies, 1891

Presumed unique sheet
Etching and drypoint in black ink on
copperplate paper, 179 × 130 mm (plate),
219 × 169 mm (sheet)
Purchased from the artist, 1902
Kupferstich-Kabinett, SKD, inv. no. A 1902-819
Kn 7

In this sheet, presumably printed only once, the artist
tries out various hand positions, which she used in her
contemporaneous figure studies and self-portraits. It is
interesting to note that the artist rotated the plate 90°
while working on it: Kollwitz tried to take maximum
advantage of the space.

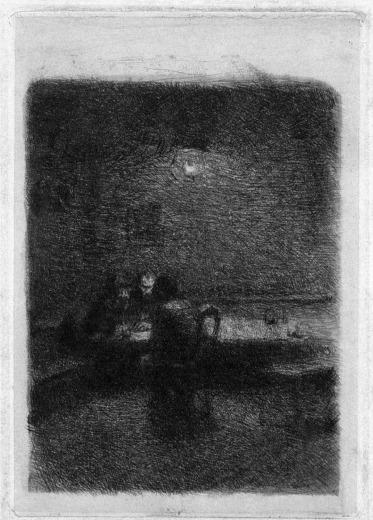

[Handwritten annotations in old German cursive script — largely illegible]

34

Three workers at a tavern table, 1891–92 (?)

First state
Etching, drypoint and emery in black ink on
white China paper, mounted on thick wove
paper, 180 × 130 mm (plate), 323 × 241 mm (sheet)
Inscribed in pencil lower left: *II*; upper right:
*von der Seite gesehen, sind/ alle Bleifederstellen als zu/
hell herausgefallen* [Seen from the side all parts in
lead pencil were removed as too light]; centre
right: *Das Ganze darf ab./ solut nicht schwarz u./
kantig wirken* [The whole thing must absolutely
not appear black and blocky]; lower centre:
*Das Ganze weniger wollig. Fußboden zu langweilig,
weniger aufdring/ lich, muß garnicht gesehen
werden. Präziser: Beine von Bank, Stuhl=Lehne u./
Beine u. Bank links. Figur links ein wenig präziser.
Mittelfigur gut/ Figur rechts präziser, Hand ganz
fort. Licht muß heller wirken, Dunkelheit/ über d.
Lampe tiefer. Zimmerecke mehr ausdrucken. Das
schwimmend=weiche/ Atmen, ohne daß es wollig wird.
Schmirgelpapier=Ton ist gut. Gesicht d. Figur/ links
heraus u. ebenfalls Hand vom Mann rechts (aufs Knie
gestützt). Schatten/ unter dem Tisch kann breiter.*
[Whole thing less woolly. Floor too boring,
less intrusive, doesn't need to be seen. More
precise: legs of bench, back of chair and legs
and bench on left. Figure on left a little more
precise. Middle figure good / figure on right
more precise, remove whole hand. Light must
appear brighter, deepen darkness above the
lamp. Corner of room more intense. Buoyant
soft breathing, without its becoming woolly.
Shade of emery good. Remove face of figure on
left as well as man's hand on right (leaning on
his knee). Shadow under table can be broader.]
Purchased from the artist, 1902
Kupferstich-Kabinett, SKD, inv. no. A 1902-827
Kn 11 I

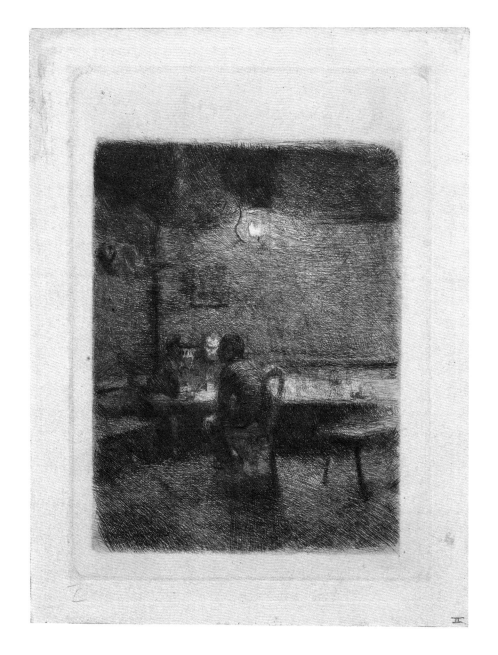

35

Three workers at a tavern table, 1891–92 (?)

Second state, presumed unique
Etching, drypoint and emery in black ink on
copperplate paper, 180 × 130 mm (plate),
211 × 162 mm (sheet)
Inscribed in pencil lower left: *I*; lower right: *II*.
Purchased from the artist, 1902
Kupferstich-Kabinett, SKD, inv. no. A 1902-830
Kn 11 II

36

Self-portrait and *Study for a scene from* Germinal, 1893 at the latest

First state, presumed unique
Etching, drypoint and emery in black ink
on white China paper, mounted on grey
copperplate paper, the self-portrait reworked
in pencil, 278 × 237 mm (plate), 350 × 326 mm
(sheet)
Inscribed in pencil upper right beside the
self-portrait: *lose Haare/ hinten/ wärmlich/ nicht
schwarz* [loose hair in the neck warmer/ not
black]; upper left beside the self-portrait:
*Wenn die Tiefen mehr/ heraus sind, demgemäß/
Kopf tönen./ Stirnhaar etwas hellen./ Kontur an
Stirn weg./ Gut sind die hellen/ Striche mit kalter
Nadel./ Glanzlicht auf Haar/ präciser./ Tiefen
saftiger/ weniger gemustert/ mehr Grundton wie x/
Das Kreidige weg* [When the depths are more
prepared tint head accordingly. Lighten
forelock a little. Remove outline of forehead.
The light lines with drypoint are fine.
Highlight on hair more precise. Depths more
lush less patterned more ground tone like x/
remove the chalky effect]; embossed seal lower
left below the image: *W. Felsing gedr.* [printed]/
Berlin
Purchased from the artist, 1902
Kupferstich-Kabinett, SKD, inv. no. A 1902-828
Kn 18 I

In 1888, Kollwitz began her graphic exploration of Emile Zola's
1884 socio-revolutionary novel of miners, *Germinal*. By 1904, she
had completed three different etchings of the fight between the
protagonist, Etienne Lantier, and Chaval, whose lover, Catherine,
Lantier is attracted to (see also cat. 61). This sheet depicts Catherine,
without the two men, observing the fight between them in a space
reminiscent of a Königsberg bar-room. The etched self-portrait
in profile on the same sheet and the notes for further reworking
demonstrate that this sheet should be considered a study. An 1888
brush drawing of the subject was also purchased, in 1918.[23]

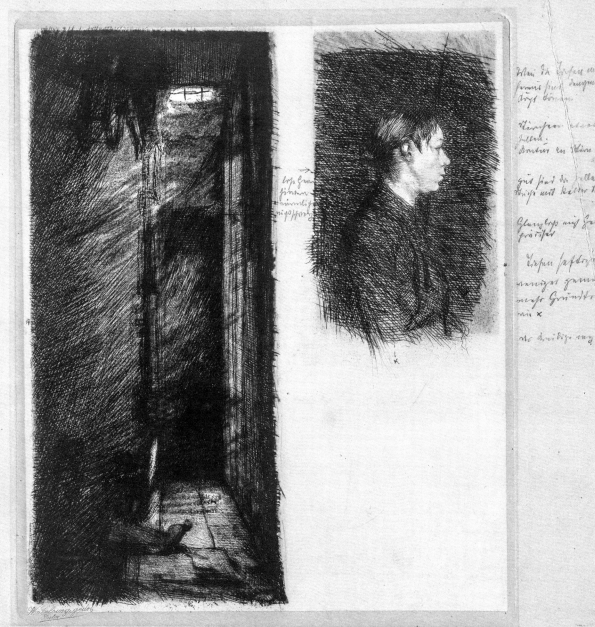

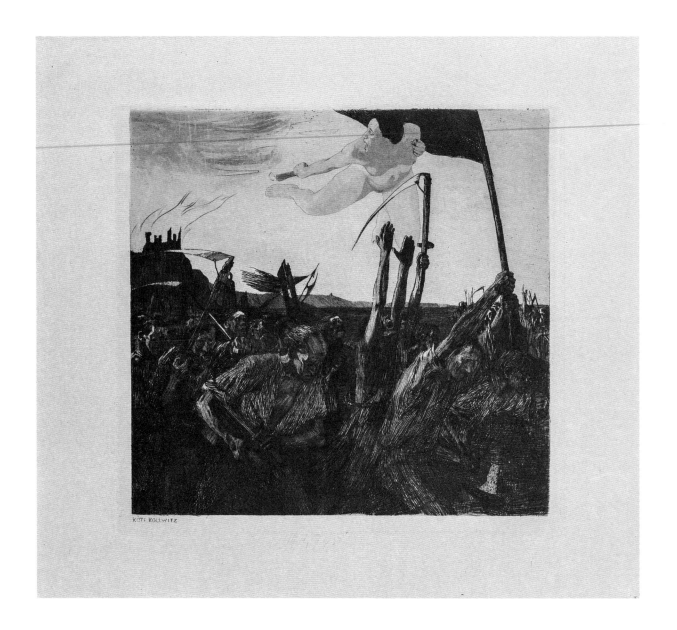

37

Uprising, before early summer 1899

Fifth state
Etching, drypoint, aquatint, brush etching,
emery and some roulette in brown on Japan
paper, 299/94 × 318 mm (plate), 398 × 433 mm
(sheet)
Inscribed lower left in the plate: *KÄTE* [sic!]
KOLLWITZ; inscribed lower right in pencil: *II*;
verso: inscribed lower left in pencil: *Aufruhr*
[Uprising]
Purchased from the artist, 1901
Kupferstich-Kabinett, SKD, inv. no. A 1901-793
Kn 46 V

This etching represents the artist's first exploration of the theme of
the German Peasants' War and a return to her manifest interest in
revolutionary movements, already apparent in *A Weavers' Revolt*. The
title of the sheet was, in fact, *The Peasants' War* in 1903 and was changed
only later to *Uprising*. As in the fifth sheet of the cycle of *The Peasants'
War*, which was entitled *Charge* from 1902–03 (see cat. 56), a woman
– in this case allegorical – incites the armed peasants. In 1902 the
Kupferstich-Kabinett purchased the first and second states as well (the
latter printed with a red tone plate to emphasize the flames leaping
from the torched castle) in addition to a preparatory drawing for the
etching in 1917; all three sheets have been missing since 1945.[24]

38

The Carmagnole, before mid March 1901

Fifth state
Etching, drypoint, aquatint and brush etching
and emery in brown on brown cardboard,
588 × 412 mm (plate), 619 × 444 mm (sheet)
Signed in pencil lower right below image:
Käthe Kollwitz; inscribed in pencil lower left
below image: *OFelsing Berlin gedr.* [printed];
lower right: *IV*
Purchased from the artist, 1901
Kupferstich-Kabinett, SKD, inv. no. A 1901-791
Kn 51 V a 3

This subject of an agitated crowd dancing
around a guillotine was probably
suggested to Kollwitz by a reading of
Charles Dickens's novel *A Tale of Two
Cities*, which recounts events in the
French Revolution. The title refers to
a republican battle song, which goes:
"*Dansons la Carmagnole, vive le son du canon*".
The Kupferstich-Kabinett originally
owned four states of this unusually large
subject, of which two have been missing
since 1945.[25]

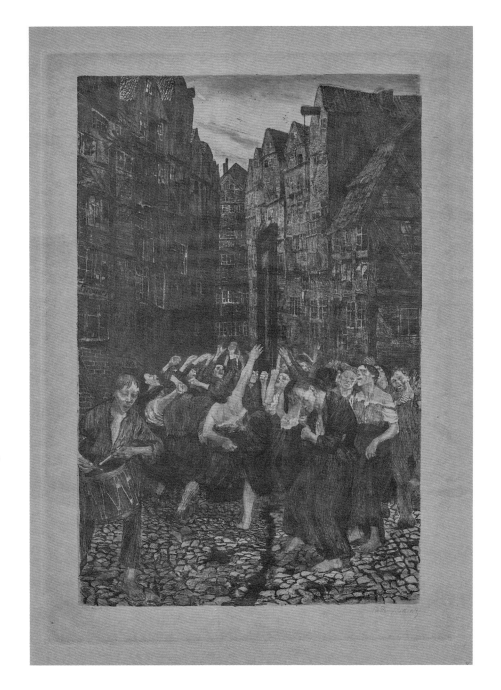

39

Taking up arms in a vaulted space, 1902

Rejected version of sheet 4 of the cycle
The Peasants' War
Lithograph made with one drawing stone
and two tone stones in three colours: drawing
stone in black crayon, with scraping, tone
stones in light green and in orange, on thin
Japan paper, 369 × 237 mm (drawing stone),
387 × 262 mm (sheet)
Signed and dated lower left, scratched
in stone: *Kollwitz 02*
Purchased from the artist, 1902
Kupferstich-Kabinett, SKD, inv. no. A 1902-860
Kn 65 B II

The fourth sheet of the cycle *The Peasants' War* was completed
as an etching in black and grey-brown, diverging from this
rejected lithograph version. Though basically retaining the
diagonal composition of the lithograph, the etching shows the
armed peasants marching from bottom left to top right (see
fig. 28, p. 44). The drama of this dynamic scene is enhanced
in both versions by the light falling through the archway and
illuminating the crowd from behind.

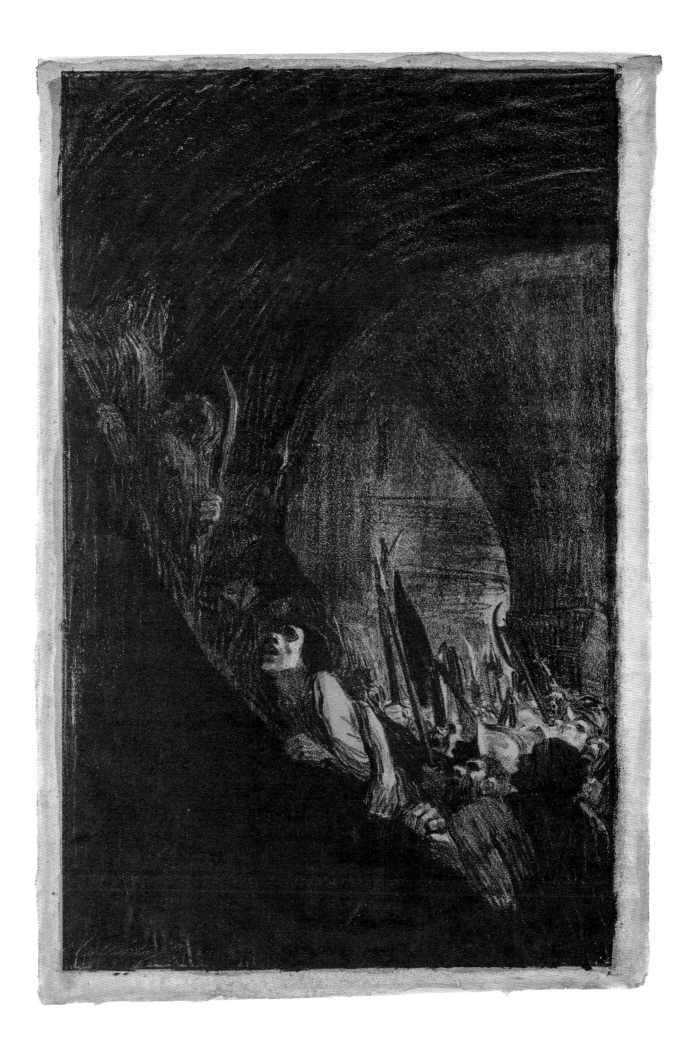

40

City outskirts, 1901

First state
Crayon algraphy in black ink combined with
a copperplate for the white lights; the street
lanterns and the houses in the background
touched-in in white, yellow and orange
tempera, on reddish brown cardboard,
228 × 179 mm (plate), 250 × 198 mm (sheet)
Monogram lower right in the stone: *KK*
Gift of the artist, 1901
Kupferstich-Kabinett, SKD, inv. no. A 1901-798
Kn 53 I

Max Lehrs listed this 1903 sheet, the first
of the three states, under the title *Workers
returning home from a day's work*. Contrary
to his assertion, it is not combined from
a copperplate and two aluminium plates,
but rather from a single aluminium plate
and a copperplate.[26] On it Kollwitz drew
the evening scene from working-class life
in lithographic crayon. The white lights
playing about the figures and the white
areas on the ground were printed with
the copperplate; the coloured spots in the
windows of the houses in the background
were applied by hand with tempera.

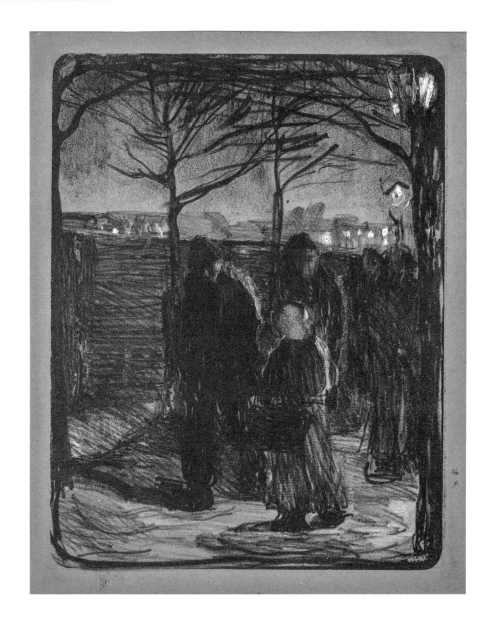

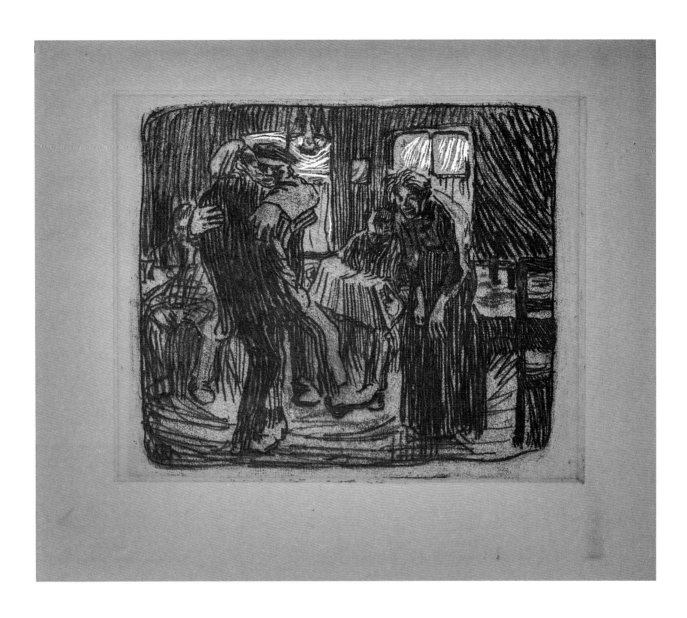

41

Hamburg tavern, before mid-June 1901

First state
Soft-ground etching with the imprint of
ribbed hand-made paper, line etching and
emery in brown, lights in the windows painted
with a brush in white tempera, on brown
coloured paper, 195 × 248 mm (plate),
275 × 326 mm (sheet)
Monogram lower left in the plate: *KK*
Gift of the artist, 1901
Kupferstich-Kabinett, SKD, inv. no. A 1901-797
Kn 55 I

For this representation of a traditional tavern scene Kollwitz
made a soft-ground etching, which transmitted her vigorous
draughtsmanship directly to the printing plate. She then
introduced touches with the brush, painting white lights in the
windows. In the second state these areas are wiped off and appear
as white surfaces. A study in pencil and white highlights of the
laughing woman on the right was purchased by the Kupferstich-
Kabinett three years later.[27]

42

Woman with orange, 1901

Second state
Combined print of a copperplate in grey-black
ink and a lithographic tone stone in an orange
colour and a further pink-coloured tone plate
(with burnished aquatint) for the lamp, on
cream-coloured paper, mounted on grey-
violet, ribbed hand-made cardboard (image
cut, only one lamp bracket can be seen),
231 × 112 mm (image; platemark not
discernible), 365 × 270 mm (sheet)
Monogrammed lower left on the plate: *KK*,
signed lower right below the image in pencil:
Käthe Kollwitz
Gift of the artist, 1902
Kupferstich-Kabinett, SKD, inv. no. A 1902-513
Kn 56 II 1

Three copies of the second state of this sheet are known. For the present
state, Kollwitz not only combined an orange-inked lithographic stone
as a tone stone and a copperplate with the motif of a woman holding a
tropical fruit, but also used an additional copperplate to impart its rosy
colour to the lampshade.

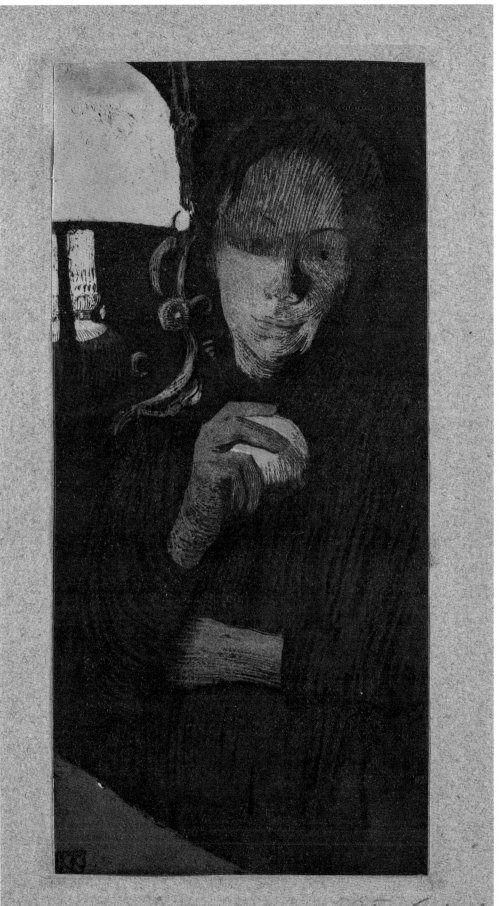

43

Portrait of Hans Kollwitz,
1896 (?)

Presumed unique
Crayon and brush lithograph in black ink,
with scraping, on copperplate paper,
264 × 208 mm (image), 287 × 223 mm (sheet)
Gift of the artist, 1906
Staatliche Museen zu Berlin,
Kupferstichkabinett, inv. no. 93-1906 (G)
Kn 39

This portrait of Hans Kollwitz is
considered Kollwitz's first lithograph.
The little boy's head is drawn in detail
with delicate crayon strokes, while the
black background, on the other hand, is
painted flat with a brush. This proof is
presumed unique. The artist gave it to the
Berlin Kupferstichkabinett while it was
under the direction of Max Lehrs.

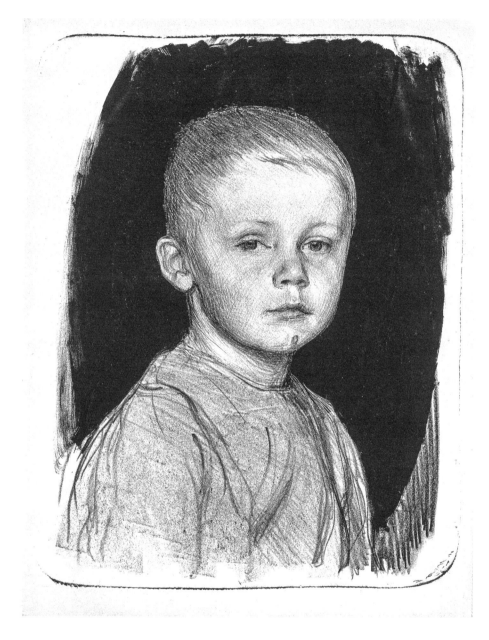

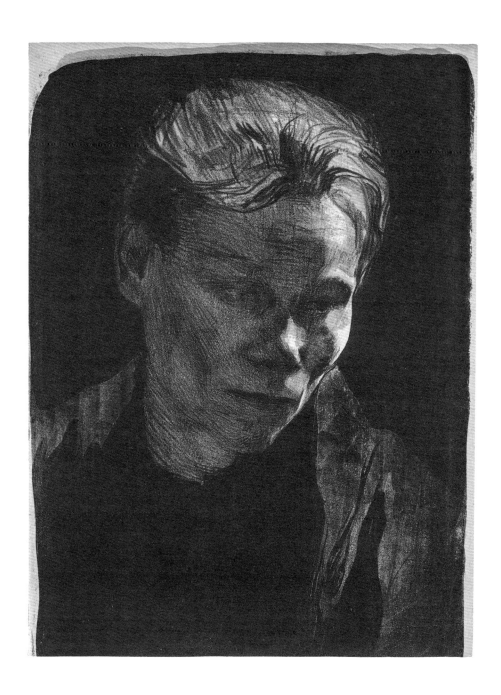

44

Bust of a working woman with blue shawl, 1903

First state
Crayon and brush lithograph in two
colours, with scraping, drawing stone in blue
(crayon and brush), tone stone in light brown
(brush), on Japan paper, image cut at bottom,
356 × 246 mm (image of the drawing stone
printed blue), 333 × 250 mm (sheet)
Signed lower right in the image with pencil:
Kollwitz
Purchased from the artist, 1904
Kupferstich-Kabinett, SKD, inv. no. A 1904-421
Kn 75 A I 1

This coloured lithograph is related to various other etched and
lithographic portraits of working women dating between 1903 and
1905. Here special emphasis is given to the embedding of the head in
the dark room surrounding it; the reflections of light on the forehead,
nose and cheeks are reserved in the light tone of the paper. The image
has been cut off at the bottom, while the other three edges display the
outline of the lithographic stone. This image reached a wide audience
through its distribution in the annual portfolio of the Gesellschaft
für vervielfältigende Kunst (Society for Reproductive Art) in Vienna in
1906. The deluxe edition included 100 proofs; the number of prints in
the standard edition, of which one copy entered the Dresden collection
in 1973, is not known.[28]

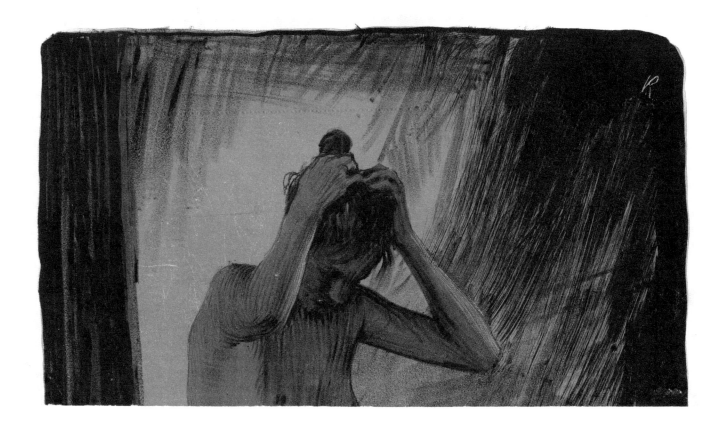

45

Woman arranging her hair,
1901 (?)

Only known print
Crayon and brush lithograph in three colours,
with scraping in the green tone stone: drawing
stone in black ink and the tone stones in green
and in orange, on copperplate paper, 151 × 268
mm (image, fragment), 287 × 399 mm (sheet)
Monogram upper right in the stone: *K*
Gift of the artist, 1902
Kupferstich-Kabinett, SKD, inv. no. A 1902-373
Kn 47

Verso: *The Ploughmen*, late 1901 or early 1902
Rejected first version of sheet 1 of the cycle
The Peasants' War
Crayon and brush lithograph, scraper, in black
ink, 250 × 350 mm (image), 287 × 399 mm
(sheet)
Kn 63

The Kupferstich-Kabinett owns the only proven copy of this
dressing-table scene printed in black, green and orange, visible
only as a fragment in the lithograph. This work is seen today in
the context of Kollwitz's first visit to Paris, and therefore assigned
to 1901, diverging from the date given in the catalogue raisonné.[29]
Kollwitz probably rejected this image and cut the sheet in order
to print a version, likewise rejected, of *The Ploughmen* as sheet 1 of
the cycle *The Peasants' War*, on the other side.[30]

46

Female nude, half-length, with pole, 1901 (?)

Crayon algraphy in red-brown ink with a tone plate in blue and black ink, with scraper in the drawing plate, on copperplate paper, 275 × 216 mm (drawing plate), 268 × 300 mm (sheet)
Purchased from the artist, 1902
Kupferstich-Kabinett, SKD, inv. no. A 1902-858
Kn 58a

The lithograph on an aluminium plate was printed in two versions (see also cat. 47). The dark background in the present version (a) emphasizes the effect of the light falling from the side, which highlights the back of the neck and arms.

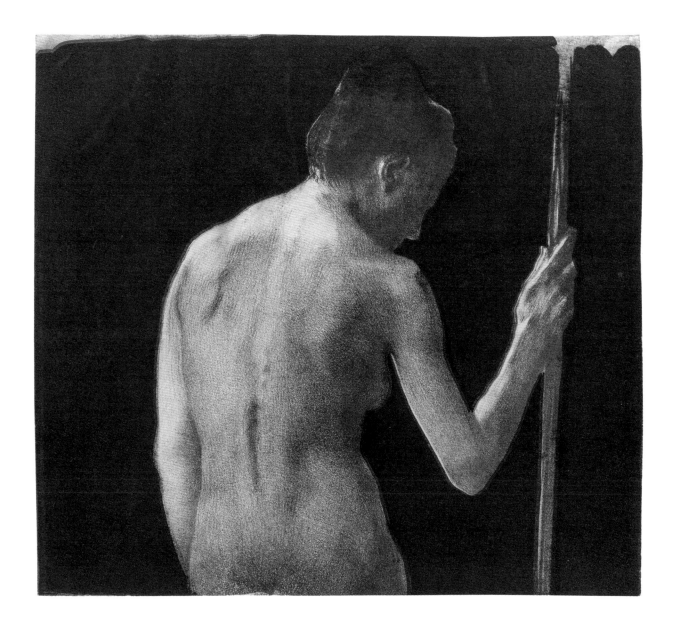

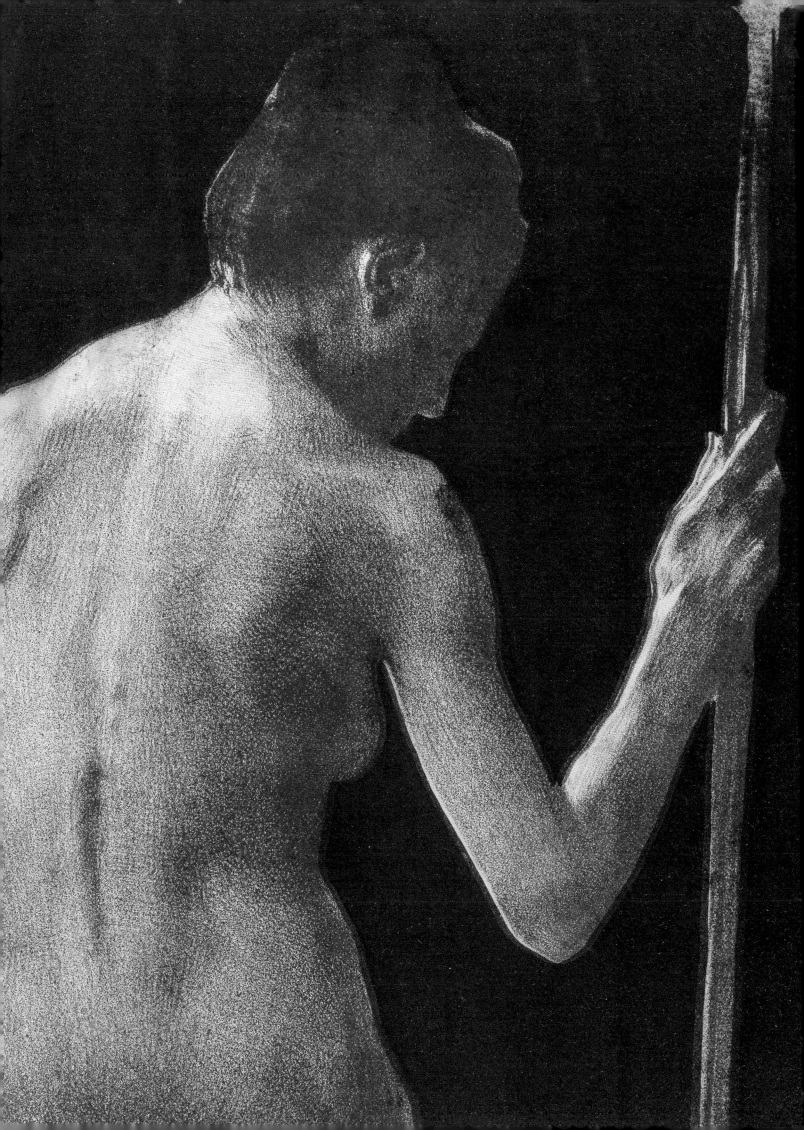

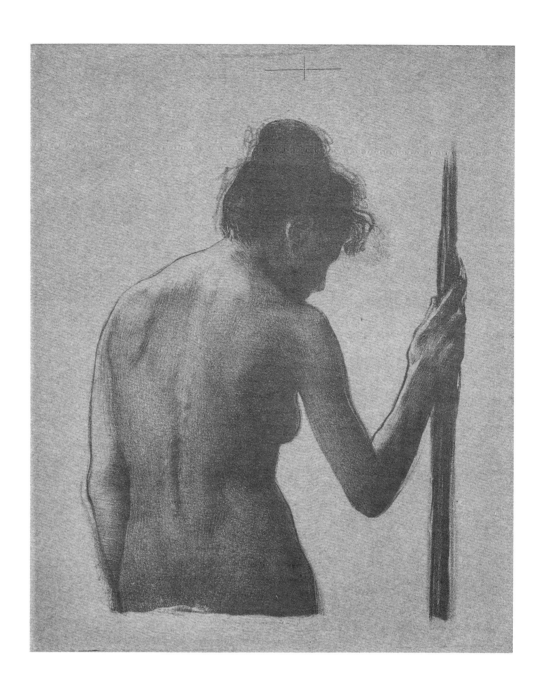

47
Female nude, half-length, with pole, 1901 (?)

Crayon algraphy in brown ink on thin Bristol cardboard (recto grey, verso white), 275 × 216 mm (drawing plate), 331 × 273 mm (sheet)
Gift of the artist, 1902
Kupferstich-Kabinett, SKD, inv. no. A 1902-375
Kn 58 b

The nude is a theme that Käthe Kollwitz engaged with for the first time during her student years.[31] In numerous sketches and drawings she explored mainly the female human figure, from 1909 especially in the context of sculpture. This half-length nude from the back with the model leaning on a pole represents a typical atelier situation.

48

Female nude, from behind, on green cloth, 1903

Second state
Crayon and brush lithograph in two colours,
drawing stone in brown, tone stone in green,
scraper used on the drawing stone, on firm,
brown coloured paper, 580 × 440 mm (image),
610 × 463 mm (sheet)
Signed and dated lower right on the image in
pencil: *Kollwitz 03*
Purchased from the artist, 1904
Kupferstich-Kabinett, SKD, inv. no. A 1904-418
Kn 76 II

Presumably, Kollwitz worked with the same model as for *Female nude,
half-length, with pole* (cat. 47) for this sheet with its atmospheric lighting.
For the theme, she measures herself against French art in the tradition of
Ingres. The lithograph, printed in two colours, is especially captivating
in the exquisitely illuminated shoulder area, virtually carved with the
scraper. The artist used the brown shade of the paper for the flesh tone.

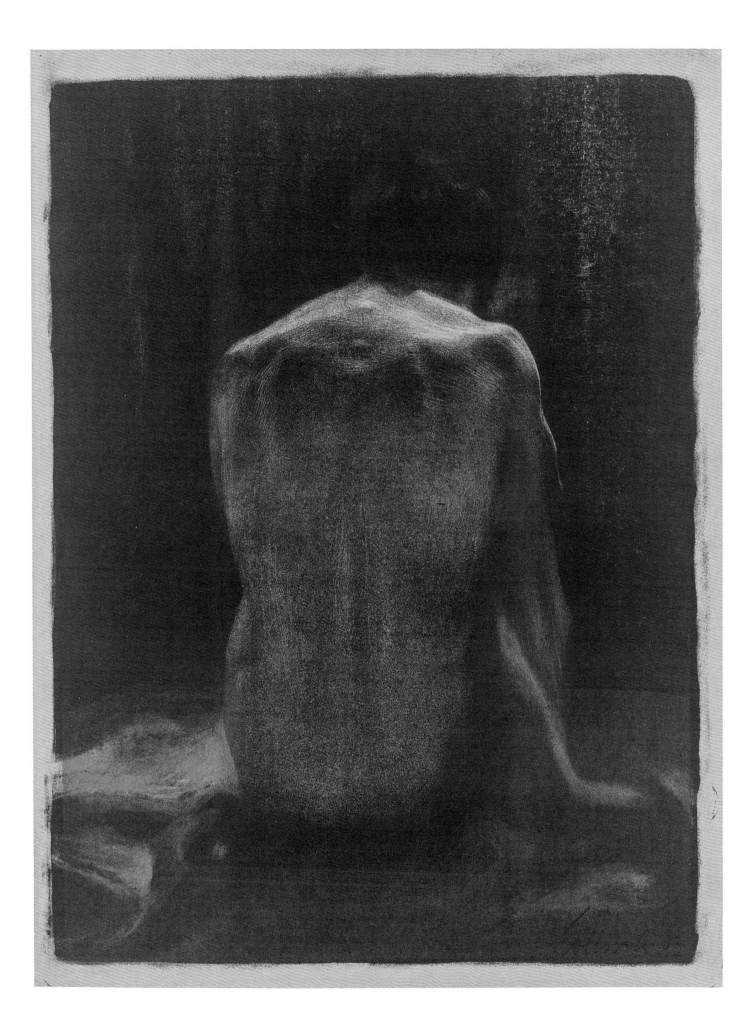

49

Woman at a cradle, 1897 (?)

Second state, without the engraved star
and oval embossed seal of the Gesellschaft
für vervielfältigende Kunst (Society for
Reproductive Art), Vienna
Etching, drypoint and emery in blue ink,
reworked with green crayon, on copperplate
paper, 276 × 146 mm (plate), 510 × 352 mm
(sheet)
Purchased from the artist, 1899
Kupferstich-Kabinett, SKD, inv. no. A 1899-471
Kn 40 II a

This scene was mistakenly identified by Max Lehrs as a rejected version
of *Need,* the first sheet in the cycle *A Weavers' Revolt*, and interpreted as
a woman at the cradle of her dying child.[32] The subject may in fact be
related to the birth of Kollwitz's son, Peter, and so shows, rather, a happy
moment.[33] The artist partially reworked this blue print in green crayon.
In 1902, a complementary reverse study of the figure of the woman,
inscribed with pen and ink, was acquired.[34]

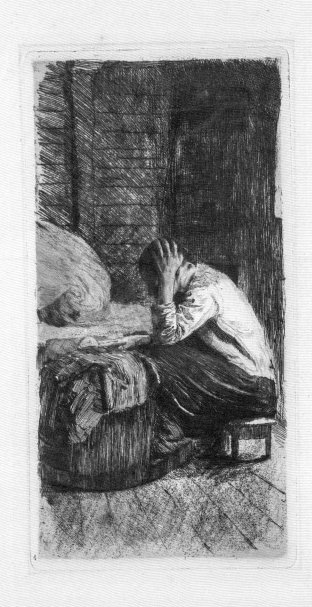

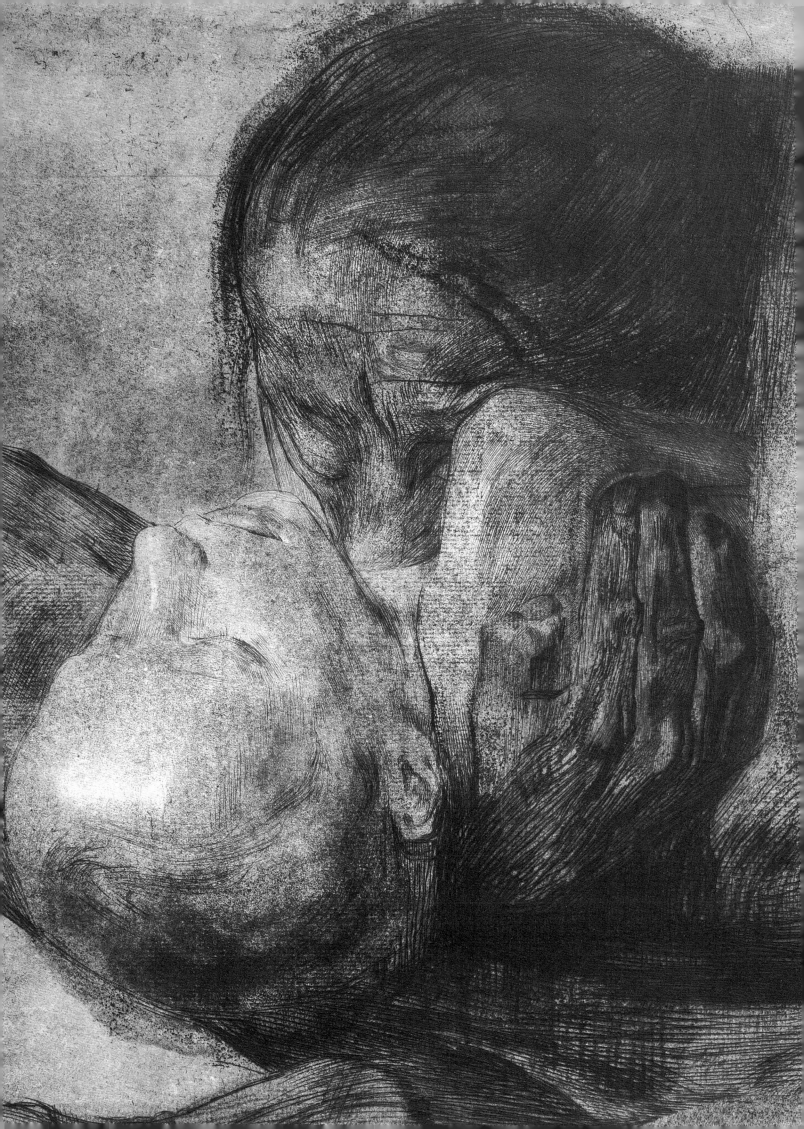

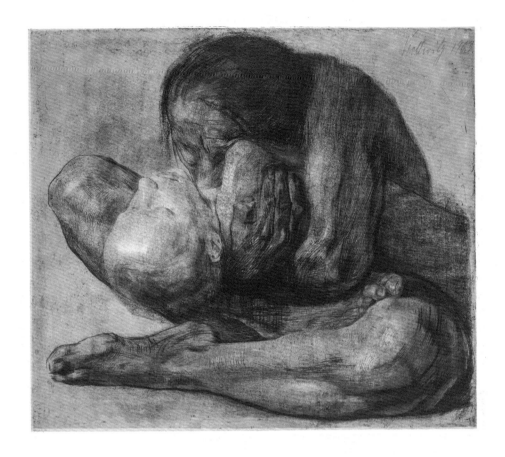

50

Woman with dead child, 1903

Eighth state
Etching, drypoint and emery, soft-ground
etching with imprint of ribbed hand-made
paper and Ziegler's transfer paper in brown
on greenish-grey China paper, mounted on
copperplate paper, 424 × 486 mm (plate),
536 × 635 mm (sheet)
Signed and dated upper right on the image
in pencil: *Kollwitz 1903*; inscribed lower left
below the image in pencil: *OFelsing Berlin gedr.*
[printed]
Purchased from the artist, 1904
Kupferstich-Kabinett, SKD, inv. no. A 1904-417
Kn 81 VIII a

This representation of a woman tightly cradling a child's lifeless
body is one of the first in which Kollwitz takes the theme of
a mother with her dead child as a subject in itself, without
embedding the figures in a larger scene. It is regarded as an
undeclared self-portrait of the artist with her son Peter, seven years
old at the time. The intertwined bodies are shaped into a surface
design through a combination of various working processes. The
work was exhibited at the Berlin Secession at the end of 1903, and
Kollwitz sent a copy for purchase to Dresden in May 1904.[35]

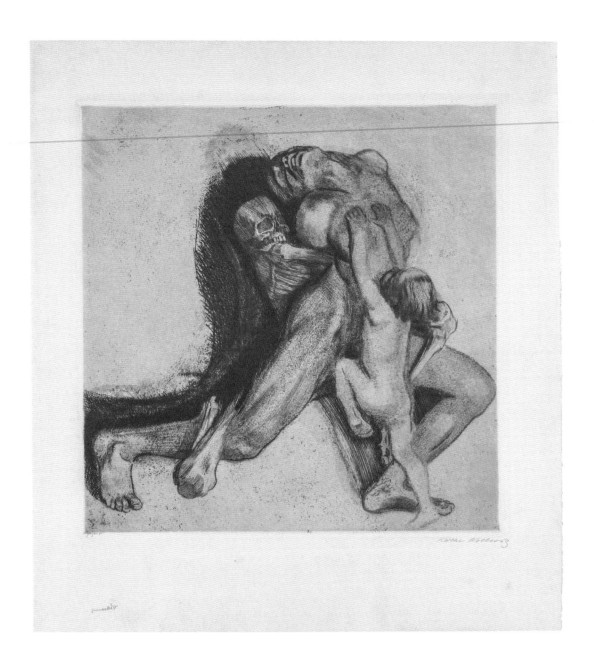

51

Death and Woman,
Spring 1910

Fifth state
Etching, drypoint, emery, soft-ground etching
with imprint of granulated coloured paper
and Ziegler's transfer paper, also some roulette
work in brown on ribbed hand-made paper
(watermark: 'van' and crowned coat of arms
cartouche with heraldic lily), 448 × 446 mm
(plate), 610 × 560 mm (sheet)
Signed in pencil lower right below the image:
Käthe Kollwitz; inscribed in pencil lower left
below the image: *OFelsing Berlin gedr.* [printed],
lower left: *unverstählt* [not steelified]
Purchased from the artist, 1911
Kupferstich-Kabinett, SKD, inv. no. A 1911-82
Kn 107 V b

This dramatic allegorical scene depicts a female figure rearing
up between the two opposing forces of life and death, both
pulling at her. A skeleton grasps the woman from behind, while
a child clutches at its mother's body from the front. Kollwitz
intensified this representation in the increasingly sculptural
development of the bodies and the augmentation of the
shadow framing them with hatching and emery up until the
fifth state.

52

Pregnant woman, before September 1910

Fourth state, earlier than the 1918 numbered edition by Emil Richter
Etching, aquatint and drypoint, soft-ground etching with imprint of hand-made paper and Ziegler's transfer paper in brown on copperplate paper, 377 × 235 mm (plate), 592 × 449 mm (sheet)
Signed lower right below the image in pencil: *Käthe Kollwitz*; inscribed lower left below the image in pencil: *OFelsing Berlin gedr.* [printed]
Purchased from the artist, 1911
Kupferstich-Kabinett, SKD, inv. no. A 1911-38
Kn 111 IVc

This representation of a pregnant woman is rendered compelling by the texture of her shawl, imitating rough wool. Kollwitz produced this effect with aquatint over the imprint of hand-made paper. The dynamic pattern of light stripes on the cloth calls attention to the woman's already decidedly curved belly. Her solemn face stands out brightly from the dark background.

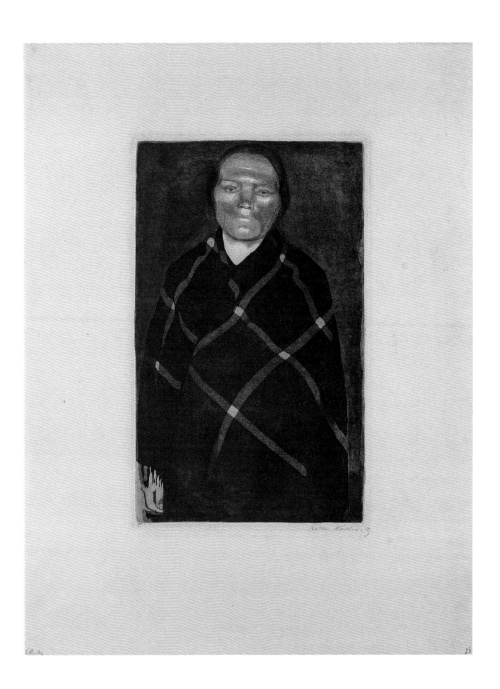

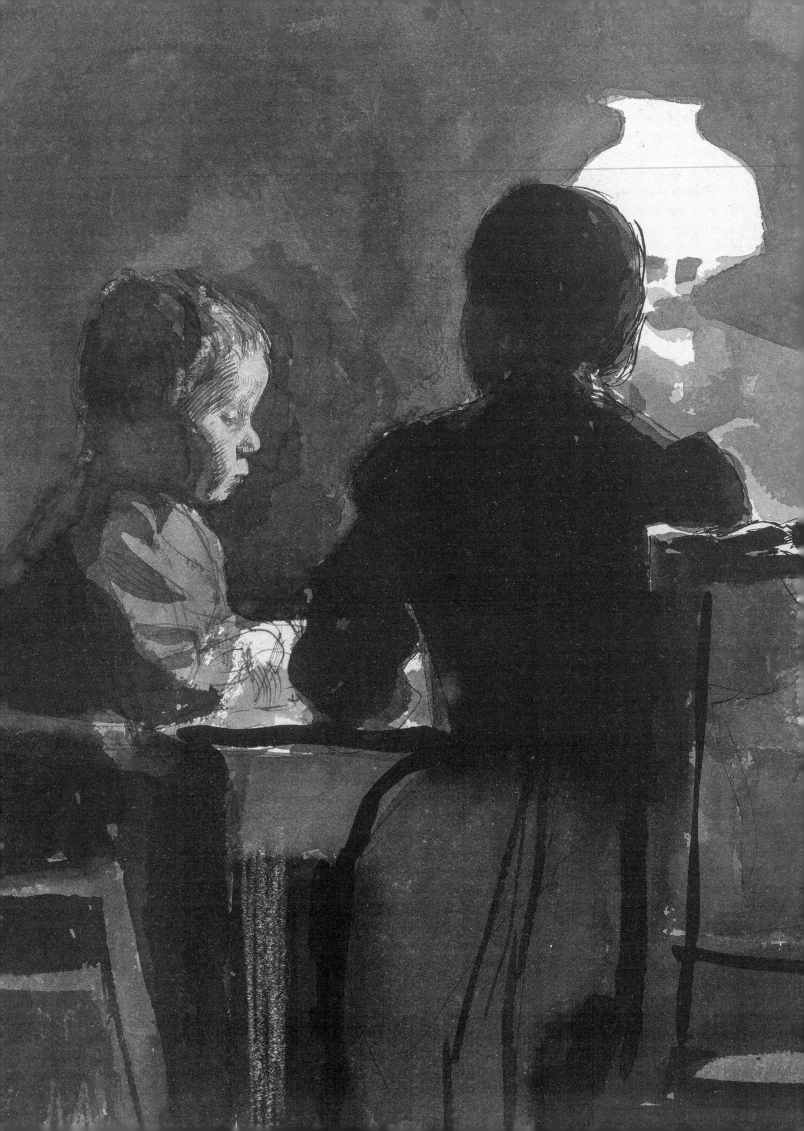

IV. Contemporary
Collecting and exhibiting 100 years ago

In 1929, in an article in the *Dresdner Anzeiger*, presumably written by Kurt Zoege von Manteuffel, the Director of the Kupferstich-Kabinett at the time, the author suggests that, when it comes to acquisitions, the "present" is not defined as a "random point in time" but as "a creative period of about two decades … that unites the endings, transitions and new beginnings of artistic forms typically permeating a transformational era. In this way, tracing the artistic activity of one's own time, with its characteristic examples and exceptional works, in addition to the seemingly immutable values of the art of previous ages, is one of the most important and fascinating tasks of a museum dedicated to the graphic arts."[36] Zoege von Manteuffel's predecessor, Max Lehrs, stayed true to this credo during his directorship, as demonstrated in particular by his dedication to Käthe Kollwitz.

The interval between the completion of one of her works and its acquisition by the collection was often short. Lehrs systematically purchased earlier works, but above all tried to keep up with current production. Characteristic of this approach are the acquisitions of the 1910s and 1920s, in which the principle of contemporaneity becomes particularly clear, especially considering Kollwitz's reaction to current political events. Central to this period were the momentous experience of the First World War and the artist's loss of her son, Peter, in 1914, and later the political and social upheaval of the Weimar Republic.

From the beginning, the newly acquired works by Kollwitz were for the most part immediately displayed in monthly or bi-monthly exhibitions in a special room of new acquisitions together with other recent purchases. In 1917, before the autumn 'Quarterly Exhibition' planned for the occasion of the artist's fiftieth birthday, Lehrs, thanks to the significant backing of a Dresden patron, was able to add to the existing six in the Museum's collection thirteen drawings from all periods of the artist's creativity. These were the centrepiece of a comprehensive presentation on Kollwitz within the 'New Acquisitions' exhibition in August and September.[37] The works were displayed in the Hall of New Acquisitions behind the glass doors of tall, polished oak collection cabinets – a hundred years ago a contemporary, modern mode of exhibition.[38]

Drawings

53

Self-portrait turned half right, c. 1890

Pen and brush in black ink on drawing paper,
233 × 166 mm
Purchased from the artist and donated to
the Kupferstich-Kabinett by Oscar Schmitz,
Dresden-Blasewitz, 1917
Kupferstich-Kabinett, SKD, inv. no. C 1917-34
N/T 19

Käthe Kollwitz completed this self-
portrait either during or shortly after
her attendance at the Münchner
Künstlerinnenschule (Munich School for
Women Artists). The head, drawn in pen
in three-quarter view, is realistically and
precisely executed. Hair, collar and the
surrounding space are merely suggested
in effortlessly placed, broad brushstrokes.
The young artist's gaze is sceptical and
confident in equal measure.

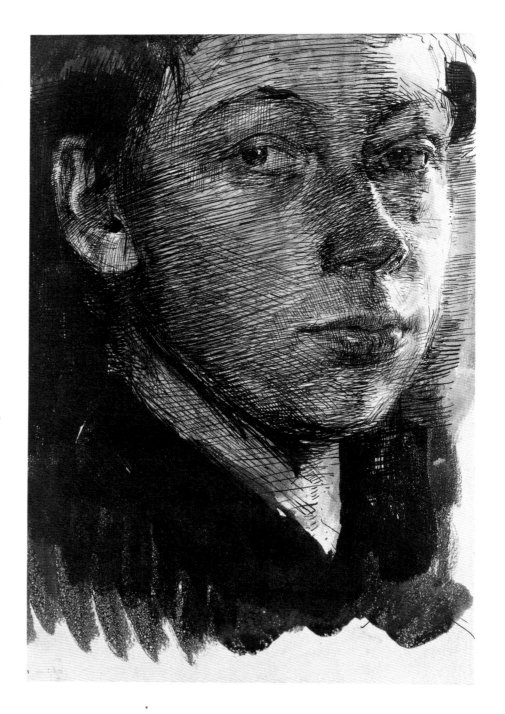

54

Self-portrait with loosened hair, en face, c. 1892

Pencil on light-brown wove paper,
216 × 178 mm
Signed lower right in pencil: *Kollwitz*
Purchased from the artist and donated to
the Kupferstich-Kabinett by Oscar Schmitz,
Dresden-Blasewitz, 1917
Kupferstich-Kabinett, SKD, inv. no. C 1917-39
N/T 74

Kollwitz drew early self-portraits mainly
in ink; this is among the few drawn in
pencil. It was completed in the same year
as her son Hans was born. With powerful,
sweeping strokes she sketches in
particular the wisps of hair playing about
her face. Her gaze is contemplative and
solemn, meeting the observer directly,
and at the same time introspective.

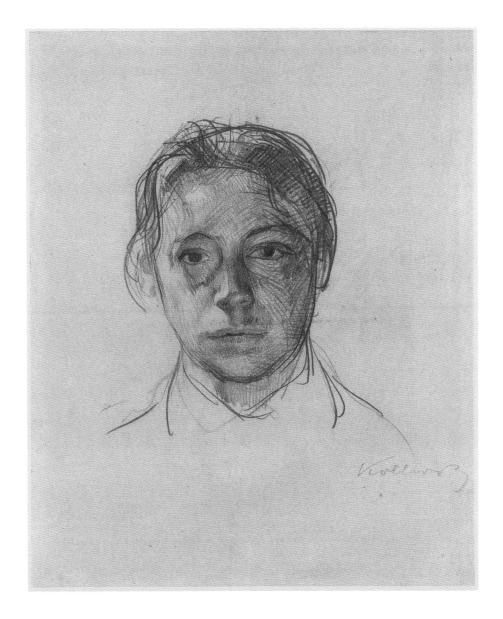

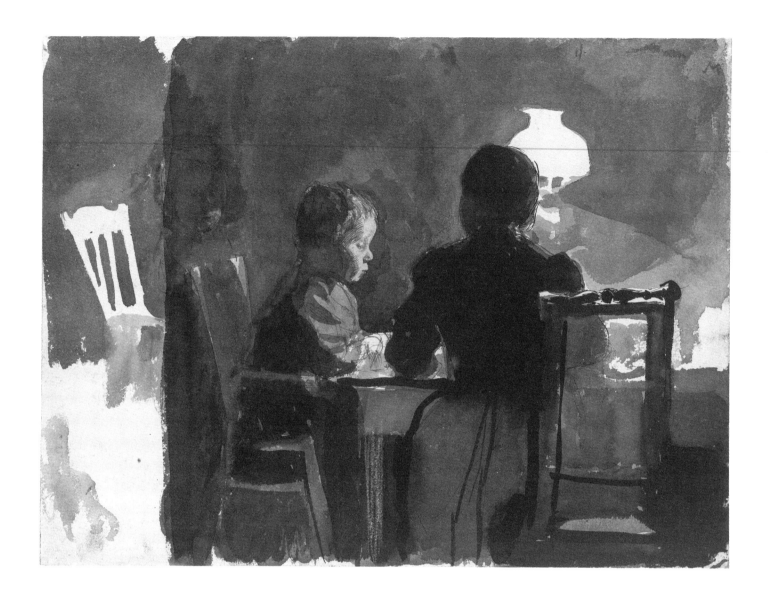

55

Under the table lamp, 1894

Pen in black ink, pencil in grey, white crayon
over pencil, on wove paper (Whatman Paper),
247 × 330 mm
Purchased from the artist and donated to
the Kupferstich-Kabinett by Oscar Schmitz,
Dresden-Blasewitz, 1917
Kupferstich-Kabinett, SKD, inv. no. C 1917-33
N/T 109

Her two sons, Hans and Peter, served repeatedly as models for
Kollwitz. In this atmospherically lit family scene, two-year-old
Hans sits at the table with a nanny, viewed from the back. In a
second drawing of the same situation the small child looks towards
his mother, but here he is shown in profile, his face softly lit by the
glow of a petroleum lamp over the table.[39] A second child's head
is indicated in silhouette behind the first figure in pen, but then
painted over with the brush. On the back are three more head
studies of the boy in black ink.

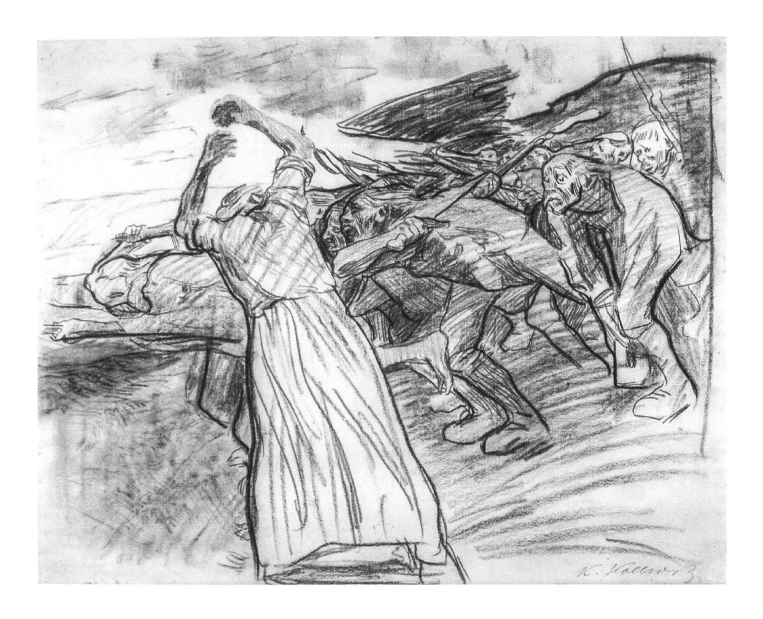

56

Charge, c. 1902

Compositional sketch for the etching, sheet 5
of the cycle *The Peasants' War*
Charcoal and red chalk on hand-made Ingres
paper (watermark 'PL BAS'), 466 × 610 mm
Signed lower right in pencil: *Käthe Kollwitz*
Purchased from the artist and donated to
the Kupferstich-Kabinett by Charles Walter
Palmié, Dresden, 1917
Kupferstich-Kabinett, SKD, inv. no. C 1917-22
N/T 189

Sheet 5 of the cycle *The Peasants' War*, which entered the collection
as a gift from the Verbindung für historische Kunst (Association
for Historic Art) in 1904, was developed by Käthe Kollwitz in
numerous drawings. The composition is significantly shaped
by the historical figure of the 'Schwarze Hofmännin', or 'Black
Anna', who incited the charging peasants. Her figure, seen from
the back with her arms thrown up, orientated obliquely to the
left, counterpoints the diagonal movement of the peasants. The
dynamic tension within the image mirrors the tension-filled
moment of revolutionary uprising.[40]

57

Seated old woman, c. 1905

Crayon on hand-made Ingres paper
(watermark 'PL BAS'), 582 × 395 mm
Signed lower right in pencil: *Kollwitz*
Purchased from Galerie Ernst Arnold,
Dresden, 1917
Kupferstich-Kabinett, SKD, inv. no. C 1917-49
N/T 376

Numerous drawings of this elderly woman with strikingly haggard
features exist, showing her in various poses. In 1901 the artist expressed
her admiration of Leopold von Kalckreuth's 1894 painting *Old Age*
(fig. 14) to Max Lehrs.[41] The dignified monumentality of the two peasant
women seated at the edge of the field in that work may have inspired
her representation of this working-class woman.

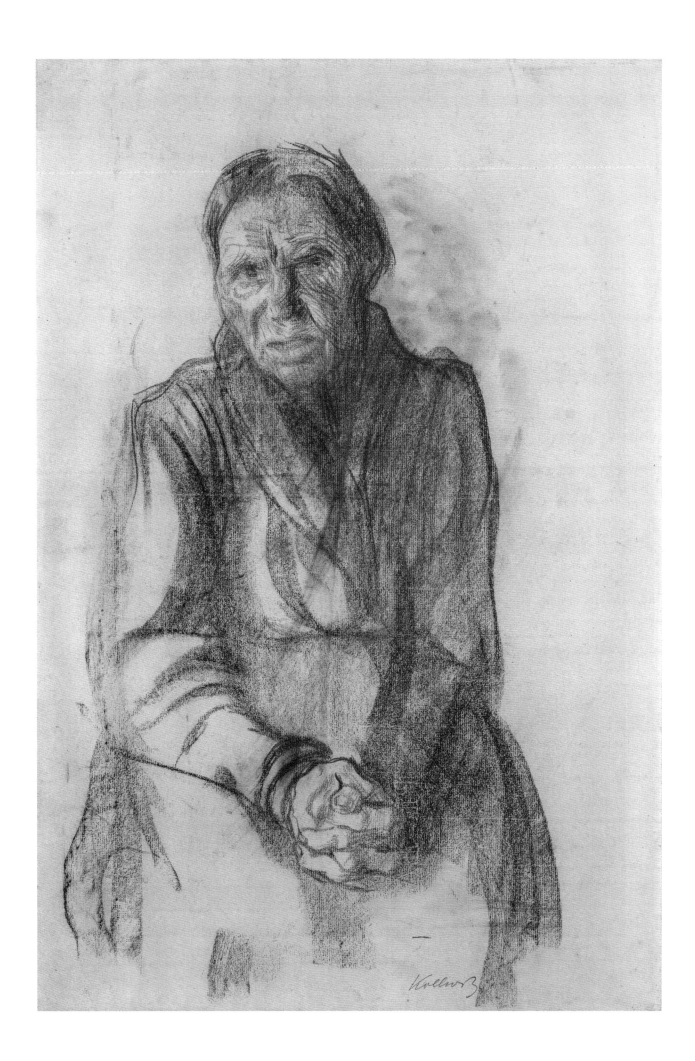

58

Bound peasant, not later than Spring 1908

Study for the etching *The Prisoners*,
sheet 7 of the cycle *The Peasants' War*
Charcoal on hand-made Ingres paper
(watermark 'PL BAS'), 608 × 438 mm
Signed lower right in charcoal: *Kollwitz*
Purchased from the artist and donated to
the Kupferstich-Kabinett by Oscar Schmitz,
Dresden-Blasewitz, 1917
Kupferstich-Kabinett, SKD, inv. no. C 1917-36
N/T 431

This study is dedicated to the middle
figure seen from the back in the etching
The Prisoners, sheet 7 of the cycle *The
Peasants' War*, dated Spring 1908. Kollwitz
drafted the composition of the prisoners,
crammed together as a block behind a
barricade, and their individual figures,
in a whole series of drawings in charcoal,
crayon and pencil.

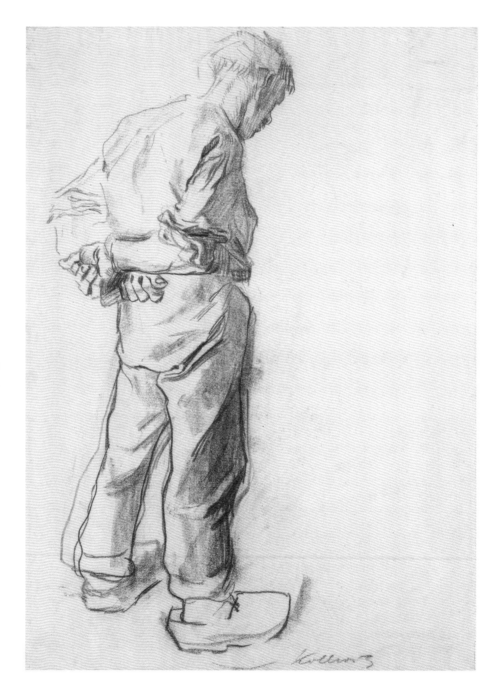

59
Sleeping child, c. 1909

Charcoal on hand-made Ingres paper
(watermark 'JCA France'), 517 × 408 mm
Signed centre right on the drawing in pencil:
Kollwitz
Purchased from Galerie Ernst Arnold,
Dresden, 1917
Kupferstich-Kabinett, SKD, inv. no. C 1917-51
N/T 538

Whether this image of a sleeping child,
like another drawing with three detailed
studies of a sleeping infant belonging to
the Kupferstich-Kabinett,[42] is related to
the etching *Unemployment* is not known.[34]
On the back is a baby's head in charcoal.

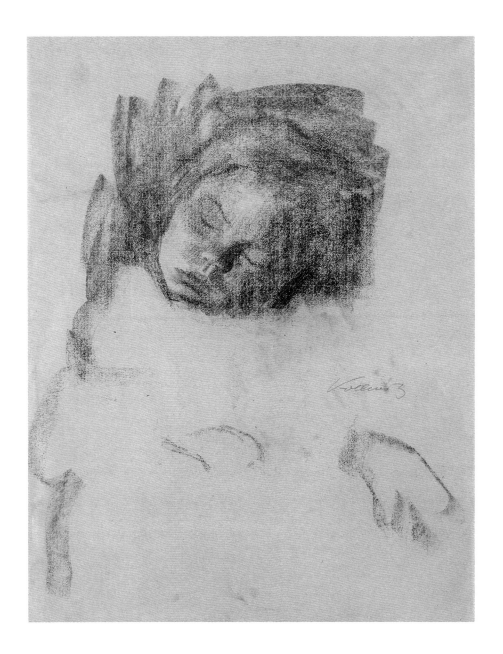

60

Frontal self-portrait, 1911

Black crayon heightened and smeared
with violet and grey crayon, on grey-brown
coloured paper, 359 × 308 mm
Signed and dated lower centre right in
pencil: *K. Kollwitz 11*
Purchased from Galerie Ernst Arnold,
Dresden, 1917
Kupferstich-Kabinett, SKD, inv. no. C 1917-50
N/T 690

This monumental head conveys a certain ruthlessness in the
solemnity of its expression and frontality. Eyes, nose and mouth are
precisely outlined in crayon and fine hatching. The shadowing of
the left side of the face and the black framing of the the head are, on
the other hand, hatched with the broad side of the crayon. The hair
is rendered halo-like with smeared grey crayon, lessening somewhat
the impression of severity.

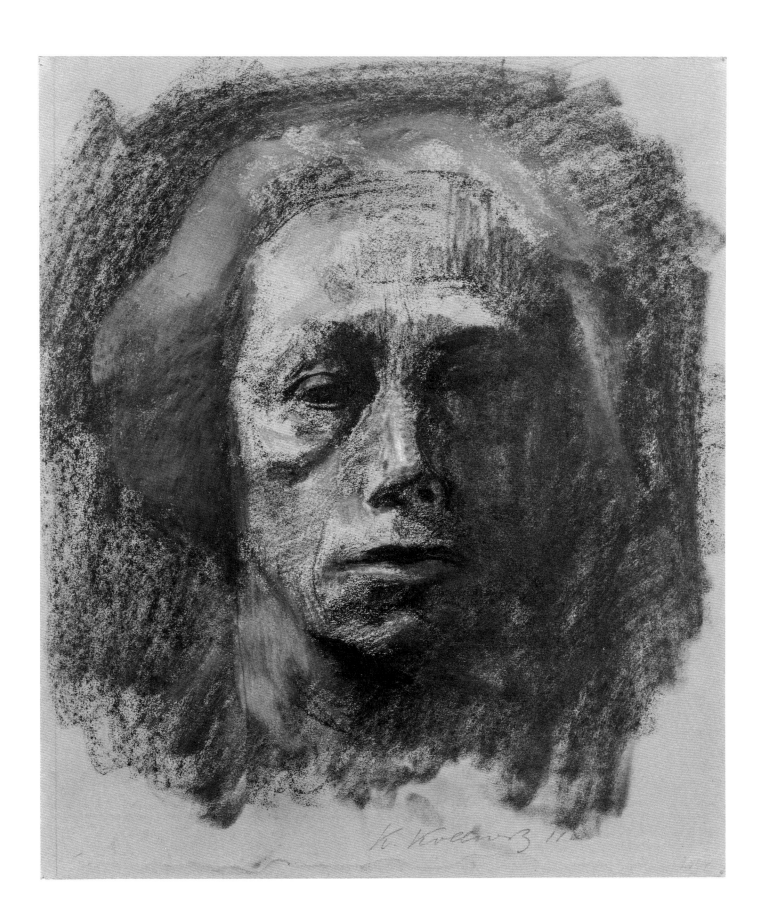

Prints

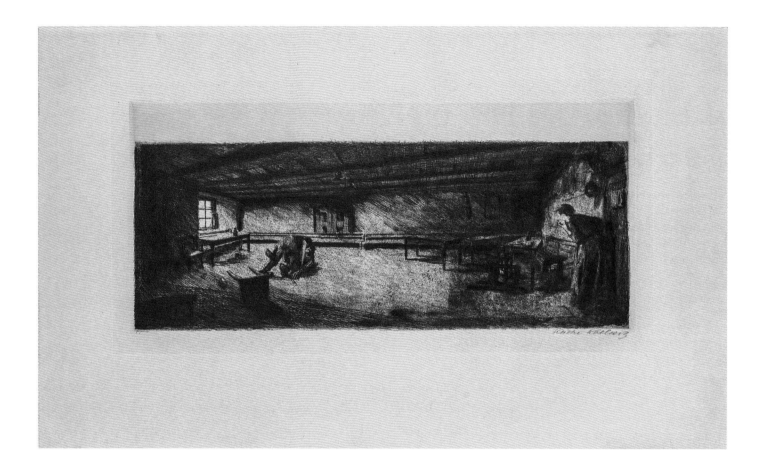

61

Scene from Germinal, not later than 1893

Third state
Etching, drypoint and emery in brown on
copperplate paper, 239 × 528 mm (plate),
430 × 723 mm (sheet)
Signed lower right below the image in pencil:
Käthe Kollwitz; inscribed lower left below the
image in pencil: *Felsing Berlin gedr.* [printed]
Purchased from Kunsthandlung P. H. Beyer
und Sohn, Leipzig, 1917
Kupferstich-Kabinett, SKD, inv. no. A 1917-253
Kn 19 III b

On subjects relating to Zola's novel
Germinal, see cat. 36.

62

Self-portrait at a table, 1893 (?)

Third (final) state
Etching, drypoint, aquatint and brush
etching in brown ink on copperplate paper,
178 × 129 mm (plate), 347 × 258 mm (sheet)
Signed lower right below the image in pencil:
Käthe Kollwitz; inscribed lower left below the
image in pencil: O*Felsing Berlin gedr.* [printed]
Purchased from Kunsthandlung P. H. Beyer
und Sohn, Leipzig, 1917
Kupferstich-Kabinett, SKD, inv. no. A 1917-476
Kn 21 III b

The situation in which the artist has
portrayed herself is identical to that
in *Under the table lamp* (cat. 55). She
depicts herself in a domestic setting
in her apartment on Weißenburger
Street in Berlin, seated at the table with
needlework, her face illuminated by the
lamp. Her head seems strangely detached
from her body and appears to float in
the darkness of the room. The first and
second states had already been purchased
for the Museum in 1902.[44] These were
supplemented in 1917 with the third
state.

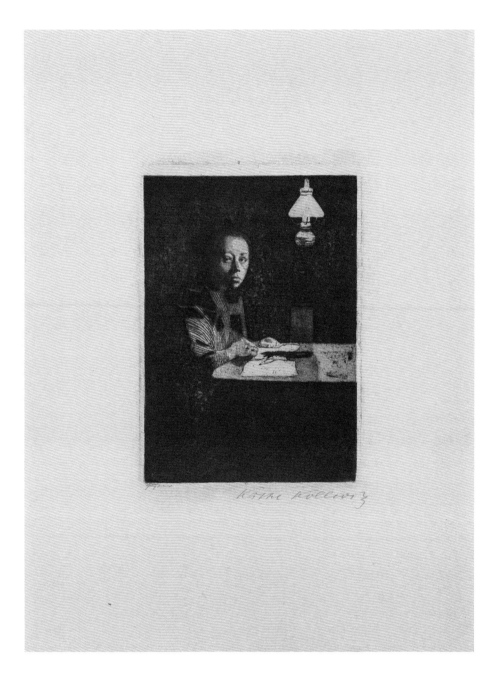

63

Standing female nude, 1900

Second state
Etching and drypoint in brown on
copperplate paper, 177 × 137 mm (plate),
348 × 281 mm (sheet)
Signed lower right below image in pencil:
Käthe Kollwitz; inscribed lower left below the
image in pencil: *OFelsing Berlin gedr.* [printed]
Purchased from Kunsthandlung P. H. Beyer
und Sohn, Leipzig, 1917
Kupferstich-Kabinett, SKD, inv. no. A 1917-477
Kn 50 II b

The figure of the nude female model with raised right arm was
etched in fine lines; Kollwitz then worked with a steel needle
directly on the copper plate to introduce fine cross-hatching for
the texture of the ground, which resembles fabric. As a result of
the contrast thus created between the carefully modelled body
and the background the body stands out in relief as if in a beam
of light.

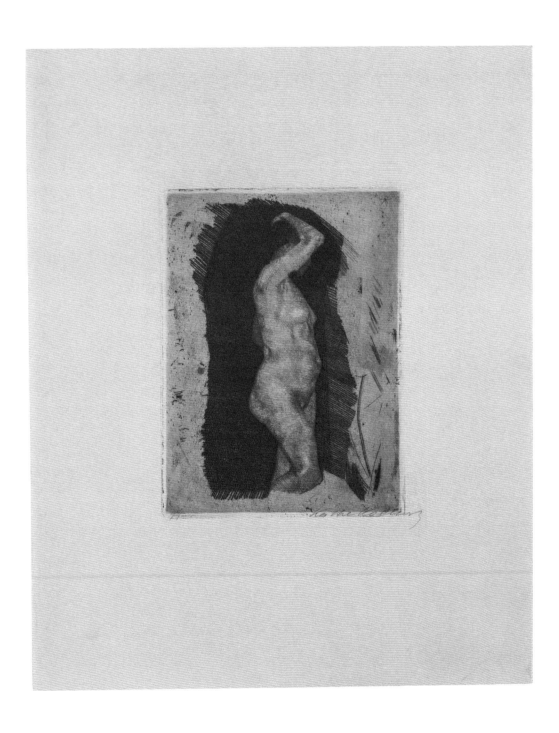

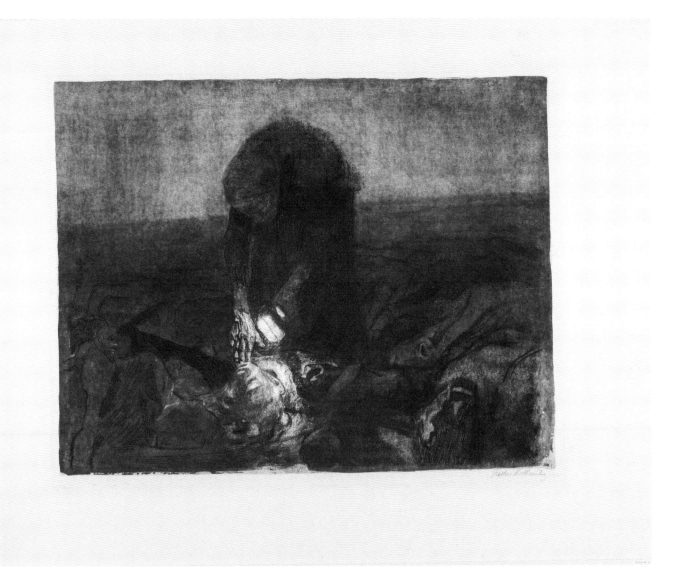

64

Battlefield, 1907

Sheet 6 of the cycle *The Peasants' War*
Tenth state, antedating the 1908 edition
Etching, drypoint, aquatint, emery and
soft-ground etching with imprint of ribbed
hand-made paper and Ziegler's transfer
paper in green-black ink on Japan paper,
410 × 531 mm (plate), 548 × 720 mm (sheet)
Signed lower right in pencil: *Käthe Kollwitz*
Purchased from Kunsthandlung P. H. Beyer
und Sohn, Leipzig, 1917
Kupferstich-Kabinett, SKD, inv. no. A 1917-252
Kn 100 X a

This sheet was completed before the edition made in 1908 for the
Verbindung für historische Kunst (Association for Historic Art),
which had commissioned the cycle *The Peasants' War* in 1904. The
motif of the woman looking for her son among the dead on the
battlefield was repeatedly reworked and distilled. The scene was
originally intended as the last sheet of the cycle, in a bitter ending:
the peasant uprising was violently repressed by the authorities.

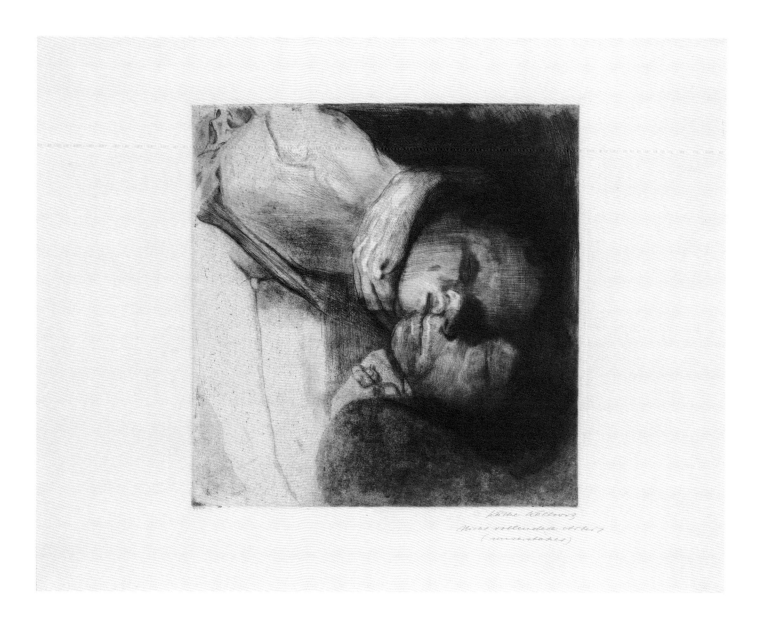

65

Death, Woman and Child, Spring 1910

Eleventh state
Etching, drypoint and emery, and soft-ground
etching with imprint of hand-made paper
and Ziegler's transfer paper, in brown on
copperplate paper, 404 × 407 mm (plate),
557 × 708 mm (sheet)
Signed and inscribed lower right below the
image in pencil: *Käthe Kollwitz/ nicht vollendete
Arbeit/ (unverstählt)* [unfinished work (not
steelified)]; inscribed lower left below the
image in pencil: *OFelsing Berlin gedr.* [printed]
Purchased from Kunsthandlung P. H. Beyer
und Sohn, Leipzig, 1917
Kupferstich-Kabinett, SKD, inv. no. A 1917-254
Kn 108 XI a

After intensive work on the cycle *The Peasants' War*, Kollwitz
returned to the subject of Mother, Child and Death in Spring 1910.
While in *Death and Woman* (cat. 51), Death, in the allegorical form of
a skeleton, rips the distraught child from its mother, here a skull is
barely indicated at top left. The focus lies instead on the converging
facial features of mother and child; the features of the mother are
reminiscent of the artist.

66

Female nude, 1910 (?)

Second state
Line etching, aquatint and soft-ground etching
with imprint of hand-made paper in brown
ink on copperplate paper, 239 × 119 mm (plate),
345 × 277 mm (sheet)
Signed and inscribed lower right below image
in pencil: *Käthe Kollwitz/ vor der Verstählung*
[before steelifying]; inscribed lower left
below the image in pencil: *OFelsing Berlin gedr.*
[printed]
Purchased from the Kunsthandlung P. H. Beyer
und Sohn, Leipzig, 1917
Kupferstich-Kabinett, SKD, inv. no. A 1917-478
Kn 116 II a

The thick texture of this female nude
was produced by means of aquatint and
soft-ground etching with the imprint of
hand-made paper. The voluminous body
shown in a side view from the back is cut
into at the top and bottom edges of the
plate, giving it the appearance of being
trapped in the dark image space.

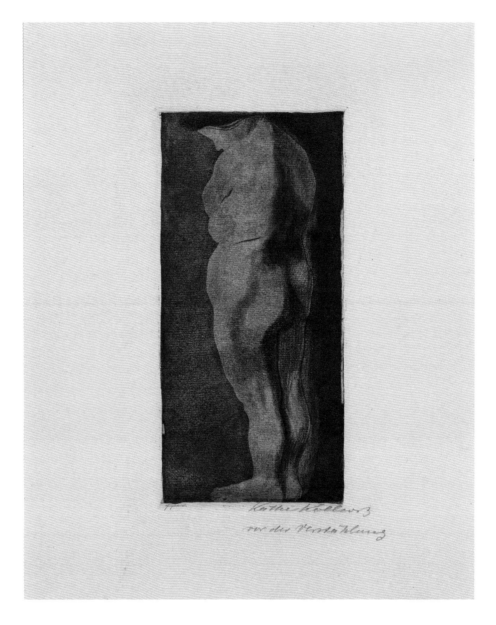

67

Waiting (Fear), before end October 1914

Proof from the original stone, first state, with the lithographed title
Crayon lithograph in black ink (imprint of an unknown drawing on ribbed hand-made paper) on Japan paper (hand printed by Pan-Presse), 340 × 245 mm (image without lithographed title), 511 × 381 mm (sheet)
Signed lower left in the stone: *Kollwitz*; inscribed lower middle below image: *Das Warten* [Waiting]
Verso: inscribed lower centre in pencil (by Hans Wolfgang Singer): *Einer der sechs Vorzugsdrucke mit 'Warten'* [one of the six proofs of the deluxe edition with 'Waiting']/ *Probedruck: Geschenk der Künstlerin/ 22.X.15/* [trial proof: gift of the artist]
Gift of the artist, 1915
Kupferstich-Kabinett, SKD, inv. no. A 1915-429
Kn 132 A I a

Kollwitz completed this drawing, transferred to lithographic stone, for *Kriegszeit. Künstlerflugblätter*, a magazine published by Paul Cassirer featuring original graphic work; it appeared while there was enthusiasm for the War, from 1914 to 1916. Contributions came mainly from artists belonging to the Berlin Secession. The original title of the sheet, *Waiting*, was changed to *Fear* by the editors. The blocky female figure with closed eyes, published in the edition of 28 October 1914, stands for the abstract concept of waiting. Like many other families, Kollwitz at this time was hoping for news of her son Peter, who had volunteered for service in the War. His death in a skirmish during the night of 22–23 October 1914 near Diksmuide in western Flanders led his mother to become a pacifist. This sheet is one of a deluxe edition of six drawn off prior to the main print run and was shown in 1916 in the exhibition 'Kriegsgraphik' (Prints of War) at the Dresden Kupferstich-Kabinett. The accompanying catalogue read: "As an image of pain, Käte [sic!] Kollwitz depicts a woman of the people with closed eyes and clenched lips".[45]

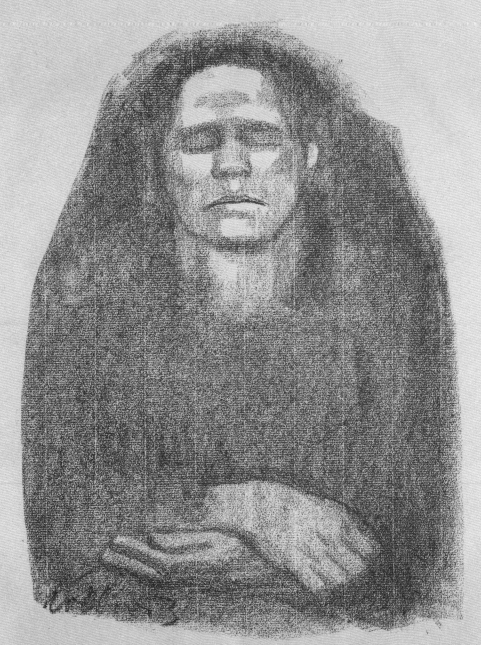

Das Warten

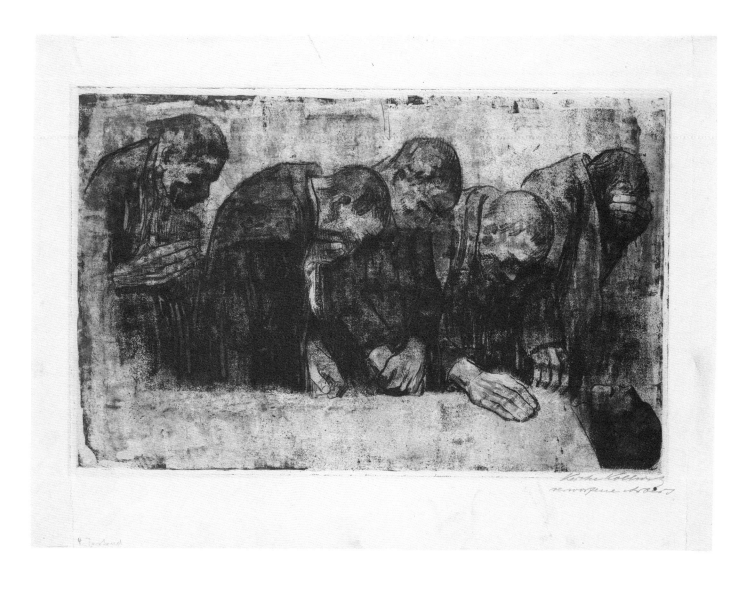

68

In Memoriam Karl Liebknecht, before October 1919

Rejected first version
Fourth state
Line etching, aquatint, emery, lift-ground etching and soft-ground etching with imprint of hand-made paper in brown on copperplate paper, 335 × 535 mm (plate), 448 × 616 mm (sheet)
Signed and inscribed lower right below the image in pencil: *Käthe Kollwitz/ verworfene Arbeit* [rejected work]; inscribed lower left: *4. Zustand* [4th state]
Purchased from the artist and donated to the Kupferstich-Kabinett by Amélie Aulhorn, Dresden, 1920
Kupferstich-Kabinett, SKD, inv. no. A 1920-596
Kn 145 IV

The politician Karl Liebknecht was murdered together with Rosa Luxemburg in Berlin by Freikorps officers following the suppression of the Spartacist uprising on 15 January 1919. Käthe Kollwitz was allowed to draw the founder of Germany's Communist party in the morgue and used this study for a draft of a memorial. She started with an etching, switching to lithography later. She rejected both works. The final version, however, retains the original composition with the mourners at the deathbed, orientated parallel to the image in woodcut. She later added a band of text with a dedication. Both these final versions (see cat. 69) were acquired by the Dresden Kupferstich-Kabinett.[46]

69

In Memoriam Karl Liebknecht, not before October 1919

Rejected second version
Crayon lithograph in black ink (imprint from drawing N/T 779 on ribbed hand-made paper) on heavy wove paper (watermark 'Papier Lipsia 2 A luftgetrocknet'), 420 × 660 mm (plate), 555 × 788 mm (sheet)
Signed and inscribed lower right below the image: *Käthe Kollwitz/ verworfene Arbeit* [rejected work]
Purchased from the artist and donated to the Kupferstich-Kabinett by Amélie Aulhorn, Dresden, 1920
Kupferstich-Kabinett, SKD, inv. no. A 1920-597
Kn 146

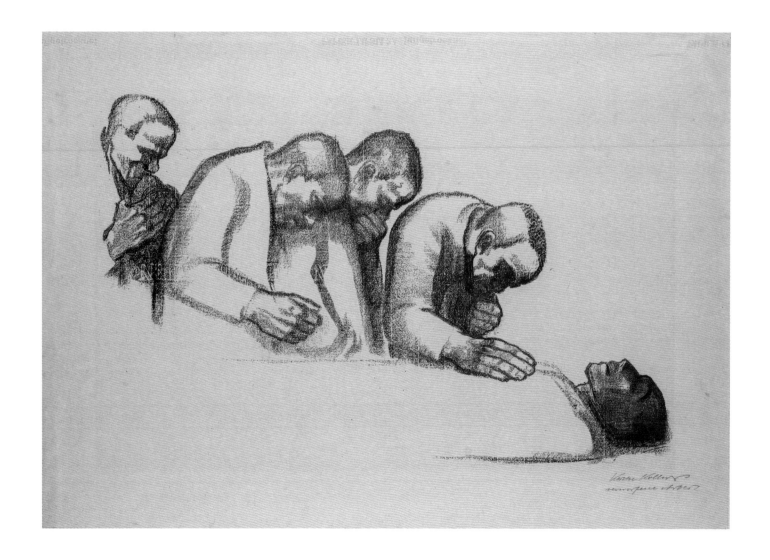

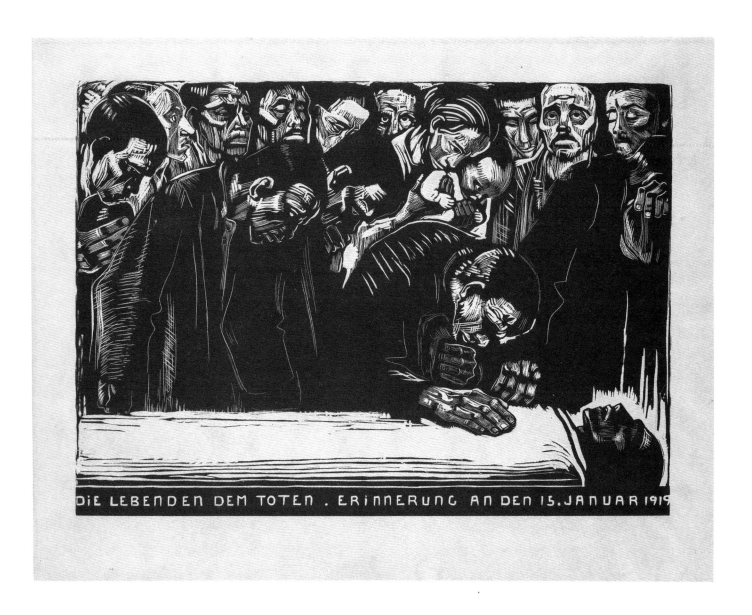

70

In Memoriam Karl Liebknecht, 1920

Third (final) version
Fifth state, with band of text
Woodcut in black ink on thick, soft,
rough wove paper, 355 × 500 mm (image),
445 × 573 mm (sheet)
Inscribed lower middle in the woodblock: DIE
LEBENDEN DEM TOTEN. ERINNNERUNG
AN DEN 15. JANUAR 1919 [The living to the
dead man. Remembering 15 January 1919]
Purchased from the artist, 1921
Kupferstich-Kabinett, SKD, inv. no. A 1921-476
Kn 159 VI a

71

Help Russia, end of August 1921

Proof from original stone, first state
Crayon lithograph in black ink (imprint)
on ribbed hand-made paper (watermark
'SALVANTIK'), 667 × 477 mm (image with
text), 797 × 590 mm (sheet)
Inscribed in the stone lower middle: *Helft/
Russland* [Help Russia]; lower centre: *Komite
für Arbeiterhilfe* [Committee for Workers' Aid]:
Berlin Rosenthalerstr. 38; signed and dated lower
right on the image in pencil: *Kollwitz 1921*
Purchased from the artist, 1921
Kupferstich-Kabinett, SKD, inv. no. A 1921-475
Kn 170 A I

With this poster, Käthe Kollwitz
campaigned for international aid,
initiated by the Socialist and Communist
parties, for the Volga region, threatened
by famine after a draught in 1921.
Although she wrote in her diary, "I've
got involved in politics again with this,
completely against my will",[47] to Max
Lehrs she characterized the work as
"successful".[48]

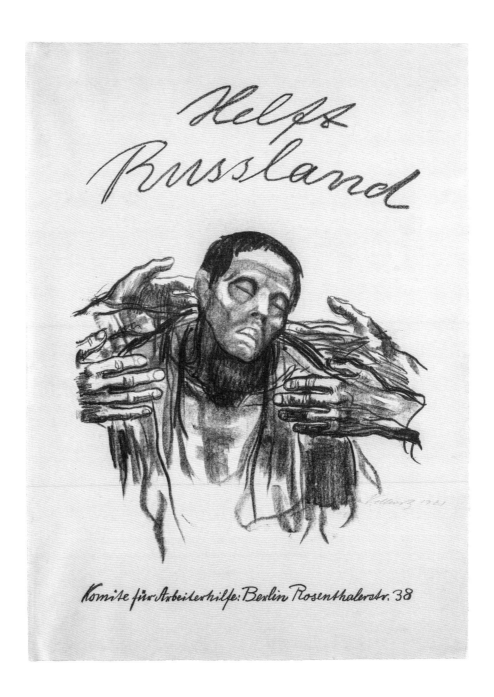

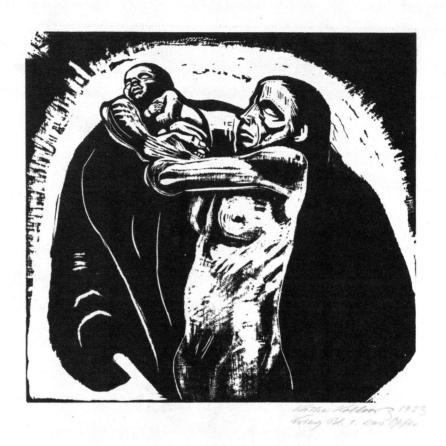

72

The Sacrifice, 1922

Sheet 1 of the series *War*
Ninth state, proof prior to the Emil Richter
edition of 1924
Woodcut in black ink on thick, soft, rough
Japan paper, 371 × 402 mm (image),
684 × 548 mm (sheet)
Signed and inscribed lower right in pencil:
Käthe Kollwitz/ Krieg Bl. 1. Das Opfer
Anonymously donated, 1924; pre-paid for
by Charles Walter Palmié, Dresden, December
1922
Kupferstich-Kabinett, SKD, inv. no. B 522h/1
Kn 179 IX a 1

On 28 October 1914, Käthe Kollwitz remarked in her diary that she could not "... find a form for what the war brings me. Every form is too familiar, too typical. Something so new should also find a new form of expression."[49] In summer 1920 she would discover in the woodcut – inspired by the work of Ernst Barlach – the medium in which she could express artistically her experience of the First World War and especially the loss of her son Peter. She worked on the seven-part series *War* from 1921 until autumn 1922; it appeared in three editions with Emil Richter in Dresden in 1924. The Kupferstich-Kabinett sheets are proofs prior to the printing.

73

The Volunteers,
1921– early 1922
at the latest

Sheet 2 of the series *War*
Fourth state, proof prior to the Emil Richter
edition of 1924
Woodcut in black ink on thick, soft, rough
Japan paper, 350 × 496 mm (image),
551 × 689 mm (sheet)
Signed and inscribed lower right in pencil:
Käthe Kollwitz/ Krieg Bl. 2. Die Freiwilligen
Anonymously donated, 1924; pre-paid for
by Charles Walter Palmié, Dresden, December
1922
Kupferstich-Kabinett, SKD, inv. no. B 522h/2
Kn 173 IV a

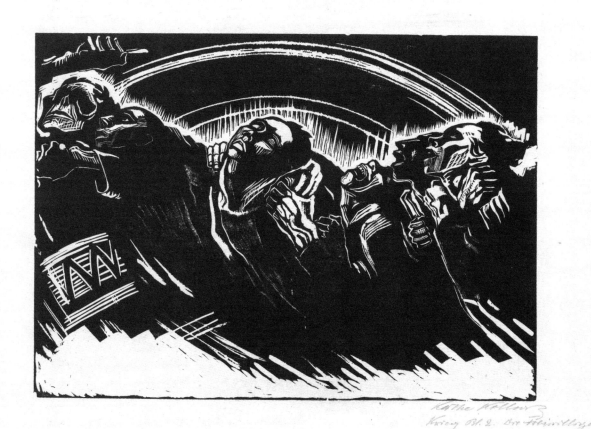

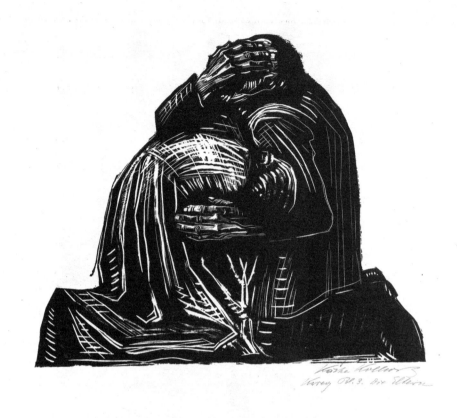

74

The Parents, 1921– early 1922 at the latest

Sheet 3 of the series *War*
Fifth state, proof prior to the Emil Richter
edition of 1924
Woodcut in black ink on thick, soft, rough
Japan paper, 350 × 427 mm (image),
687 × 552 mm (sheet)
Signed and inscribed lower right in pencil:
Käthe Kollwitz/ Krieg Bl. 3. Die Eltern
Anonymously donated, 1924; pre-paid for
by Charles Walter Palmié, Dresden, December
1922
Kupferstich-Kabinett, SKD, inv. no. B 522h/3
Kn 174 V a

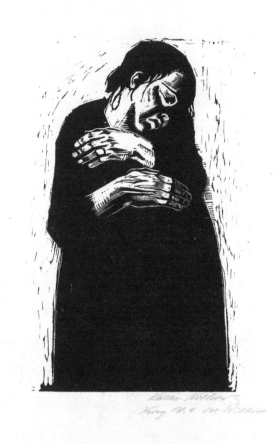

75

The Widow I, 1921–
early 1922 at the latest

Sheet 4 of the series *War*
Fifth state, proof prior to the Emil Richter
edition of 1924
Woodcut in black ink on thick, soft, rough
Japan paper, 370 × 225/235 mm (image),
678 × 551 mm (sheet)
Signed and inscribed lower right in pencil:
Käthe Kollwitz/ Krieg Bl. 4. Die Wittwe [sic]
Anonymously donated, 1924; pre-paid for
by Charles Walter Palmié, Dresden, December
1922
Kupferstich-Kabinett, SKD, inv. no. B 522h/4
Kn 175 V a

76

The Widow II, probably Spring 1922

Sheet 5 of the series *War*
Seventh state, proof prior to the Emil Richter
edition of 1924
Woodcut in black ink on thick, soft,
rough Japan paper, 300 × 525 mm (image),
550 × 688 mm (sheet)
Signed and inscribed lower right in pencil:
Käthe Kollwitz/ Krieg Bl. 5 Die Wittwe [sic]
Anonymously donated, 1924; pre-paid for
by Charles Walter Palmié, Dresden, December
1922
Kupferstich-Kabinett, SKD, inv. no. B 522h/5
Kn 178 VII a

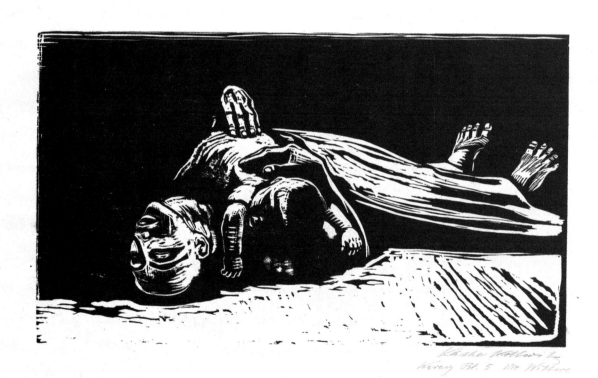

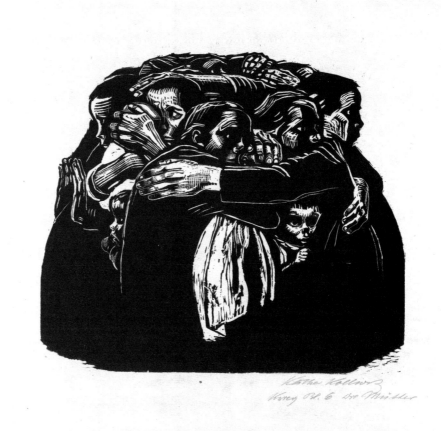

77

The Mothers, mid October 1921–early 1922 at the latest

Sheet 6 of the series *War*
Seventh state, proof prior to the Emil Richter
edition of 1924
Woodcut in black ink on thick, soft, rough
Japan paper, 340 × 400 mm (image),
680 × 550 mm (sheet)
Signed and inscribed lower right in pencil:
Käthe Kollwitz/ Krieg Bl. 6 Die Mütter
Anonymously donated, 1924; pre-paid for
by Charles Walter Palmié, Dresden, December
1922
Kupferstich-Kabinett, SKD, inv. no. B 522h/6
Kn 176 VII a

78

The People, Autumn 1922

Sheet 7 of the series *War*
Seventh state, proof prior to the Emil Richter
edition of 1924
Woodcut in black ink on thick, soft, rough
Japan paper, 360 × 300 mm (image),
687 × 548 mm (sheet)
Signed and inscribed lower right in pencil:
Käthe Kollwitz/ Krieg Bl. 7 Das Volk
Anonymously donated, 1924; pre-paid for
by Charles Walter Palmié, Dresden, December
1922
Kupferstich-Kabinett, SKD, inv. no. B 522h/7
Kn 190 VII a

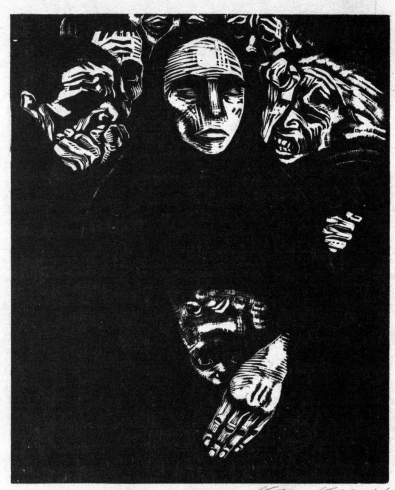

Käthe Kollwitz
Krieg Bl. 7 Das Volk

1 On these three phases see Seeler 2007, pp. 10–11. On other self-portraits in chapters 3 and 4 see cat. 36, 50, 53, 54, 60, 62 and 65.

2 Lehrs 1922, p. 2.

3 See Lehrs 1903, following p. 61.

4 Kollwitz's etchings were printed with few exceptions at the Otto Felsing Hofkunstkupferdruckerei in Berlin from about 1891 through the 1960s; this establishment was headed by Wilhelm Felsing from 1892 until 1940; see Knesebeck 2002, pp. 34–35.

5 See Knesebeck 1998, p. 93.

6 Inv. nos. A 1902-372 and A 1902-845.

7 Inv. no. A 1901-796.

8 See Seeler 2007, p. 78.

9 See Berlin 1995, p. 30.

10 Kaemmerer 1923.

11 See the letter from Max Lehrs to the Saxon Ministry of Education and Cultural Affairs, 30 May 1923, SKD archive, 01/KK 09 vol. 5, no. 132.

12 See Kn 203.

13 Kollwitz 2012, p. 740.

14 Ibid.

15 Inv. nos. A 1902-831 and A 1902-832 have been missing since 1945.

16 Inv. no. A 1902-839 (Kn 27 I).

17 Inv. nos. A. 1902-861 (Kn 28 I) and A 1902-862 (Kn 28 III); A 1899-165 (Kn 28 I) has been missing since 1945.

18 Inv. no. A 1898-613.

19 Inv. no. A 1898-614.

20 See Knesebeck 1998, pp. 206–227.

21 See Kn 49bis.

22 Inv. no. C 1902-11; see Dittrich 1987, p. 66, no. 656.

23 Inv. no. C 1918-20.

24 Inv. nos. C 1917-38, A 1902-850 and A 1902-851.

25 Inv. nos. A 1901-792, A 1902-856 and A 1902-857.

26 See Kn 53.

27 Inv. no. C 1904-98.

28 Inv. no. A 1973-544.

29 In Kn 47 still assigned to between 1899 and 1900.

30 A drawing with a full-length figure is in a private collection.

31 See Hansmann 2007.

32 See Lehrs 1903, p. 64.

33 See Kn 40.

34 The drawing inv. no. C 1902-13 has been missing since 1945.

35 See Kn 81.

36 Anon. 1929, p. 1.

37 See Lehrs 1917. On the quarterly exhibition see the notice in the *Dresdner Anzeiger* of 24 October 1917, p. 5.

38 See Lehrs 1898.

39 See N/T 111.

40 See Cologne 2017.

41 See letter from Käthe Kollwitz to Max Lehrs, 2 May 1901, SKD archive, 01/KK 04 vol. 6, nos. 237–38. The painting is in the Albertinum, Galerie Neue Meister, Staatliche Kunstsammlungen Dresden, gal. no. 2496.

42 Inv. no. C 1917-37.

43 Kn 104.

44 Inv. no. A 1902-822 and A 1902-823.

45 Seidlitz 1916, p. 8.

46 Inv. no. A 1920-598.

47 Kollwitz 2012, p. 508.

48 Postcard from Käthe Kollwitz to Max Lehrs, postmark 30 September 1921, SKD archive, 01/KK 04 vol. 25, no. 257.

49 Kollwitz 2012, p. 174.

Glossary of print techniques

Etching/ line etching

Etching, also known as line etching, is an intaglio process. Only the lines and points applied deeply to the surface of the print medium take on the printing colour and transfer it to the paper during printing. For this, a metal plate , usually copper, is covered with an acid-resistant layer, the etching ground. The etching, or drawing, is done with an etching needle that only needs to penetrate the etching ground. Afterwards the plate is immersed in an acid bath, allowing the acid to eat into the metal areas exposed by the etching needle so that these areas sink deeper into the metal plate. According to the duration of the acid exposure, thin and delicate or broadly printed lines are produced. Etching in stages results in a distinct light-dark contrast. Areas intended to be lighter are covered with an acid-resistant layer, for example asphalt lacquer, during additional acid exposure.

Prior to printing on paper the acid-proof layer is removed and the plate is rubbed with printing ink until all the grooves are saturated with colour, while the flat areas remain blank. Only when a plate tone is desired does a film of colour remain on the flat areas.

Drypoint

In this simple intaglio process an etching needle or other tool is used to scratch the drawing directly into the print medium. It is called drypoint because the grooves are formed without the operation of acid (unlike etching).

Aquatint

Aquatint (from Latin *aqua* = water and Italian *tinta* = coloured) is an intaglio process (see etching) that produces flat tones. A watercolour effect is achieved, which gave the technique its name.

First, powder (for example, colophony) is sifted on to the print medium. When the plate is heated from beneath, the powder kernels start to soften and melt into droplets. This creates an acid-resistant, webbed surface. During the subsequent etching process, the acid can only penetrate into the tiny gaps. The etching ground can be graded by covering the areas that should be lighter with an acid-resistant layer after a short etching process. The areas that are again exposed to the acid become deeper and produce a darker print.

Lift-ground technique

With this etching technique, differentiated surface effects can be achieved, in particular the appearance of brushstrokes on paper. Brushes or other drawing instruments are used to spread a solution (often made of sugar) on to the blank metal plate, which is then covered with asphalt lacquer. Next, the plate is rinsed and the varnish comes off in the areas covered by the solution, exposing the metal. The etching process deepens the grooves of the shape made by the solution in the plate.

Soft-ground etching/ vernis mou

In the intaglio process *vernis mou* (French *vernis* = varnish; *mou* = soft), the acid-proof layer covering the plate does not become hard, but rather remains soft. By laying a piece of paper on top, drawing on it and then carefully lifting the paper up, the soft ground adheres to it wherever the pressure of the drawing utensil was applied. This exposes a grainy, soft line on the print medium, which can then be deepened through the etching process.

Another possibility offered by the soft-ground technique is to create surface textures on the plate, from ribbed hand-made paper, for example, or from textiles. In this case, the desired material is laid on the soft ground and then the print medium passes through the press. When this layer is

carefully lifted, the white ground adheres to all the prominent areas of the design and exposes the underlying metal, which can then be etched. With its painterly, shading effects, soft-ground etching simulates drawing.

Ziegler's transfer paper

This is an industrially produced, grainy paper with a fine, regular, dotted texture originally designed to transfer drawings to lithographic stones. The graininess of such stones is mimicked to some extent by the texture of this paper. The surface texture of Ziegler's transfer paper could be transferred on to the metal plate by soft-ground etching.

Burnisher

In an intaglio process, a burnisher can be used to smooth over corrected areas on the print medium so that the printing ink will not adhere. Lights can be created in this way, polishing a texture applied by aquatint, emery or soft-ground etching in order to produce soft transitions in the surrounding tone.

Roulette

The roulette is a tool for producing grid and continuous tones in intaglio. This pen-like device has a small swivelling cylindrical roller with metal teeth. This produces regular dot-like indentations in the etching ground or directly on the metal plate. It can also roughen surfaces that have been too finely polished, thus correcting shades of tone. Depending on how closely spaced the grid points are, shades of grey to deep black are created.

Emery

With emery (sandpaper), a line etching (see etching) can be complemented with shaded areas. Usually emery is used with varying grains, but loose sand is also suitable. Kollwitz passed the metal plate, coated in an asphalt lacquer, with the emery on top,

through the printing press. When the emery is lifted, the protruding grains of sand will have perforated the acid-proof protective layer, exposing the metal surface.

By covering selected parts a second time and etching in stages (see aquatint), certain areas can appear variously tinted light or dark when printed on paper.

It is also possible to draw on the emery with the grainy side lying on the varnished plate. The lines, which are then etched in the print medium, resemble lines drawn with charcoal or crayon that fray slightly at the edges.

PLANOGRAPHIC PRINTING/
SURFACE PRINTING

Lithography

Lithography is a planographic printing process, meaning that printed and non-printed areas lie on the same plane. It is based on the principle that the areas drawn with oil-based ink on a special limestone (Solnhofen limestone) repel water and simultaneously absorb the oil-based ink. Conversely, areas dampened with water do not absorb the ink. Drawing material containing oil is used directly on the stone, on specially prepared paper or on simple hand-made Ingres paper that is then transferred to the stone.

The drawing material is available in the form of pens, similar to crayons, which is called crayon lithography. It can also be prepared as a liquid, like ink. In this case it can be applied with a pen, brush or as a spray, and the print is then defined as a pen, brush or ink lithograph. Before printing from the drawing stone prepared uniformly in this way, a background surface can be applied to the printing paper with the help of oil-based colour, either homogenously or with a variously tinted tone stone.

The scraping technique offers another option. Here the oily solution is scraped off with a scraper or scraping needle in areas that should not display any printing colour. In these areas on the print, the underlying paper is revealed or, in coloured lithographs with multiple stones, the colour of the underlying stone.

Algraphy/ lithography on aluminium

In the planographic printing process algraphy ('aluminium' and Greek 'graphein' = write or draw), a grainy zinc or aluminium plate is used. This is easier to handle than heavy lithographic stone. The metal plates are specially treated to repel water and absorb fat, or vice versa.

RELIEF PRINTING

Woodcut

In woodcuts as in all relief printing techniques using wooden plates (preferably from beech, oak or fruit trees), only the prominent parts of the print medium are printed. The image is carved inversely into the wooden plate with various cutting tools. The special character of the woodcut consists in its linear simplification and the contrasting black-white effect. Intermediate shades are not possible with this technique.

STATE/ PROOF OF A STATE

The proof of a state documents the print composition while the work is undergoing completion. It is a print from a copper plate, a lithographic stone or a woodblock that reflects a specific state of the composition's development. It is created as an intermediate step to check progress.

We would like to thank the Käthe Kollwitz Museum Köln (Cologne) for their generous permission to reprint this glossary, which we have adapted slightly for the needs of this publication.

Bibliography

EXHIBITION CATALOGUES

Berlin 1893a
Große Berliner Kunst-Ausstellung 1893, exh. cat.
Berlin 1893

Berlin 1893b
Freie Berliner Kunst-Ausstellung 1893, exh. cat.
Berlin 1893

Berlin 1898
Große Berliner Kunst-Ausstellung 1898, exh. cat.
Berlin 1898

Berlin 1899
*Katalog der deutschen Kunstausstellung der
Berliner Secession*, Berlin 1899

Berlin 1902
*Katalog der Sechsten Kunstausstellung der
Berliner Secession: Zeichnende Künste*, Berlin
1902

Berlin 1903
*Katalog der achten Kunstausstellung der Berliner
Secession: Zeichnende Künste*, Berlin 1903

Berlin 1917
*Kaethe Kollwitz Sonder-Ausstellung zu ihrem
fünfzigsten Geburtstag*, exh. cat. Paul Cassirer
Berlin, Berlin 1917

Berlin 1995
Sigrid Achenbach, *Käthe Kollwitz (1867–
1945): Zeichnungen und seltene Graphik im
Berliner Kupferstichkabinett*, Bilderheft der
Staatlichen Museen zu Berlin – Preußischer
Kulturbesitz, nos. 79–81, exh. cat.
Kupferstichkabinett Berlin, Berlin 1995

Cologne 1988
*Die Kollwitz-Sammlung des Dresdner Kupferstich-
Kabinetts: Graphik und Zeichnungen 1890–1912*,
ed. Werner Schmidt, exh. cat. Käthe
Kollwitz Museum Köln (Cologne), 1988

Cologne 1995
Käthe Kollwitz: Meisterwerke der Zeichnung,
ed. Hannelore Fischer, exh. cat. Käthe
Kollwitz Museum Köln (Cologne), 1995

Cologne 1999
*Käthe Kollwitz: Die trauernden Eltern: Ein
Mahnmal für den Frieden*, ed. Hannelore
Fischer, exh. cat. Käthe Kollwitz Museum
Köln (Cologne), 1999

Cologne 2007
*"... mit liebevollen Blicken ...": Kinder im Werk
von Käthe Kollwitz*, ed. Hannelore Fischer,
catalogue by Alexandra von dem Knesebeck,
Einblicke, vol. 8, exh. cat. Käthe Kollwitz
Museum Köln (Cologne), 2007

Cologne 2010
*"Paris bezauberte mich". Käthe Kollwitz und die
französische Moderne*, eds. Hannelore Fischer
and Alexandra von dem Knesebeck, exh. cat.
Käthe Kollwitz Museum Köln (Cologne),
Munich 2010

Cologne 2017
*Aufstand! Renaissance, Reformation, Revolte
im Werk von Käthe Kollwitz*, ed. Hannelore
Fischer, catalogue by Annette Seeler,
exh. cat. Käthe Kollwitz Museum Köln
(Cologne), 2017

Dresden 1899
*Offizieller Katalog der deutschen Kunst-
Ausstellung Dresden 1899*, 1st edn, Dresden
1899

Dresden 1900
*Leopold Graf Kalckreuth: Gemälde – Zeichnungen
– Graphische Arbeiten: Sonderausstellung in
Emil Richter's Kunstsalon Dresden März 1900*,
Dresden 1900

Dresden 1901
*Offizieller Katalog der Internationalen
Kunstausstellung Dresden 1901*, 1st edn,
Dresden 1901

Dresden 1908
*Offizieller Katalog der Großen Kunstausstellung
Dresden 1908*, 3rd edn, Dresden 1908

Dresden 1917
*Herbst-Ausstellung 1917 verbunden mit einer
Ausstellung von Jugend-Werken von Max Klinger:
Sonder-Ausstellung Käthe Kollwitz*, exh. cat.
Künstler-Vereinigung Dresden, Dresden
1917

Dresden 1960
*Käthe Kollwitz: Graphik und Zeichnungen aus
dem Dresdener Kupferstich-Kabinett*, exh. cat.
Staatliche Kunstsammlungen Dresden/
Städtische Sammlungen Dresden, Dresden
1960

Dresden 2001
Die Brücke in Dresden 1905–1911, ed.
Birgit Dalbajewa, exh. cat. Staatliche
Kunstsammlungen Dresden, Galerie Neue
Meister, Cologne 2001

Hamburg 2011
Max Liebermann: Wegbereiter der Moderne, exh.
cat. Hamburger Kunsthalle, Heidelberg 2011

Königsberg 1917
*Käthe Kollwitz Sonder-Ausstellung zu ihrem
fünfzigsten Geburtstag*, exh. cat. Königsberg,
Berlin 1917

London 1906
*A Catalogue of the Gravings and Sculpture in the
Sixth Exhibition of the International Society of
Sculptors, Painters and Gravers held in the New
Gallery, February and March 1906*, London 1906

London 1984
*The Print in Germany 1880–1933: The Age of
Expressionism*, exh. cat. British Museum,
London, London 1984

Munich 1899
*Offizieller Katalog der Münchner Jahres-
Ausstellung im kgl. Glaspalast*, Munich 1899

Washington 1992
Käthe Kollwitz, ed. Elizabeth Prelinger,
exh. cat. National Gallery of Art,
Washington, D.C., New Haven/ London
1992

Vienna 1898
*Katalog der V. Ausstellung der Vereinigung
bildender Künstler Österreichs "Secession"*,
Vienna 1898

GENERAL LITERATURE

Alp 1898
Alp [Anna Plehn], 'Die Künstlerinnen-
ausstellung im Salon Gurlitt', in *Deutsche
Kunst*, vol. 2, 1898, no. 13, p. 266

Anon. 1929
Anonymous, 'Staatliches
Kupferstichkabinett: Saal der neuen
Erwerbungen', supplement to *Dresdner
Anzeiger,* 14 April 1929, pp. 1–4

Beth 1917
Ignaz Beth, 'Berliner Ausstellungen', in
Die Kunst für Alle, vol. 32, 1916/17, nos. 3–4,
November 1916, pp. 70–73

Biedermann 2006
Heike Biedermann, 'Einzug der Moderne:
Die Sammlungen Oscar Schmitz und
Adolf Rothermundt', in *Von Monet bis
Mondrian. Meisterwerke der Moderne aus
Dresdner Privatsammlungen der ersten Hälfte
des 20. Jahrhunderts*, eds. Heike Biedermann,
Ulrich Bischoff and Mathias Wagner, exh.
cat. Staatliche Kunstsammlungen Dresden,
Galerie Neue Meister in collaboration with
the Kupferstich-Kabinett, Munich 2006,
pp. 45–60

Bierbaum 1891
Otto Julius Bierbaum, 'Vom Münchner
Salon', in *Das Magazin für Litteratur*, eds. Fritz
Mauthner and Otto Neumann-Hofer,
vol. 60, 1891, no. 40, 3 October 1891,
pp. 629–32

Bohnke-Kollwitz 1992
Käthe Kollwitz: Briefe an den Sohn 1904 bis 1945,
ed. Jutta Bohnke-Kollwitz, Berlin 1992

Bonus-Jeep 1948
Beate Bonus-Jeep, *Sechzig Jahre Freundschaft
mit Käthe Kollwitz*, Boppard 1948

Braun 1989/90
Ernst Braun, 'Der Briefwechsel zwischen
Max Lehrs und Max Liebermann', in
Jahrbuch Staatliche Kunstsammlungen Dresden,
vol. 21, 1989/90, pp. 81–106

Braun 2012
Max Liebermann: Briefe 1896–1901, ed. Ernst
Braun, Schriftenreihe der Max-Liebermann-
Gesellschaft Berlin e. V., vol. 2, Baden-Baden
2012

Carey/ Griffiths 1984
Frances Carey and Anthony Griffiths, 'Käthe
Kollwitz', in *The Print in Germany 1880–1933:
The Age of Expressionism*, exh. cat. British
Museum, London, London 1984, pp. 60–75

Dittrich 1987
Christian Dittrich, *Vermißte Zeichnungen des
Kupferstich-Kabinettes Dresden*, Dresden 1987

Echte/ Feilchenfeldt 2011
Bernhard Echte and Walter Feilchenfeldt,
*"Das Beste aus aller Welt zeigen": Kunstsalon
Bruno & Paul Cassirer: Die Ausstellungen 1898–
1901*, Wädenswil 2011

Elias 1893
Julius Elias, 'Die Freie Berliner
Kunstausstellung', in *Die Nation*, vol. 10,
1892/93, no. 44, 1893, pp. 673–74

Elias 1917
Julius Elias, 'Käthe Kollwitz', in *Kunst und
Künstler*, vol. 15, 1917, pp. 540–49 (reprinted
in *Die Kollwitz-Sammlung des Dresdner
Kupferstich-Kabinetts: Graphik und Zeichnungen
1890–1912*, ed. Werner Schmidt, exh. cat.
Käthe Kollwitz Museum Köln (Cologne),
1988, pp. 21–28)

Hansmann 2010
Doris Hansmann, 'Käthe Kollwitz und der
moderne Akt', in *"Paris bezauberte mich":
Käthe Kollwitz und die französische Moderne*,
eds. Hannelore Fischer and Alexandra von
dem Knesebeck, exh. cat. Käthe Kollwitz
Museum Köln (Cologne), Munich 2010,
pp. 137–75

Heilbut 1903
H. [Emil Heilbut], 'Die Schwarz-Weiß-
Ausstellung der Berliner Secession', in *Kunst
und Künstler*, vol. 1, 1902/03, no. 3, pp. 81–94
(illus. pp. 95– 122)

Kaemmerer 1923
Ludwig Kaemmerer, *Käthe Kollwitz:
Griffelkunst und Weltanschauung: Ein
kunstgeschichtlicher Beitrag zur Seelen- und
Gesellschaftskunde*, Dresden 1923

Klipstein 1955
August Klipstein, *Käthe Kollwitz: Verzeichnis
des graphischen Werkes*, Bern/ New York 1955

Knesebeck 1998
Alexandra von dem Knesebeck, *Käthe
Kollwitz: Die prägenden Jahre*, Studien
zur internationalen Architektur- und
Kunstgeschichte, vol. 6, Petersberg 1998

Knesebeck 1999
Alexandra von dem Knesebeck, '"Der
Volkskrieg dieser Zeit hatte auch seine
Heldinnen": Zum Frauenbild der frühen
Graphikfolgen', in *Käthe Kollwitz: Das Bild
der Frau*, ed. Jutta Hülsewig-Johnen, exh.
cat. Kunsthalle Bielefeld/ Stiftung Museum
Schloss Moyland, Bielefeld 1999, pp. 59–71

Knesebeck 2002 (Kn)
Alexandra von dem Knesebeck, *Käthe
Kollwitz: Werkverzeichnis der Graphik*, [revised
edition of the complete catalogue by August
Klipstein (1955)], 2 vols., Bern 2002

Knesebeck 2007
Alexandra von dem Knesebeck, '"… Das
gewaltige herrliche und traurige Leben
fasste er und deutete es uns": Käthe
Kollwitz und Klinger', in *Max Klinger:
"Alle Register des Lebens": Graphische Zyklen
und Zeichnungen*, exh. cat. Käthe Kollwitz
Museum Köln (Cologne)/ Suermondt-
Ludwig-Museum Aachen, Berlin 2007,
pp. 54–71

Knesebeck 2010
'"Daß überhaupt der Aufenthalt in Paris
– so kurz der war – Anregung in Fülle
brachte, brauche ich Ihnen nicht zu sagen":
Die erste Parisreise von Käthe Kollwitz
1901', in *"Paris bezauberte mich": Käthe Kollwitz
und die französische Moderne*, eds. Hannelore
Fischer and Alexandra von dem Knesebeck,
exh. cat. Käthe Kollwitz Museum Köln
(Cologne), Munich 2010, pp. 83–105

Kollwitz 1966
Käthe Kollwitz, Briefe der Freundschaft und Begegnungen: Mit einem Anhang aus dem Tagebuch von Hans Kollwitz und Berichten über Käthe Kollwitz, Munich 1966

Kollwitz 1981
"Ich will wirken in dieser Zeit": Auswahl aus den Tagebüchern und Briefen, aus Graphik, Zeichnungen und Plastik, ed. Hans Kollwitz, Berlin 1981

Kollwitz 2012
Käthe Kollwitz: Die Tagebücher, ed. Jutta Bohnke-Kollwitz, new edn, Munich 2012 (Berlin 1989)

Kuhlmann-Hodick 2004
Petra Kuhlmann-Hodick, 'Toulouse-Lautrec im Kupferstich-Kabinett Dresden', in *Henri de Toulouse-Lautrec: Noblesse des Gewöhnlichen*, eds. Petra Kuhlmann-Hodick and Wolfgang Holler, exh. cat. Sinclair-Haus, Bad Homburg/ Tiroler Landesmuseum Ferdinandeum, Innsbruck, Cologne 2004, pp. 18–37

Kurth 1917
Willy Kurth, 'Ausstellungen: Käthe Kollwitz' Zeichnungen', in *Kunstchronik*, vol. 28, 1916/17, no. 30, 27 April 1917, columns 309–11

Lehrs 1898
Max Lehrs, 'Königliches Kupferstich-kabinet: Saal der neuen Erwerbungen', supplement to *Dresdner Anzeiger*, 3 November 1898, p. 1

Lehrs 1899
Max Lehrs, 'Königliches Kupferstich-kabinet: Saal der neuen Erwerbungen', offprint *Dresdner Anzeiger*, 13 May 1899, p. 1

Lehrs 1901
Max Lehrs, 'Käthe Kollwitz', in *Die Zukunft*, vol. 37, 1901, pp. 351–55

Lehrs 1902
Max Lehrs, 'Königliches Kupferstichkabinet: Saal der neuen Erwerbungen', offprint *Dresdner Anzeiger*, 6 July 1902, pp. 1–3

Lehrs 1903
Max Lehrs, 'Käthe Kollwitz', *Die Graphischen Künste*, vol. 26, 1903, pp. 55–67

Lehrs 1911
Max Lehrs, 'Königliches Kupferstich-kabinett: Saal der neuen Erwerbungen', offprint *Dresdner Anzeiger*, 10 March 1911, pp. 1–3

Lehrs 1912
Max Lehrs, 'Zur Geschichte des Dresdner Kupferstichkabinetts', offprint *Mitteilungen aus den Sächsischen Kunstsammlungen*, vol. 3, Dresden 1912, pp. 1–12

Lehrs 1917
Max Lehrs, 'Königliches Kupferstich-kabinett: Saal der neuen Erwerbungen', offprint *Dresdner Anzeiger*, 14 August 1917, pp. 1–2

Lehrs 1921
Max Lehrs, 'Kupferstichkabinett: Saal der neuen Erwerbungen', offprint *Dresdner Anzeiger*, 8 July 1921, pp. 1–2

Lehrs 1922
Max Lehrs, 'Käthe Kollwitz', *Berliner Tageblatt und Handels-Zeitung*, vol. 51, no. 553, 5 December 1922, evening edn, p. 2

Lehrs 1925
Max Lehrs, 'Etwas vom Kupferstichsammeln', in *Amslerdrucke und Schroll's Albertina-Facsimiledrucke: Kupferstiche, Holzschnitte und Handzeichnungen alter Meister in originalgetreuen Nachbildungen*, with essays by Max Lehrs and Josef Meder, Berlin/ Vienna 1925, pp. 1–6

Liebermann 1899
Max Liebermann, *Degas*, Berlin 1899

Liebermann 1901
Max Liebermann, *Josef Israels*, Berlin 1901

Loeser 1902
Charles Loeser, 'Käthe Kollwitz', *Sozialistische Monatshefte*, vol. 6 (8), 1902, part 1, no. 2, February 1902, pp. 107–11

Matelowski 2017
Anke Matelowski, '"So blüht mein Weizen und ich freu mich dessen": Käthe Kollwitz und die Berliner Secession', in *Käthe Kollwitz und Berlin: Eine Spurensuche*, exh. cat. Galerie Parterre Berlin, Berlin 2017, pp. 185–97

Matthias 2010
Agnes Matthias, 'Sammlungsgeschichte – Mediengeschichte: Fotografie am Dresdner Kupferstich-Kabinett', in *KunstFotografie. Katalog der Fotografien von 1839 bis 1945 aus der Sammlung des Dresdner Kupferstich-Kabinetts*, ed. Agnes Matthias, Berlin/ Munich 2010, pp. 16–31

Nagel/ Timm 1980 (N/T)
Käthe Kollwitz: Die Handzeichnungen, ed. Otto Nagel in collaboration with Sibylle Schallenberg-Nagel, catalogue by Werner Timm, in consultation with Hans Kollwitz, 2nd edn, Stuttgart et alibi 1980

Orlik 1981
Emil Orlik: Malergrüße an Max Lehrs 1898–1930, ed. Adalbert Stifter Verein, Munich 1981

Plehn 1902
Anna Plehn, 'Käthe Kollwitz', *Die Kunst für Alle*, vol. 17, 1901/02, no. 10, 15 February 1902, pp. 227–30

Plehn 1904
Anna Plehn, 'Die neuen Radierungen von Käthe Kollwitz', *Die Frau: Monatsschrift für das gesamte Frauenleben unserer Zeit*, vol. 11, 1903/04, no. 4, January 1904, pp. 234–38

Röver-Kann 2007
Röver-Kann, 'Die Sammlung des Dr. H. H. Meier jr. – ein kurzer Versuch, Vielfalt und Kontraste zu beschreiben', in *Altes, Neues, Allerneuestes: Sammeln um 1900: Eine Ausstellung zu Ehren von H. H. Meier jr. und Heinrich Wiegand*, exh. cat. Kunsthalle Bremen, Bremen 2007, pp. 10–25

Rosenhagen 1903
Hans Rosenhagen, 'Die sechste Ausstellung der Berliner Secession', *Die Kunst für Alle*, vol. 18, 1902/03, no. 8, 15 January 1903, pp. 186–90

Schade 1995
Werner Schade, 'Vom Vorauseilen der Zeichnung', in *Käthe Kollwitz. Meisterwerke der Zeichnung*, ed. Hannelore Fischer, exh. cat. Käthe Kollwitz Museum Köln (Cologne), 1995, pp. 20–32

H.-W. Schmidt 1985
Hans-Werner Schmidt, *Die Förderung des vaterländischen Geschichtsbildes durch die Verbindung für historische Kunst, 1854–1933*, Studien zur Kunst- und Kulturgeschichte, vol. 1, Marburg 1985

W. Schmidt 1960
Werner Schmidt, 'Max Lehrs und Käthe Kollwitz', in *Käthe Kollwitz: Graphik und Zeichnungen aus dem Dresdener Kupferstich-Kabinett*, exh. cat. Albertinum Dresden, Dresden 1960, pp. 19–25

W. Schmidt 1988
Werner Schmidt, 'Max Lehrs und Käthe Kollwitz: Die Entstehung der Kollwitz-Sammlung des Dresdner Kupferstich-Kabinettes', in *Die Kollwitz-Sammlung des Dresdner Kupferstich-Kabinetts: Graphik und Zeichnungen 1890–1912*, ed. Werner Schmidt, exh. cat. Käthe Kollwitz Museum Köln (Cologne), 1988, pp. 10–20

Schultze-Naumburg 1897
Paul Schultze-Naumburg, 'Die Große Berliner Kunstausstellung II', *Die Kunst für Alle*, vol. 12, 1896/97, no. 19, 1 July 1897, pp. 303–05

Schumann 1908
Paul Schumann, 'Die Große Kunstausstellung Dresden', *Die Kunst für Alle*, vol. 23, 1907/08, no. 23, 1 September 1908, pp. 529–40

Seeler 2007
Annette Seeler, 'Betrachtungen zu den Selbstbildnissen von Käthe Kollwitz', in *Käthe Kollwitz. Selbstbildnisse*, exh. cat. Käthe-Kollwitz-Museum Berlin, ed. Martin Fritsch, Leipzig 2007, pp. 9–16

Seeler 2016
Annette Seeler, *Käthe Kollwitz: Die Plastik. Werkverzeichnis*, ed. Käthe Kollwitz Museum Köln (Cologne), Munich 2016

Seidlitz 1898
Woldemar von Seidlitz, 'Der Karlsruher Künstlerbund', *Pan*, vol. 3, 1897/98, no. 4, 1898, pp. 235–38

Seidlitz 1905
Woldemar von Seidlitz, 'Max Lehrs', *Dresdner Jahrbuch. Beiträge zur bildenden Kunst*, 1905, pp. 113–20

Seidlitz 1911
Woldemar von Seidlitz, 'Forains Lithographien und Radierungen im Kupferstichkabinett zu Dresden', *Mitteilungen aus den Sächsischen Kunstsammlungen*, vol. 2, 1911, pp. 95–99

Seidlitz 1916
Woldemar von Seidlitz, ['Kriegsgraphik'], in *Kriegsgraphik: Königliches Kupferstichkabinett. Katalog der Ausstellung Januar bis Juli 1916*, ed. Generaldirektion der Königlichen Sammlungen Dresden, Dresden 1916, pp. 4–11

Sievers 1913
Johannes Sievers, *Die Radierungen und Steindrucke von Käthe Kollwitz innerhalb der Jahre 1890 bis 1912: Ein beschreibendes Verzeichnis*, Dresden 1913

Singer 1902
Hans Wolfgang Singer, 'Modern Etching and Engraving in Germany', in *Modern Etching and Engraving*, ed. Charles Holme, London et alibi 1902, pp. 1–5

Singer 1908
Hans Wolfgang Singer, *Käthe Kollwitz*, Führer zur Kunst, vol. 15, ed. Hermann Popp, Esslingen 1908

Singer 1909
Hans Wolfgang Singer, *Max Klingers Radierungen, Stiche und Steindrucke*, Berlin 1909

Singer 1916
Hans Wolfgang Singer, *Handbuch für Kupferstichsammlungen: Vorschläge zu deren Anlage und Führung*, Leipzig 1916

Tröger 2011
Sabine Tröger, *Kunstpopularisierung und Kunstwissenschaft: Die Wiener Kunstzeitschrift "Die Graphischen Künste" (1879–1933)*, Berlin 2011

Vanderbilt Balsan 1973
Consuelo Vanderbilt Balsan, *The Glitter and the Gold*, 2nd edn, Kent 1973

Vickers 1987
Hugo Vickers, *Gladys, Duchess of Marlborough*, 2nd edn, London 1987

Walk 1988
Joseph Walk, *Kurzbiographien zur Geschichte der Juden 1918–1945*, ed. Leo Baeck Institute Jerusalem, Munich et alibi 1988

Weinmayer 1917
Konrad Weinmayer, 'Käthe Kollwitz zu ihrem 50. Geburtstag', *Die Kunst für Alle*, vol. 32, 1916/17, nos. 19–20, July 1917, pp. 361–70

Weisbach 1905
Werner Weisbach, 'Käthe Kollwitz', *Zeitschrift für Bildende Kunst*, new series, vol. 16, 1904–05, pp. 85–92

Weisner 1967
Ulrich Weisner (ed.), *Käthe Kollwitz an Dr. Heinrich Becker: Briefe*, Bielefeld 1967

Weixlgärtner 1938
Arpad Weixlgärtner, 'Max Lehrs', *Die Graphischen Künste*, new series, vol. 3, 1938, pp. 156–59

Wieland 1899
E. Wieland, 'Die Jahres-Ausstellung im kgl. Glaspalaste zu München', *Die Kunst für Alle*, vol. 20, 1898/99, no. 20, 15 July 1899, pp. 305–13

Zimmermann 1901/02
Ernst Zimmermann, 'Die Dresdner Internationale Kunst-Ausstellung', *Kunstchronik*, vol. 13, 1901/02, no. 3, 24 October 1901, columns 33–36

Index of persons

This catalogue was first published to accompany the exhibition

Käthe Kollwitz in Dresden

Staatliche Kunstsammlungen Dresden
Kupferstich-Kabinett

19 October 2017 – 14 January 2018

Realised with the generous support of

A. Woodner Fund

CATALOGUE

Published and edited by:
Staatliche Kunstsammlungen Dresden
Petra Kuhlmann-Hodick, Agnes Matthias

German copyediting: Thomas Frangenberg

English copyediting: Paul Holberton

Translation from the German: Jennifer Heber-Brown

Transcription of correspondence between Max Lehrs and Käthe Kollwitz: Patrick Wilden

Design: Laura Parker, Paul Holberton publishing

Origination and printing: e-Graphic Spa, Verona

© 2017 Staatliche Kunstsammlungen Dresden, Paul Holberton publishing, London, and authors

Published by
Paul Holberton publishing
89 Borough High Street, London SE 11 NL
WWW.PAULHOLBERTON.COM

A catalogue record for this book is available from the British Library.

ISBN 978-1-911300-30-4

EXHIBITION

Director general: Marion Ackermann

Management director: Dirk Burghardt

Director Kupferstich-Kabinett: Stephanie Buck

Curators: Petra Kuhlmann-Hodick, Agnes Matthias

Administration: Kristina Schüffny

Conservation: Olaf Simon in collaboration with Ines Beyer

Exhibition management: Katrin Bäsig, head: Barbara Rühl

Marketing: Andrea Vogt, head: Martina Miesler

Press and communication: Anja Priewe, head: Stephan Adam

Publications department: Evelin Pfeifer

Education: Grit Lauterbach, head: Claudia Schmidt

Accounting and auditing: Elke Schmieder

Exhibition design: Karen Weinert

Exhibition installation: Ines Beyer, Matthias Herbst, Natalie Lochner

Technical support: Peter Handrick, Gunter Knehler, head: Michael John

LENDERS TO THE EXHIBITION

Akademie der Künste, Berlin, Kunstsammlung

Staatliche Museen zu Berlin – Preußischer Kulturbesitz, Kupferstichkabinett

Sächsische Landesbibliothek – Staats- und Universitätsbibliothek Dresden

Käthe Kollwitz Museum Köln (Cologne)

Front cover: cat. 53 (detail)
Back cover: cat. 63
Pages 4, 8, 9, 10, 11: cat. 58, 52, 49, 12, 38 (details)
Catalogue opener: cat. 45 (detail)

PHOTOGRAPHIC CREDITS

Kupferstich-Kabinett, Staatliche Kunstsammlungen Dresden, Andreas Diesend: pp. 14, 16, 24, 25, 32, 35, 46–53, cat. 4, 5, 7–9, 11–22, 24, 26, 27, 32–35, 37–39, 41, 44, 47, 49–52, 56–59, 61–78, Details pp. 4, 6, 8–11, 22, 33, 34, 44, 66, 132; Herbert Boswank: pp. 12, 13, 15, 17, 18, 19, cat. 3, 6, 23, 25, 28, 31, 36, 40, 42, 45, 46, 53–55, 60, Details pp. 56, 64–65, 84, 102, 106, 126, 136

Albertinum, Galerie Neue Meister, Staatliche Kunstsammlungen Dresden, Elke Estel: p. 30
Akademie der Künste, Berlin, Kunstsammlung, Ilona Ripke: cat. 29
bpk / Kupferstichkabinett, SMB, Volker-H. Schneider: cat. 2, 43; Dietmar Katz: cat. 30
The Dr. Richard A. Simms Collection, The Getty Research Institute, Los Angeles: p. 36
Käthe Kollwitz Museum Köln: pp. 26, 58–61, cat. 1, 10
Kunsthaus Lempertz, Sascha Fuis Photographie, Köln: p. 37
Münchner Stadtmuseum, Sammlung Fotografie, Archiv Kester: p. 28
Nuremberg, Germanisches Nationalmuseum, Deutsches Kunstarchiv, NL Lehrs, Max, I,A-2a (0007): p. 27